Jon Ramer • Ron Miller

Editors

The Beauty of Space Art

An Illustrated Journey Through the Cosmos

Second Edition

 Springer

Editors
Jon Ramer
IAAA
Mill Creek, WA, USA

Ron Miller
South Boston, VA, USA

Second edition of the original work published by the IAAA with the title "Beauty of Space, 2012"

ISBN 978-3-030-49361-5 ISBN 978-3-030-49359-2 (eBook)
https://doi.org/10.1007/978-3-030-49359-2

Cover image credit: *Cosmic Conception - Immaculate Star* by Michael Turner

This Springer imprint is published by the registered company Springer Nature Switzerland AG
The registered company address is: Gewerbestrasse 11, 6330 Cham, Switzerland

Foreword

By Alan Bean, Apollo 12 Astronaut
(written before Alan's passing on 29 May 2018)

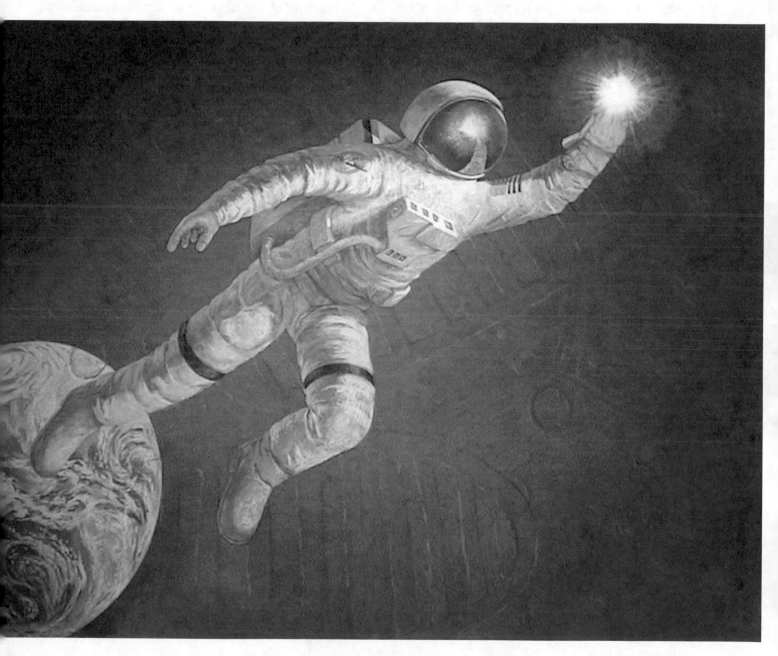

Fig. 1 Photograph of mural at the Astronaut Hall of Fame painted by Alan Bean, photo by Jon Ramer

Most of the art that we see around us, and hangs in the world's great museums, are what we would see if we lived at the time of the artist on Earth. A record from the distant past to the present, we can see what animals and humans looked like, and what they were doing centuries ago, decades before, and yesterday.

For example, all of us seem to enjoy seeing what life was like in France as painted by Impressionist artists the likes of Claude Monet, August Renoir, Edgar Degas, Alfred Sisley and others at turn of the 20th century. I love that period of time.

Others are entertained by seeing what it was like at the time of the opening of the American West, painted so brilliantly by Fredrick Remington and Charles Russell, among others. I know I do.

The artists' work you will see in this amazing and tradition-breaking book are all about our future. What our descendants will see, as the centuries unfold and they travel the vast distances to distant worlds, we can view right now through the eyes and imagination of the Artist.

These paintings are not just a simple flight of fancy, but are based on thorough scientific research and study. The artists visualize the world that probably exists, not that might exist. These are worlds our children's, children's, children's, children will explore someday in future generations.

I am one of twelve lucky human beings to have ever experienced the breathtaking awe of stepping onto the shores of an alien world. That world was hauntingly familiar because of art that I had seen over the years created by some of the great artists in this magnificent book. I am forever in their debt for making me feel more comfortable in a dangerous and distant world.

The twelve of us that moved about on the Moon's surreal terrain acknowledge a spiritual beauty in the mysterious rocks and craters. We had been sent to this cratered rocky and dusty world and left our footprints where there is no wind, nor rain to erase them. They will remain as they were when we first made them for the next thirty million Earth years.

I went as an Astronaut, but with the heart of an Explorer and the eyes of an Artist. The most incredible adventure of our generation left us somewhat transformed when we returned home.

I now paint pictures of what we humans did, and will do, when we first encounter worlds other than our own. When we go to the distant worlds depicted in this wondrous book, these same activities will be repeated because they are the best way discovered so far that allow us to understand how these new worlds were formed, and if they can be of value to the people on Earth.

I include artifacts from my spacesuit, still retaining magical sprinklings of dust from the Ocean of Storms, and from the spaceship that carried me there. I have embedded these sacred objects in my paintings. It is my dream that these first paintings of another world created by an artist who has actually been there, will document experiences that can be forever shared by humanity.

I hope this book, *The Beauty of Space Art*, will enlighten the general public of the islands beyond our atmosphere and gravity, and will create an intense desire to go there.

As centuries unfold, we will surely visit other planetary neighbors around our beautiful star, the Sun. We will then travel out to nearby stars, a few of the hundreds of billions of worlds within our Milky Way Galaxy.

We artists bring dreams to life; and we've only begun to dream.

Alan Bean
Fellow IAAA
Reston, VA, USA

Fig. 2 *That's How it Felt* by Alan Bean, Fellow, International Association of Astronomical Artists

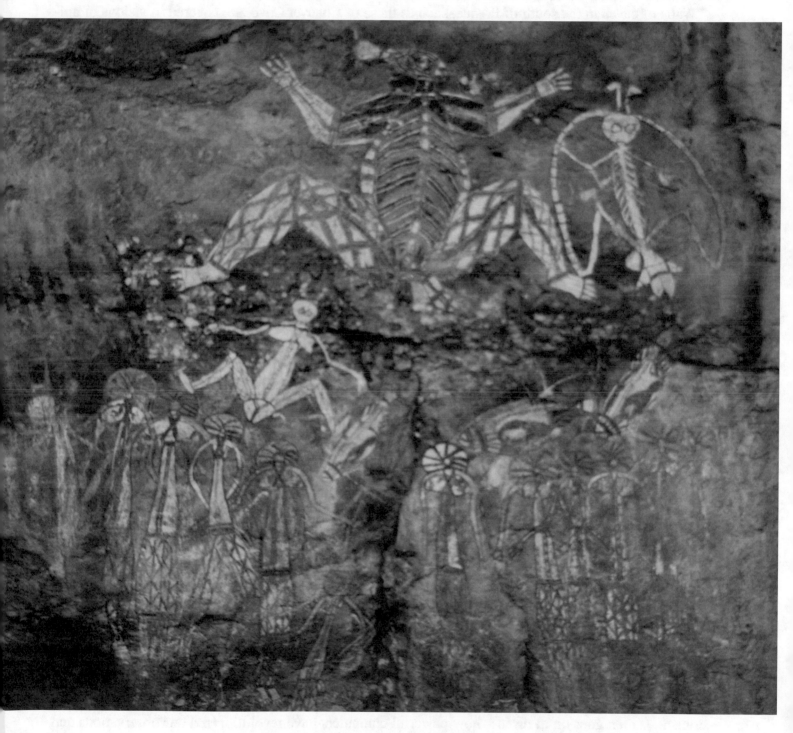

Fig. 1 Photograph of aboriginal cave painting in northern Australia, photo by Jon Ramer, FIAAA

Humans are visual creatures. Yes, we have five senses, but some 75% of what the human brain learns comes from what we see. Most of the modern alphabet you are looking at right now was permanently set when the first printing press was created around 1440 AD, but the origins of using letters to make an alphabet can be traced all the way back to a mnemonic symbol form of proto-writing developed around 7000 BC. "Writing" in some form or another has been used by humans for more than 9,000 years.

Walls of caves in the south of France, such as those of Chauvet Cave, are covered in visions of animals that are more than 35,000 years old. Rock paintings in Australia have been dated to over 40,000 years old. There are pictograms and images in every place across Earth where people have lived that are thousands of years older than the written word.

Long before humans wrote, we painted.

A painting can cross not just the gulf of years, but any and all language barriers. What did ancient Proto-Canaanite sound like when spoken? What words did Cro-Magnon people use when talking about deer or mammoth? We will never know. But we know they talked about those animals because they painted pictures of them – pictures which depict their subjects so accurately that thousands of years later, a viewer instantly recognizes what the artist was thinking. Such is the power of art.

Those artists from millennia ago painted with simple implements, like sticks and tufts of animal fur. The pigments they used were made from natural resources: colored mud, animal fat, ash, and plant extracts. Yet if one of those long-gone artists were miraculously transported to today, they would have no problem painting with the tools we now use. The "art" of making "art" hasn't changed much. The subjects of what we paint, though, have changed considerably.

Over the centuries, our mastery of our world has advanced to where we are sending mechanical proxies to explore other worlds of the Solar System, machines that return digital images every bit as amazing to us as a tube of paint would have been to that ancient cave artist. But as incredible as these achievements are, human imagination has gone even farther.

"Space" or "astronomical" art is the embodiment of that leap in human imagination. It is a genre of artistic expression that strives to show the wonders of the universe. Inspiring, uplifting, mesmerizing, space art helps to fulfill a deep-set need in the human spirit to go and see. We are a species of explorers; it is in our very nature to wonder about what is over the hill, across the river, beyond that mountain – or on the next planet. And when we can't go and explore ourselves, we send the imagination of an artist.

This book documents the birth and development of the genre of space art, tracing what humanity has artistically depicted in the skies above. As we evolved and grew, so too did our artistic expressions. And believe it or not, many of the great leaps of human understanding came about because of the imagination and skills of artists.

In the first part of this book, we explore how humanity slowly but surely began exploring the heavens through art, as we traverse chronologically from ancient times to the industrial revolution. New scientific discoveries and instruments were developed at an ever-increasing pace from the Victorian Era through World War II, bringing new expressions of astronomical art. The war wrought devastation and loss on a massive scale, but spurred scientific development to a profound degree. In just a few short decades, airplanes flew higher and faster than ever before, and rockets reached into space to deliver probes to other worlds – and humans to our own Moon. Space art made even more dramatic leaps during this period, becoming a movement large enough to form an international guild of artists.

The second part of this book delves into the techniques and the various subgenres of astronomical art, where you will learn about terminology and topics like rocks and balls, hardware art, and cosmic expressionism. It then goes on to discuss how powerful computers have revolutionized our observations and artistic representations of the universe, providing new topics and places for artists to depict, as well as fostering a rich field of digitally created art. Finally, we'll look at who has supported astronomical art through the years and where the genre is going in the future.

Fig. 2 *Proxima* by Mark Garlick, FIAAA

Words are fantastic, but an image can instantly explain the unknown, move you to tears, or lift your soul to the stars above. We invite you on this journey of human imagination from the deep past to the far future, from the small blue world we call Earth to the far reaches of the universe. Join us in admiring *The Beauty of Space Art*.

Jon Ramer
President and Fellow, IAAA, 2019
Mill Creek, WA, USA

Contents

About the Authors

Judy Broome-Riviere Judy Broome-Riviere (wife of Kara Szathmáry) holds an MFA from the University of Florida. She is a visual arts instructor with fifty years' teaching experience. She is International Baccalaureate certified and is an Associate Member of the IAAA.

Michael Carroll Writer, lecturer, and artist, Michael Carroll has over thirty books in print. He is a Fellow and founding member of the International Association for the Astronomical Arts, and recipient of the Lucien Rudaux award for lifetime achievement in the astronomical arts. He was a fellow in the 2016–17 Antarctic Artists and Writers Program of the US National Science Foundation. One of his paintings is on the surface of Mars – in digital form – aboard the Phoenix lander.

Matt Colborn Matt Colborn is a self-taught artist with an academic background in cognitive science who also enjoys modelling. He has been a keen amateur astronomer since childhood, has done work on SETI and consciousness and writes speculative fiction. His favored space art topics are alien landscapes and planetary geology.

Don Davis Don Davis is an artist and animator whose subjects have included the Ancient World as well as the fruits of space exploration. Events, life and scenes from the history of the Earth and Moon are among the subjects of his art. Many of his space paintings were made because the information needed for detailed accurate portrayals was brand new.

Mark Garlick Mark Garlick is a freelance illustrator, writer, and artist specializing in space and paleo art. His original background was in astrophysics, for which he earned a PhD in 1993. He followed this with three years' postdoctoral research, but he left academia in 1997 to pursue a more creative path. Since then he has written and illustrated numerous books on astronomy and astrophysics.

Steven Hobbs Dr. Steven Hobbs is a peer-reviewed author of planetary geomorphology and published space artist. Steven has pursued a life-long interest in space, with artworks and reprocessed historical spacecraft imagery appearing in numerous books and publications. One of Steven's scientific publications was used in part to determine a safe landing site on Mars for NASA's Curiosity Rover.

Ron Miller Ron Miller has been specializing in astronomical illustration for nearly 50 years. He is the author of numerous articles and papers on the subject as well as books such as *Space Art*, *The Art of Space*, and the Hugo Award-winning *Art of Chesley Bonestell*.

Jon Ramer Jon Ramer is a career military officer and avid world traveler who uses his experience as a landscape photographer, both aerial and underwater, as source material for his paintings. He works in both acrylics and oils and is a Fellow member and the President of The International Association of Astronomical Artists. His works have been seen in several astronomical and scientific art shows and books, and he has written numerous treatises on the topic of astronomical art.

Pat Rawlings Pat Rawlings has over 40 years a space illustrator and designer. His realistic views of both human and robotic exploration provide a chronology of the plans, hopes, and desires of the planet's best space visionaries. His works have been reproduced in and on hundreds of magazines, books, television programs, films and murals in both in the US and abroad. Rawlings is a Fellow and former Trustee of the IAAA.

Lois Rosson Lois Rosson is a PhD candidate at U.C. Berkeley. She was the 2018–2019 Guggenheim Predoctoral Fellow at the Smithsonian's National Air and Space Museum in Washington, D.C., and worked at NASA's Ames Research Center before starting graduate school. Her work focuses on the history of astronomical illustration and the visual culture of space exploration.

Aldo Spadoni Aldo Spadoni is an aerospace engineer with over 35 years of experience supporting advanced programs for NASA and the DoD. He created an award-winning visualization team at Northrop Grumman and is a Fellow and Board Member of the International Association of Astronomical Artists. He is an accomplished illustrator, concept designer, and Hollywood technical consultant.

Nick Stevens Nick Stevens studied Astronomy at University College, London, and is a former board member of the IAAA. He works 100% digitally, for stills and animation, and his main tool is Lightwave 3D. He specializes in unbuilt projects and spacecraft of the Soviet Union, and is coauthor of the book *N-1 For the Moon and Mars*.

Kara Szathmáry Kara Szathmáry holds a Bachelor's of Science degree in Physics and Mathematics from McMaster University and a Master's of Science in Astrophysics from the University of Western Ontario. In 2005, he made a presentation regarding the impact of space art on modern culture to the National Hungarian Science Academy in Budapest, Hungary. His paintings are impressions of scientific knowledge that spiritually impacts the human mind at the threshold of space travel.

Part I

The History of Space Art

Introduction to the Beauty of Space Art

Jon Ramer

Astronomical art reaches from right here on our home planet all the way to the farthest expanses of the universe. As humanity learned just how incredible the universe really is, our artistic depictions of cosmic objects expanded in equal measure.

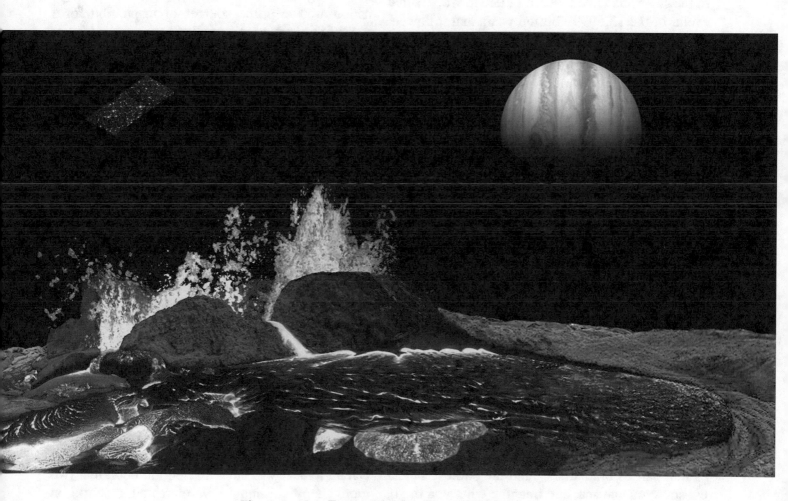

Fig. 1.1 *New Eruption* by Jon Ramer, FIAAA

J. Ramer (✉)
Mill Creek, WA, USA

© Springer Nature Switzerland AG 2021
J. Ramer, R. Miller (eds.), *The Beauty of Space Art*, https://doi.org/10.1007/978-3-030-49359-2_1

"– oh my God – it's full of stars!"

Astronaut Dave Bowman in *2001: A Space Odyssey* by
Arthur C. Clarke

The universe we live in is a breathtakingly complex and astonishingly beautiful place. More than just the one little world we occupy, our universe is a vast region some 93 billion light-years across that contains trillions of galaxies, each of which holds hundreds of billions of stars. It is indeed "full of stars." Some 13.7 billion years ago though, it was an infinitely small point that exploded into existence, then expanded into the vastness we see in the skies above. We weren't there to witness that event, or the 13.69999 billion years that followed. But we are here now, and we can't help but look up into the night sky and wonder.

As far as we can tell, humans are the only species on the planet that does this. We are also the only species that tries to create images of things we may not actually be looking directly at or perhaps cannot even see. We call this "art." From all archaeological indications, humans have been creating art for as long as we have been humans. We have found tools, jewelry, and even paintings that are tens of thousands of years old – and older. It seems that everything we have looked at we have made artistic representations of in some form or other. It was only a matter of time before we started painting the night sky and the fascinating objects we found there. In earlier times, such imagery was most likely and often religiously based. Today, science and imagination are the prime sources of inspiration for a genre of artistic creation called *astronomical art* or *space art*.

So, exactly what is "Space Art?" The term *astronomical art* is often used interchangeably with the term *space art*, which has grown to encompass not only visions of strictly astronomical subjects – planets, moons, stars and galaxies – but scenes on other worlds and the hardware, spacecraft, vehicles, and people sent into space. The roots of the genre lie deep in our history and psyche.

Human beings are naturally curious, inquisitive creatures. We want to know what is over the horizon, how we got where we are, where we came from, where we are going, and how we are going to get there. The human mind is constantly examining the world around us, collecting information, trying to figure out the puzzle of our universe. The irony is that answers to the greatest questions of our collective existence are all above our heads, just waiting for us to reach up and discover their secrets. Even the simplest act of curiosity has a tremendous history of discovery behind it.

Look up into the night sky with a telescope or even a pair of binoculars. Find the darkest, blackest spot you can see, and imagine what you might find if you were able to zoom in. Then imagine zooming in again. And again. And again. What would be there? Astronomers running the Hubble Space Telescope asked and did exactly that, and what they found were *galaxies*. Lots and lots of galaxies. The results were rather surprising, as was their unexpected beauty.

The astronomers actually were expecting to see some galaxies, but not *three thousand* of them in such a tiny area of the sky. A composite picture was assembled from 342 images exposed over 100 hours of observation time by the Hubble Space Telescope. This was famously called the Hubble Deep Field. It was such a scientific boon that two more deep field images were created, resulting in

the Hubble Ultra Deep Field image. These pictures literally show the state of the universe all the way back as far as light can be seen, revealing galaxies, quasars, and mega-stars that are nearly 13 billion light-years away. In fact, we can't see galaxies older than this in visible light. To see farther back in time, we need to observe in the infrared.

The Hubble Ultra Deep Field image was an amazing benefit to space artists as well. Never before had we seen such a dazzling array of colorful galaxies. Besides giving insights into the shapes and structures of the infant universe, it showed artists entirely new ranges of colors that could be added to their pallet when depicting deep-space objects.

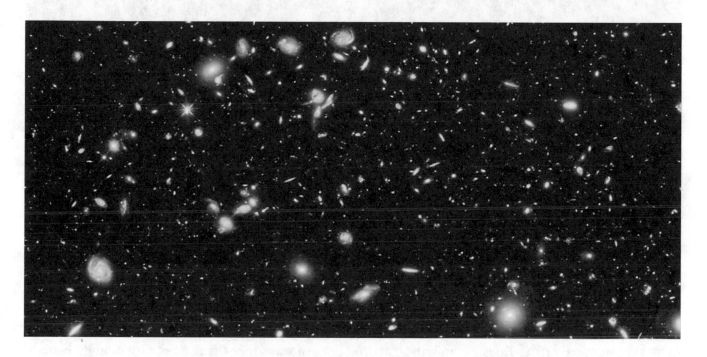

Fig. 1.2 The Hubble Ultra Deep Field image, STScI gallery, image 1427a

How do we know these facts? How do we know those tiny smudges of light are actually 13 billion light-years away? Because of something we call the *cosmic distance ladder*. It's a series of measurements developed over centuries of scientific study that extends our understanding of the size of the universe from Earth all the way out to the edge of seeable space.

We can determine the distance to nearby stars with simple *parallax*. Measure where a star is in January, measure where it is again in June when the Earth is on the opposite side of the Sun, then use some math invented over two thousand years ago to calculate how far away the star is. For more distant stars we use *main sequence fitting*. Stars age in the same way and change color in the same way as they age. How much light they emit is measured as the *magnitude*. Astronomers have developed an extraordinarily accurate formula that calculates the distance to a star just from its color and magnitude. The final step on the cosmic distance ladder is something called *redshift*, or the *Doppler Effect*. In the same way that the sound from a firetruck siren gets higher in pitch as it approaches you and lower in pitch as it moves away, light from an object will be red- or blue-shifted by its speed away or towards you. Astronomers can examine the spectra of stars and measure the amount of that shift. How far it has shifted will tell how far away the star is.

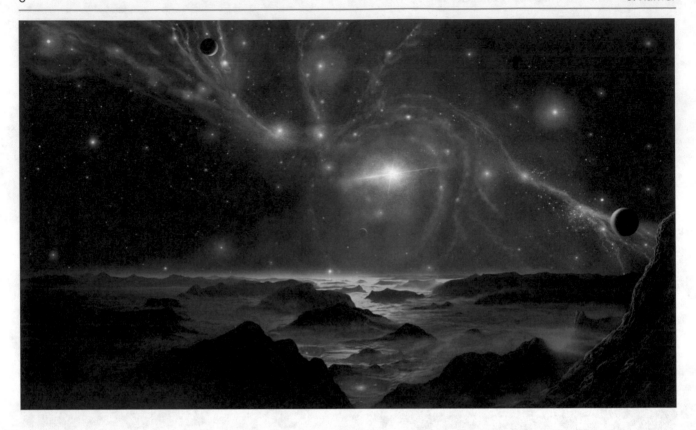

Fig. 1.3 *Cosmic Conception - Immaculate Star* by Michael Turner

Why is the cosmic distance ladder so important to an astronomical artist? Because an artist can do the one thing a camera cannot: they can traverse the eons, leap across the light-years, and, using data from telescopes and probes, show us what those galaxies, quasars, and mega-stars of the early universe might have looked like up close. An artist can apply human imagination to the realities of our cosmos to create images of things so far away they are impossible to see clearly, yet actually exist. As humanity ascended the cosmic distance ladder, our perceived universe became larger and larger, and we discovered strange and exotic new objects. Not only were artists able to convey the enlarged sense of scale of the universe to the viewer, but they were able to present new, incredible scenes. "Wandering stars" became planets with surface features and views unlike any on Earth, one Sun in the sky became possibly two or

more, a smudge of light became a galaxy of billions of stars, then the darkest spot of night became a blazing menagerie of colors and shapes across billions of light years.

When we look into the sky, we are peering into the past, seeing the light emitted by stars millions or billions of years ago. Physics and chemistry work the same across the cosmos and across time. Because of this, we can logic out the history of galaxies, stars, and planets anywhere in the universe and figure out what they might actually look like to a visitor. An artist is often tasked with conveying scientific information and this enlarged sense of scale to the viewer, realistically depicting what a planet orbiting another star might look like just from knowing the basic parameters such as distance from the star, star color and type, and planet size. Armed with such knowledge, artists can create images that tell an incredible story.

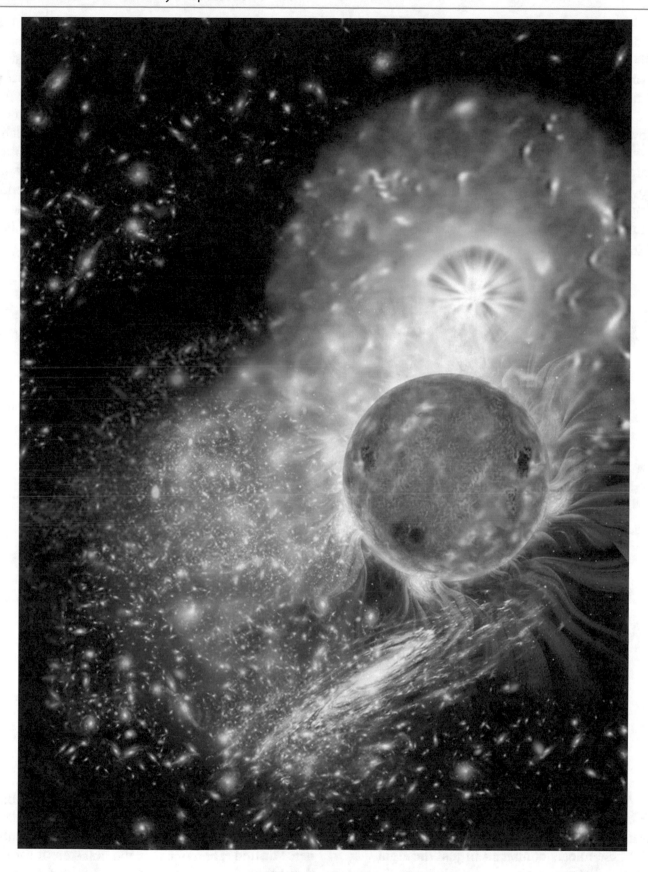

Fig. 1.4 *Ancient Suns* by Don Dixon, FIAAA

We know the universe began some 13.7 billion years ago in a titanic burst of energy we now call the Big Bang. Math and observation show us that less than 500 million years after that event, galaxies had formed, including one that became our own galaxy, the Milky Way. We can see through our telescopes how over the billions of years since, countless stars have formed, lived, and died, and we can surmise that somewhere, sometime, a star must have gone supernova near a cloud of interstellar dust. The shockwave from the explosion slammed into that cloud of dust, causing it to collapse. In about ten million years, the cloud swirled into a disk, coalesced, and burst into the fusion-driven light of a new star. Debris in the disk clumped together in mini-swirls around the star, and in just a few million more years, formed a batch of rocky and gaseous planets. One of those rocky planets was just the right distance from the star for liquid water to collect on the surface. A storm of comets and asteroids crashed into the planet, including one object so large it was almost a planet in its own right. The impact blasted a massive blanket of debris into orbit and nearly destroyed the small world. In less than 10,000 years, the orbiting debris coalesced into a large satellite that would affect everything about the planet for billions of years to come.

Fig. 1.5 *New Moon* by Gary Harwood, FIAAA

After 300 million years, the hail of fire and ice from the heavens slowed, leaving a vast ocean of water that harbored the perfect conditions. The right chemicals combined in just the right way to duplicate themselves, and something in the waters of that ocean became "alive."

Now a long quiet set in. For the next three billion years the only living things on the planet were single-celled organisms. Mountains rose, continents drifted. Then one day, the first step of evolution began. Two cells stuck together and became more than either were apart.

Fig. 1.6 *Early Life* by Richard Bizley, FIAAA

Life exploded into a dizzying array of species, becoming ever more complex, filling the oceans. Another 100 million years passed before life evolved the ability to live on dry land. The speed of evolution sped up. Different forms of life quickly filled the continents, adapting to take advantage of whatever resources could be found. With each passing generation, life adapted and grew, developing new and better abilities. Occasionally debris from the formation of the star system fell from the sky again, wiping out entire species, but opening up room for more adaptable species to evolve and take their place. Where life once took billions of years to develop a single new strategy, now new possibilities came into being in millions, even thousands of years.

Eventually, one species evolved that looked up at the night sky and wondered, "What is that?" An incredible, improbable, nearly impossible story, the odds against it happening are, well, astronomical. This story, however, is all the more amazing because the planet in it is *not* called "Earth."

Fig. 1.7 *Earthlike Planet* by Lynette Cook, FIAAA

Where is it? What does it look like? What do the beings living there call themselves? Those are questions the people of Earth can't answer – yet. But in some not-too-distant tomorrow, we will encounter our "star-cousins" and possibly learn to communicate with them. Then we'll share our story, our knowledge, and our art. In fact, sharing our art might be the most important thing we could do. To appreciate a written or spoken word, you first have to understand the language and perhaps even the culture. Art however, may have a better chance of transcending those limitations. We can look at ancient murals on a cave wall and surmise what the artist was thinking, or observe a 500-year-old painting by an artist who lived in a different place, spoke a different language, and had completely different cultural values, and get some sense of what the image is about. A thousand years from now, people will be able to look at a painting made by a one of the first humans to walk on the Moon and know he is talking to them across the millennia. Art is a window into the soul of humanity.

Fig. 1.8 *Listening* by Pat Rawlings, FIAAA

Until that momentous day when we meet our star-cousins, humanity will have to suffice with thinking and dreaming about what life on other worlds might be like. It's a sobering process. The questions are endless. What would an alien being look like? How do they communicate? What do they eat? What is their home like?

Fig. 1.9 *Life on a Tidally-Locked World* by Richard Bizley, FIAAA

We know the physical and chemical laws of the universe are the same everywhere. Astronomers have found complex carbon-based compounds throughout the universe, many of which are the building blocks of amino acids. The yellow, orange, and red colors of Saturn, Jupiter, Titan, and other Solar System locations are all the results of organic compounds. Chemistry has shown that at least the foundations of life as we know it are everywhere.

Time and time again, we have seen that if there is a possibility of something happening, given enough time and space, eventually it will happen. Intelligent life evolved here on Earth in just 4.5 billion years. The universe is three times older than our Solar System. Using conservative estimates from the lat-

est scientific studies, there could be as many as 38 *septillion* Earth-like planets in the universe. That's a 38 followed by 24 zeros. Written out, it looks like this: 38,000,000,000,000,000,000,000,000.

In a period three times longer than our planet has existed, on 38 septillion possible planets, in a universe filled with organic chemicals, it is practically impossible to believe that life has evolved only once, here on Earth. But the vastness of space cannot be understated. There could be an intelligent society at the same level of development as is Earth right now, but on the other side of the galaxy. It would take 50,000 years for signals from that civilization to reach us. That's more than ten times the number of years since the Egyptians built the Pyramids. Will we be here to pick those signals up? Would they still be there to receive our reply another 50,000 years in the future? We thus might not be able to communicate with other intelligences due simply to the physical properties of space. Whatever the case may be, it is overwhelmingly likely that there is intelligent life in the universe beyond that of Earth, and lots of it.

Fig. 1.10 *Mountaintop Twilight* by Dan Durda, FIAAA

We once believed that the Earth was flat, and that it was the center of the universe, with the Sun and planets revolving around it. The art of our history reflected that belief. Over time, flat maps and a flat world gave way to globes and artistic images of a curved world seen from above. Then the discoveries of Galileo, Copernicus, and others showed us that the universe was bigger than we thought. We learned the Earth was only one of several planets going around the Sun and how far away those planets were, but for a time we still thought the Sun was the center of everything. Artwork began appearing showing those other worlds as seen through a telescope. Later on, we made the great leap of understanding that those other planets are actual *places* that could be visited, and artists took us to the surfaces of the Moon, Mars, Saturn and more.

Then we stepped up the cosmic distance ladder again and learned the Sun was just one star out of millions of stars in a wide galaxy. Artists began creating scenes of other stars from the surface of other planets. Edwin Hubble made the next great step and showed us our galaxy was but one of trillions in the greater universe. Art made that great leap too, and space artists began depicting a universe billions of years old.

Even as we experienced the world-shaking revelations that accompanied each new step of the cosmic distance ladder, much of humanity still held dear the belief that we are special – that the universe is here for us and us alone. The day that we conclusively learn life exists outside of Earth will likely be watershed event in the history of the human race and the greatest culture shock we have ever experienced. Accepting and integrating that fact will be difficult for many. But as difficult as it might be, the transition can be made easier. This is where astronomical artists play a positive role in the group consciousness of our race.

Fig. 1.11 *Life on Mars – Cave Colonies* by Adrianna Allen

We've experienced somewhat similar culture shocks before. When explorers returned to Europe from forays to North America, they brought back tales of strange new peoples, animals, and plants. Importantly, they brought back drawings and paintings of those new wonders, created by artists who were part of those initial expeditions. Such images were immensely popular and fired the imaginations of Europeans. The same thing happened when envoys visited Japan and China. Artists from both cultures created incredibly popular works about the discovery of entirely new worlds, inhabited by strange beings and creatures. It is space artists who fill that role today.

Seeing something, either real or imagined, and translating it into an image that others can relate to is what an artist does best. By combining scientific principles with plausible settings and imagination, artists can create images of what humanity might encounter "out there." Remember, the physical laws of the universe are the same everywhere. Gravity pulls, chemicals react, light reflects. The interaction between rock, atmosphere, and light is the same no matter where in the galaxy the light, atmosphere, and rock are. It is through the imagination of an astronomical artist that we can climb the cosmic distance ladder, cross the light-years, and try to answer those as-yet-unanswerable questions.

Fig. 1.12 *Foreign Planet* by Michael Boheme, FIAAA

Space artists can show us the "rock and ball" places we are destined to go, the hardwares that we will use to get there, and capture the emotional impacts our herculean efforts will have. We use traditional paint, computer-assisted digital programs, three-dimensional sculpture, music, and forms of creativity yet to be imagined, in order to show distant galaxies, stars, exoplanets, and possible alien life. Space artists open the minds of humanity, showing us a wonder of possibilities, letting us step off of the Earth for a brief moment, marvel at the greater Universe, and prepare ourselves for a not-too-distant tomorrow – today.

Fig. 1.13 *Warm Lights of Night* by Simon Cattlin

Fig. 1.14 *Hairtree Falls* by Dan Durda, FIAAA

All it takes to make that first step, that first great leap of imagination, is to do what artists have been doing for thousands of years: pick up a paint brush.

Astronomical Art: From Ancient Times to the Industrial Revolution

Don Davis

Astronomical art has origins almost as old as art and human imagination. This chapter describes the ancient fascination with the night sky and how humans have documented that fascination over the eons.

Fig. 2.1 *Milky Way Galaxy* by Don Davis, FIAAA.

Space art has roots deep in the history of art itself. A dark, starry sky has been a universally awe-inspiring sight to all peoples across the world in every era. History is filled with both written and visual stories in great variety of what people thought the stars really were. The randomness of the stars scattered across the sky simply begs for patterns to be drawn across them in the human mind.

D. Davis (✉)
Palm Springs, CA, USA

© Springer Nature Switzerland AG 2021
J. Ramer, R. Miller (eds.), *The Beauty of Space Art*, https://doi.org/10.1007/978-3-030-49359-2_2

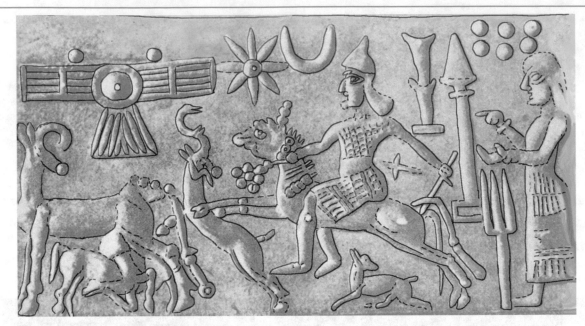

Fig. 2.2 Cylinder seal impression with Moon and stars. Neo Assyrian, about 800 BCE (Before Current Era). Courtesy Pergamon Museum, Berlin, Germany.

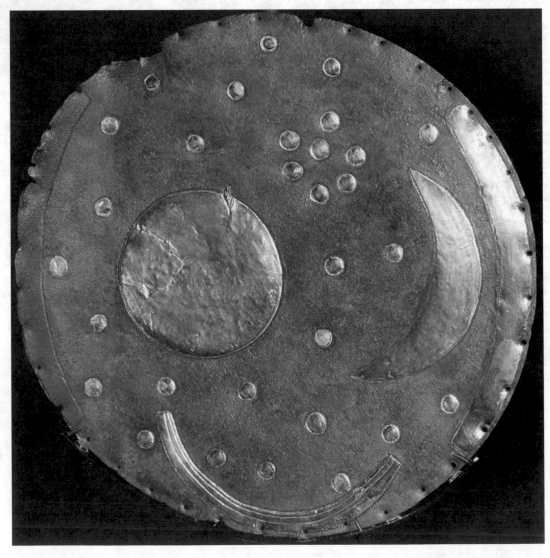

Fig. 2.3 Nebra Sky Disk, about 1600 BCE. Wikimedia commons photo by Anagoria.

Symbols representing clearly astronomical objects have appeared almost since the very first efforts of humanity to write. Star and crescent Moon imagery appear on cylinder seals, an early information transfer format invented in Mesopotamia about 3500 BCE. A unique bronze and gold amulet from 1600 BCE Germany, called the Nebra Disk, features sky symbols. Star charts were known in Egypt from 1534 BCE onwards, and the ceilings of Egyptian temples and tombs are painted and carved with neat rows of stars. Ancient Sumerians were the first to record the names of constellations on clay tablets. Astronomical symbols are prominent in royal Babylonian art, and historical records reference Babylonian star catalogues that were compiled from observations made between 1531 and 1155 BCE.

Perhaps the most detailed star catalog of the ancient classical world was created by Hipparchus, a Greek astronomer of some renown. Hipparchus observed a supernova, recorded accurate planetary observations, and invented the stellar magnitude scale we still use today. When he compared his data with older Babylonian data, he proved the axis of the Earth's poles turns toward different areas of the heavens over wide stretches of time and thereby discovered the 25,000-year long processional cycle of the equinoxes. His star catalog, compiled in 129 BCE, is the first confirmed star catalog in human history. The catalog and all copies of star globes that Hipparchus made from it have been lost to time, but the Farnese Atlas, a statue found in Naples, Italy, depicts the Greek figure of Atlas holding a globe on his shoulders. Sculpted around 150 CE, the globe has numerous classic Greek constellation figures on the surface. The configuration of these constellation has been extensively studied in recent times, and it was determined that the patterns very closely match where the stars would have been around 129 BCE. This in turn strongly suggests that the globe was made from a copy of Hipparchus's star globe.

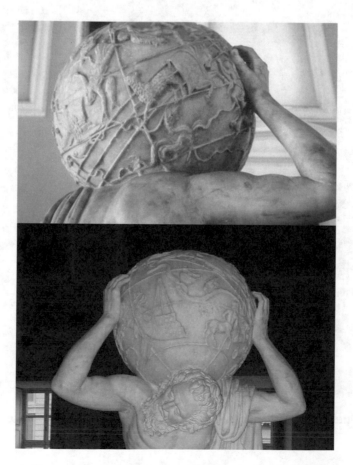

Fig. 2.4 Farnese Atlas statue, Museo Archeologico Nazionale, Naples, Italy. Image Wikipedia Commons and Dr. Gerry Picus, Griffith Observatory.

The oldest known surviving star chart in the world is the Dunhuang chart from ancient China. Discovered in a trove of documents in the early 1900s in a temple cave that had been sealed for nearly a thousand years, the paper scroll depicts accurate positions of more than 1,300 stars in the northern hemisphere. The data on the scroll was compiled from observations by at least three different official government astronomers made over hundreds of years, and the chart itself was drawn sometime between the years 650 and 680. How it got placed in a library cave near the desert town of Dunhuang, China is unknown.

An ancient tomb in the Nara Prefecture of Japan dated to around the late seventh century to early eighth century CE contains a detailed star map engraved into the tomb ceiling. The Kitora Tomb Star Chart depicts 68 constellations with stars represented by gold disks. Three concentric circles represent the movement of celestial objects and another circle shows the movement of the Sun. Modern analysis suggests that the positions of the stars in the tomb chart were from observations made between 50 and 100 BCE.

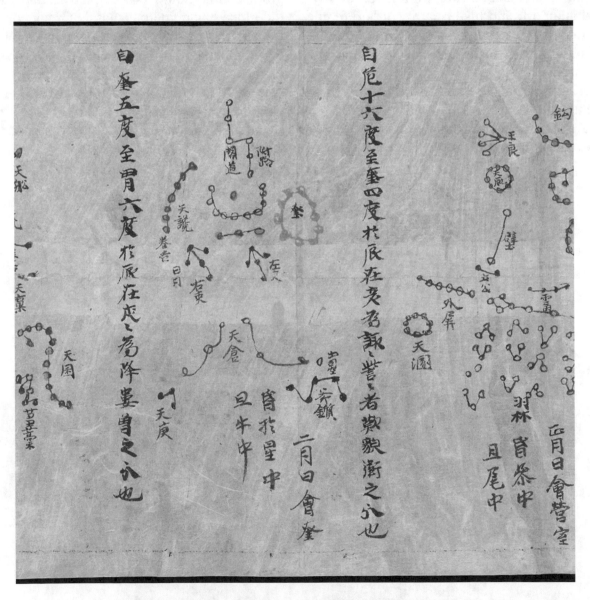

Fig. 2.5 Panel of the Dunhuang Star Chart. British Library image Or.8210/S.3326 from the International Dunhuang Project.

The intricate zodiac relief on the ceiling at the Egyptian Dendera Hathor temple is one of the most famous works depicting astronomical features from the ancient world, made about 50 BCE. It is a carving of a *planisphere* – a map of the stars projected on to a flat plane – that shows 48 constellations, the planets, the Sun, and the Moon, and includes a lunar and a solar eclipse. The constellations depict first-magnitude stars in the signs of the zodiac using the same Greco-Roman iconographs that are used today. In 1821, the entire ceiling was removed from the temple and taken to Paris, where it is now on display in the Louvre.

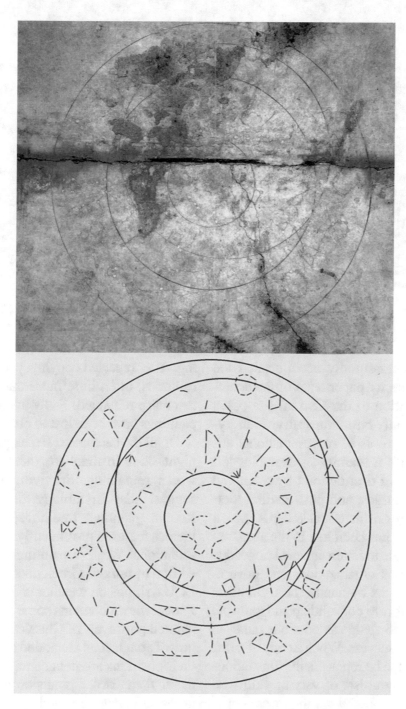

Fig. 2.6 Kitora Star Map, Japan. Image of map in the Kitora Tumulus from Wikipedia Commons; redrawn map by Don Davis.

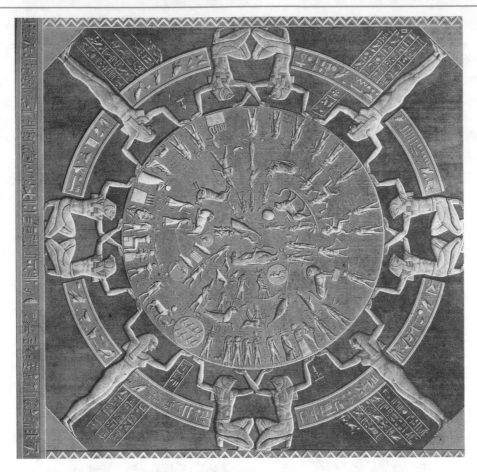

Fig. 2.7 Ceiling of the Dendera Hathor Temple in Egypt. Image Wikipedia Commons.

Illustrations almost assuredly accompanied the astronomy and geography paper texts of the centuries during the transition to the Current Era (CE), however, in general, only rare scraps survive. In trying to reconstruct the roots of representational art, one is confronted with a scarcity of examples left behind after episodes of destruction of written and visual works. Fires, purges, and post-conflict looting all took their toll on historical records. Much knowledge – and art – has been lost to the ages.

Great effort was made to retain ancient knowledge however. Both religious organizations and governments often copied books by hand. The Byzantines made a significant effort to consolidate and replicate as much classic era knowledge as possible, but even this had only a limited success. When a copy of a text became worn and had to be replaced, the illustrations were redrawn, often by artists of varying skill who may not have comprehended what they were copy-

ing. After repeated copying, perhaps after only a few centuries, often little more than a simplified visual summary remained. Sadly, many Western Classical paintings have been lost to oblivion.

Of all the celebrated Greek painters who used the night skies in their art, there is no trace of their works remaining. Surviving literature references suggest that mythology dominated the Greco-Roman painting traditions, much as Christian themes featured prominently in the revival of representational Western painting. An 816 CE recopied edition of famous Greek poet Aratus's third century BCE writings on weather and astronomy, titled *The Phaenomena*, contains some of the oldest surviving painted portrayals of Classical era constellation figures. Though stars are added to the mythical figures, their positions are not accurate, and one must wonder if their earlier precision degenerated into randomness during repeated cycles of copying.

Fig. 2.8 *Orion* from the *Leiden Aratea* manuscript. 816 CE.

The passage of the years in ancient times often led to loss of knowledge, followed by the rediscovery of that knowledge decades or centuries later. Whether it was Mesopotamia, Greece, Persia, China, or Japan, a similar cycle of bloom and decay can be seen throughout history. Fortunately, some repositories of knowledge were made on more durable media, such as metal star globes and stone carvings, which have survived the ravages of time, along with a few lucky, more fragile finds, like silk maps from Chinese tombs. Perhaps only one out of hundreds of books in circulation made it through time to the present day, with fragments of many more referenced in other surviving scraps. Arab scholars became catalysts in the preservation of knowledge as their initial Islamic conquests exposed them to ancient scientific literature. Coming from a tradition that promoted literacy, they valued and elaborated upon works seen as useful.

As the second millennium was reached, pictorial representations of the skies in Western art became dominated by symbolism, with little effort being made to accurately represent what was seen in the sky. Nevertheless, real, remarkable events in the heavens, such as a comet or supernova, often found their way into symbolic artistic depictions.

Across the Atlantic Ocean, Native American and Mesoamerican civilizations were also recording stellar events. A rock drawing near the Chaco Canyon complex in present day New Mexico, USA, may depict a celestial spectacle observed throughout the world: the 1054 supernova that formed the Crab Nebula. The drawing also shows a conjunction of the Moon and Venus, which was a fairly common event. Since a conjunction occurred when the supernova was visible, and this site was known to have been inhabited at the time of the supernova, archaeologists have a high confidence that the pictogram is of the 1054 supernova.

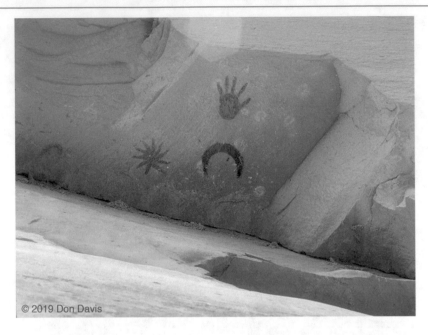

Fig. 2.9 Chaco Canyon Cliff art possibly depicting the 1054 Supernova rising with the crescent Moon at dawn, 4 July 1054. Image Don Davis.

There also exists Mesoamerican literature and art describing astronomical events. The Aztec and Mayan civilizations were keenly aware of the night sky and developed elaborate, impressively accurate calendar systems to keep track of practically everything, including when to plant crops, when to go to war, and when to conduct religious ceremonies. There are only four surviving "codex" documents from the Mayan civilization, all of them containing significant representational art and tables of data about celestial events such as planetary conjunctions and solar eclipses, dating all the way back to the eighth century CE. These extant codices were all created between 1150 and 1450, indicating that they are likely copies of older documents.

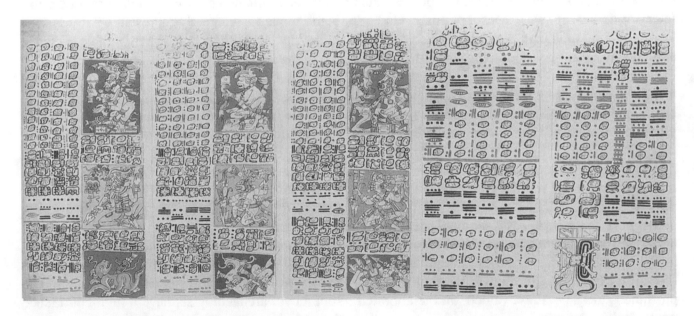

Fig. 2.10 Several pages of the Dresden Codex. Reproduction made by Alexander von Humboldt for his 1811 book *Vues des Cordillères et Monuments des Peuples Indigènes de l'Amérique.*

While much of Europe was relatively stagnant in scientific studies for centuries after the fall of the Holy Roman Empire in 476 CE, other parts of the world experienced golden ages of great discoveries and artistic achievements. The Islamic cultures in Persia and the Middle East at first began translating and copying the works of Greek, Babylonian, Chinese, and Indian astronomers, but quickly surpassed them and began making numerous astronomical discoveries of their own. Indeed, many star names we use today are of Arabic origin. These discoveries were quickly incorporated into the well-developed artistries of the time. During the Islamic Golden Age from the ninth to the thirteenth centuries, thousands of manuscripts with intricate and ornate hand-painted imagery of stars and constellations were created, and even more objects such as ink wells, ewers, trays, and globes were made by metalsmiths that incorporated astrological figures and star charts in extraordinary detail and beauty.

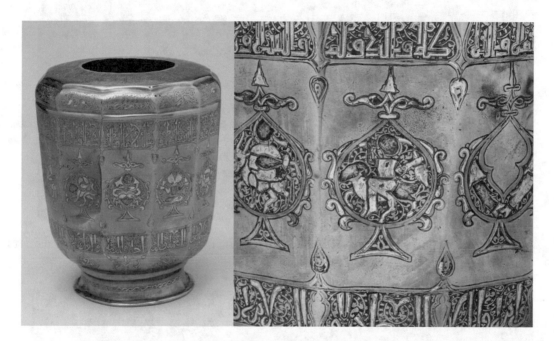

Fig. 2.11 Engraved brass ewer with Zodiac medallions, inlaid with silver and copper, circa 1325, from the Edward C. Moore Collection, Bequest of Edward C. Moore, 1891 to The Met museum, image courtesy The Metropolitan Museum of Art.

Islamic astronomers made such great contributions to the study of stars that their practices and learning strongly influenced their neighboring Byzantine and Indian astronomers. Indian cultures had been studying the night sky since at least 1400 BCE and had produced significant art with astronomical themes, but still made great strides in understanding from their Islamic counterparts. Back in Europe, representational art began climbing back to ancient standards due in part to the influence of Byzantine scholars and their efforts to preserve ancient works. By the 1300s, great works were appearing in new centers of art and learning. In stages, painting freed itself from Medieval constraints. The portrayal of light and shade in paintings began to change, with depth and form being enhanced through faces and hands, then expanding to full figures, animals and drapery, and finally the surrounding landscape and the skies above.

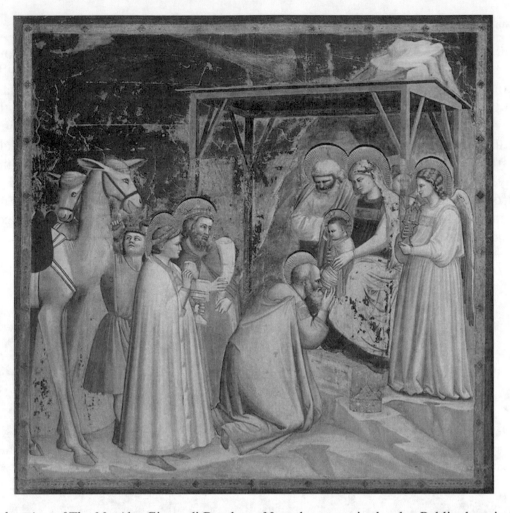

Fig. 2.12 *Adoration of The Magi* by Giotto di Bondone. Note the comet in the sky. Public domain image of the frescoes in the Scrovegni Chapel in Veneto, Italy.

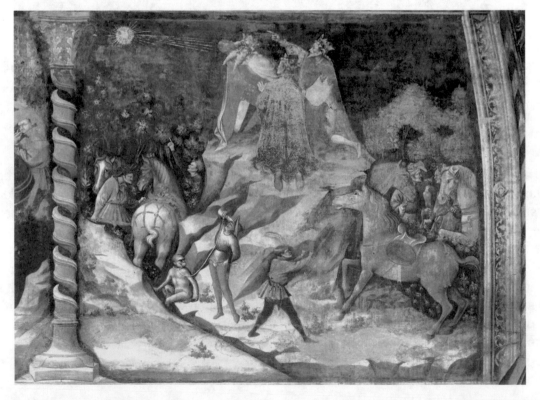

Fig. 2.13 The Appearance of the Star 1412 by Giovanni di Pietro Falloppi showing people reacting to the Great Comet of 1402. Public Domain image from the San Petronio Basilica collection, Bologna, Italy.

An early milestone in artistic treatment of the skies is a work by Giotto di Bondone, titled *Adoration of The Magi*. Included in the sky is a comet, probably based on observations of Halley's Comet in 1301. Another early portrayal of a comet in painting is a 1412 work by Giovanni da Modena, probably showing the Great Comet of 1402. The use of engraved woodblocks as an image reproduction medium began about 1400, steadily growing in sophistication over time. Numerous comets are represented as they appeared over the next few centuries in woodcuts and later in paintings.

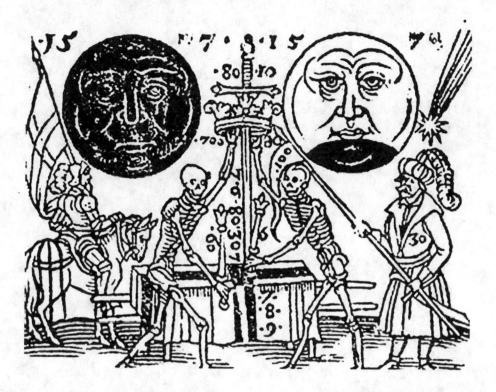

Fig. 2.14 Woodcut with eclipses and Halley's Comet, 1507.

A spectacular treatment of the starry sky appears in the miniature paintings by the Limbourg brothers Herman, Paul, and Jean in the early 1400s for John, the Duke of Berry in specially commissioned prayer books. Stars and meteors whizzing by are painted in gold atop a deep blue night sky, with zodiac signs in curved panels above different scenes for each month of the calendar. Painted and inked on calfskin vellum, these two "Book of Hours" are some of the finest examples of illuminated books of the Gothic period.

The invention of the printing press in both China and Europe quickly attracted the efforts of authors to preserve what ancient literature had survived up to the early 1500s. By coincidence, the start of the print run for the famed Gutenberg Bible began in 1453, the fateful year Constantinople was finally overwhelmed by the armies of Islam. The artistic influence of that remnant of Classical civilization passed away with a final spread of texts carried by fleeing refugees.

With the rise of the printing press from 1453 onward, the recopying of a book became far less time-consuming and error-prone, and many literary works of the far past received a new lease on life. Importantly, the printing press allowed for greater uniformity in illustrations and texts across many copies of new and old works.

Fig. 2.15 Page for the month of February from the Limbourg Brothers book *Les Très Riches Heures du Duc de Berry*, 1413.

Fig. 2.16 *Astro Book of Hours: Apollo* by Marilynn Flynn, FIAAA. A modern astronomical interpretation of the "Book of Hours" image style.

Fig. 2.17 The first detailed perspective drawing of Earth. Albrecht Durer, 1515. Color added by Don Davis.

The 1500s ushered in notable works that incorporated humankind's expanding grasp of the world. A 1515 perspective view of Earth by Albrecht Durer represents a breakthrough in the visualization of geographical data. In a show of artistic prudence, he carefully oriented the view of the globe to feature the accepted knowledge of his day. The Mediterranean and Western Europe are well mapped, but sketchiness and guesses creep in along the edges.

It is said that the landscape as a primary subject was first developed as a theme by the German painter Albrecht Altdorfer. His observations of the scenery, and especially of the sky, climax in a monumental 1529 painting *The Battle of Issus*. A pivotal battle in ancient word history (dated to 333 BCE) is seen through a 16th-century filter, with late Medieval-style armies surging at one another. Beyond these anachronistic armies lies a spectacular backdrop. As it widens in the distance, villages, mountains, and seashore gradually fade into a bowed horizon. Altdorfer's painting is the first known image to portray the curvature of the Earth as seen from on high. Above this, a vast weather system looms in the sky with the Sun setting on the right, overlooked by the crescent Moon at the upper left. It is a landmark in visualizing the grandeur of cosmic proportions between humanity and its larger natural surroundings.

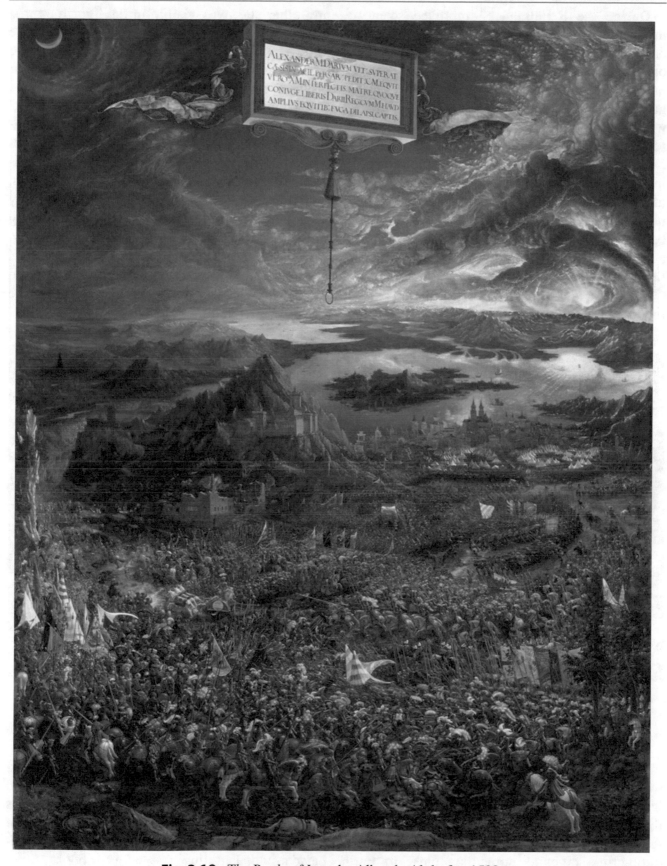

Fig. 2.18 *The Battle of Issus* by Albrecht Altdorfer, 1529.

During the Renaissance, improved scientific instruments led to ever more precise astronomical observations. A great comet in 1556 was widely observed in Europe, and printed sheets depicting the movement of the comet across the star background became extremely popular. Following were two supernovae events that fostered new ideas and challenged old ones. The first, in early November 1572, was a brilliant star appearing in the constellation Cassiopeia, which shone with a magnitude about the same as the planet Venus at its brightest, then remained visible for months before fading. It was named "Tycho's Supernova" because of that astronomer's devoted documentation of the event.

The next such event occurred in 1604. First recorded on October 9, it appeared brighter than any other star, was visible in daylight for three weeks, and was observable for a year. It became known as "Kepler's Supernova," for the same reason as Tycho's. This event in particular brought renewed thoughtful attention to the skies, and a disquieting realization that the surrounding heavens were not necessarily unchanging. At the time, extant works by ancient authors like Aristotle were still regarded with near-religious reverence. To Aristotle, the planets, Sun, and stars were made up of a divine unearthly substance whose heavenly presence circling Earth was represented as manifestly unchanging, cyclic perfection. It was believed that vapors high in the sky were responsible for comets and the Milky Way. These impossible-to-ignore events challenged that ideal.

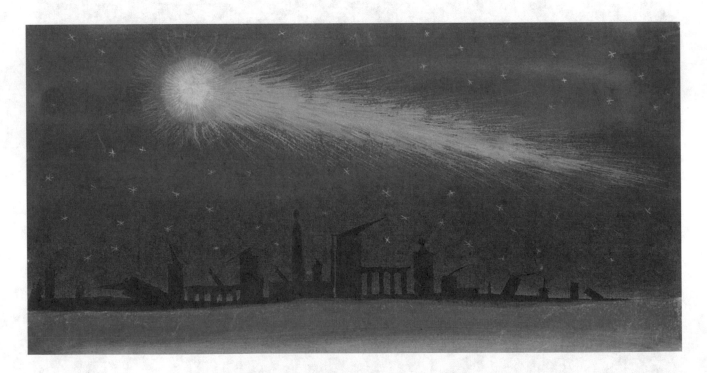

Fig. 2.19 Painting of a comet from a German manuscript *Book of Miracles*. About 1550.

Among those who directed their attention skywards was a man whose skills included mathematics and astronomy, Galileo Galilei. He observed the "new star" of 1604 and saw it remained fixed relative to the starry surroundings, not drifting during one night as something close to Earth would. This meant it was very distant, which had troubling implications for the Aristotelian scenarios of unchanging cosmic surroundings. Galileo had artistic training and was a good observer. His only surviving sketches are the ink portrayals of his observations of the Moon, which were replicated as woodcut illustrations for his book.

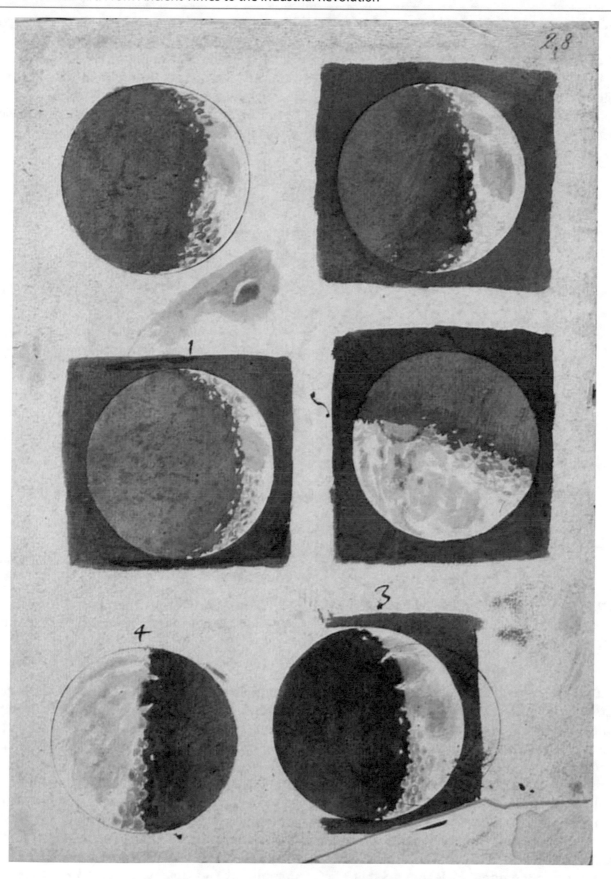

Fig. 2.20 Ink drawings of the Moon by Galileo Galilei, early 1610.

Galileo's early 1610 telescopic observations of the Moon, planets, and stars had the benefit of his knowledge of light and shadow, resulting in his recognizing the phases of Venus in relation to the Sun. Galileo intuitively understood the nature of the dim light illuminating the entire disk of the Moon when it was sunlit with a thin crescent. He understood that from the Moon, Earth would appear in its sky at the opposite phase, larger than our Moon appears to us and brightly illuminating the nighttime scenery. In his writings, he compared this *bounce light* from the day-lit Earth to the nighttime Moon to the sunlit areas of a scene "bouncing" light and color into nearby shadows, something of which painters were acutely aware.

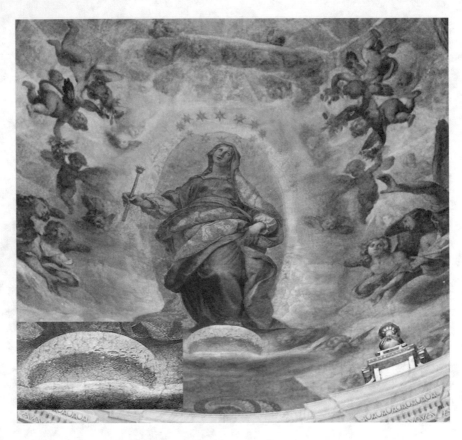

Fig. 2.21 Portion of *Immacolata* by Lodovico Cigoli. 1610-12. Inset is a closeup of the crescent Moon beneath the Virgin Mary. This artwork marks the debut of technology-aided illustrations of objects in the sky, an initial incorporation of "space art" into a conventional painting.

Galileo was friends with the renowned painter Lodovico Cigoli, whose keen interest in Galileo's research was expressed in his art. In several versions of Cigoli's *Adoration of the Shepherds* painted in 1599 and 1601, crescent Moons appear in the skies. A 1607 work by Cigoli, *Deposition*, showing Christ being taken down from the cross, has the Sun and the ghostly Moon appearing as if almost hidden in dark, smoky clouds. In the 1610–12 *Immacolata*, painted inside the dome of Rome's Santa Maria Maggiore church, the Virgin Mary stands atop a crescent Moon, but one unlike any crescent Moon ever painted before. Surface textures including craters appear along the lunar crescent's lower edge, or terminator. Apart from the drawings of Galileo, this may be the first conventional painting based on visual observations through a telescope. At first, the texture was explained as the natural rough surface of the Moon, but it was eventually revealed to be mountains and shadow-filled depressions.

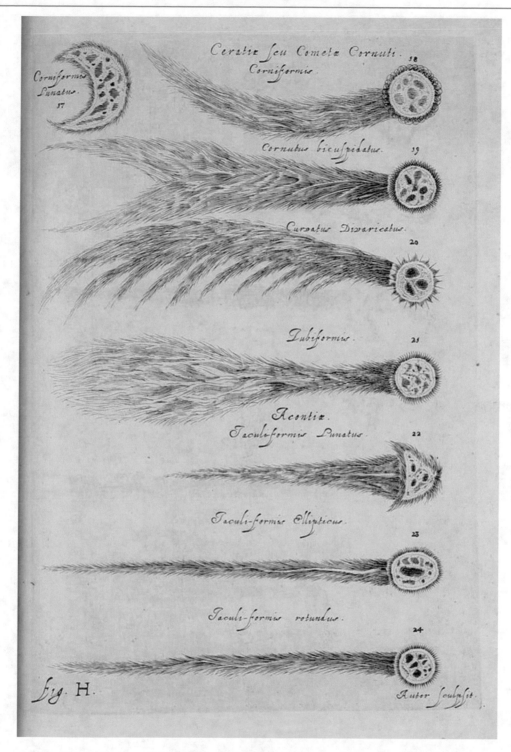

Fig. 2.22 Comet drawing from *Cometographia* by Johannes Hevelius.

From the moment the telescope was invented, objects seen through it appeared in art. As curiosity and technology amplified our understanding of the skies, artists found fresh visual ground to explore, and incorporated the latest scientific concepts into their works. For example, observations of comets were graphically represented in the 1668 book *Cometographia* by Johannes Hevelius.

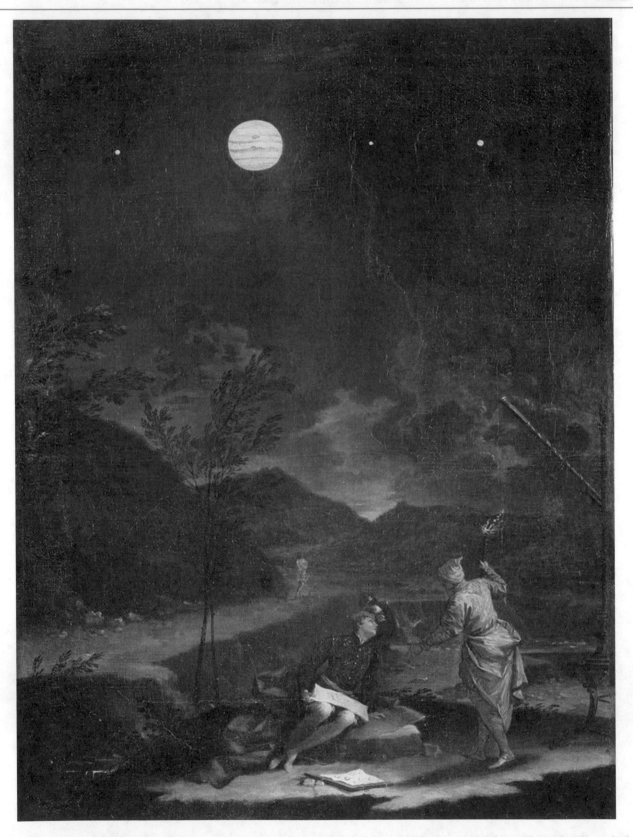

Fig. 2.23 Jupiter by Donato Creti, c. 1711, showing Jupiter and its satellites as seen through a telescope, being regarded by astronomers.

Innovations in mass communication of astronomical information continued as printing media became a more exacting process. Such technology, coupled by the knowledge-driven attitude of the Renaissance, set the stage for further dramatic leaps in human knowledge and astronomical art.

Pioneers of the Final Frontier: Space Art from Victorian Times to World War II

Ron Miller

Like astronomy, mathematics, and just about every other scientific field, space art also made dramatic leaps in understanding, detail, and availability when the Industrial Revolution reached full swing.

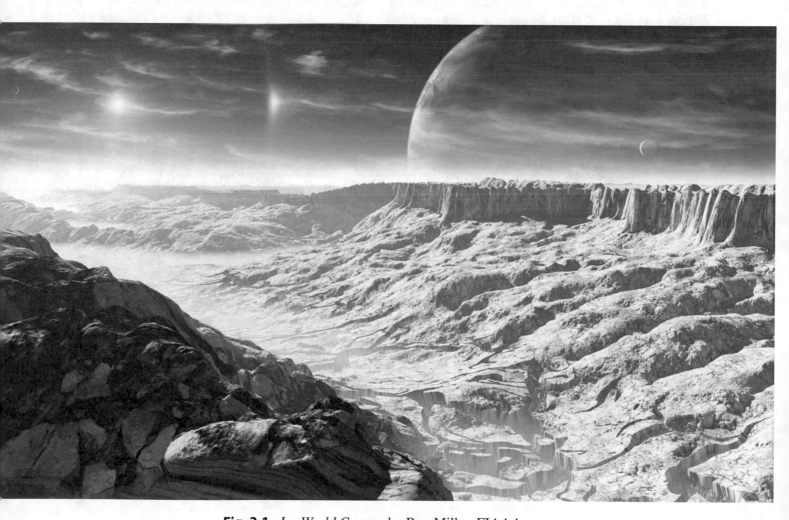

Fig. 3.1 *Ice World Canyon* by Ron Miller, FIAAA.

R. Miller (✉)
South Boston, VA, USA

© Springer Nature Switzerland AG 2021
J. Ramer, R. Miller (eds.), *The Beauty of Space Art*, https://doi.org/10.1007/978-3-030-49359-2_3

The first example of true astronomical art – the first time that an effort had been made to depict a scene from the surface of another world with scientific accuracy (or at least according to the best science available at the time) – can be precisely dated to 1865 in a novel by Jules Verne. Until then, the development of space art had moved fairly slowly. There were depictions of space flight, such as the art that accompanied Francis Godwin's *The Man in the Moone* (1638) and Cyrano de Bergerac's *The Other World: Comical History of the States and Empires of the Moon* (1657), but these were clearly fantasy, with no real attempt by either the authors or artists to base their descriptions even on the limited *scientific* knowledge of the time. There were also observation-based depictions of the Moon and Sun as seen through a telescope, but those images were faithful reporting of what could be seen, not what could only be imagined.

Many of these astronomical images were presented in books and thus seen by an ever-widening number of people. However, limitations in the printing methods of the time meant an unfortunate loss of detail in reproduced artwork. Some artists replicated their works as woodcut line drawings; but this early technique could not show the detail inherent in a painting. Fortunately, for the first printed books about astronomy, there was little that needed to be included that was anything more elaborate than diagrams and star charts. The art of the woodcut engravings advanced along with printing technology, and many wonderful works of art were successfully reproduced using wood or steel engraved printing blocks until halftone printing became available in the late-1800s. By the middle of the nineteenth century, both astronomy and printing technology had advanced to the point where books such as *The Orbs of Heaven* (1851) by Ormsby Macknight Mitchel and *Mechanism of the Heavens* (1859) by Denison Olmsted could be published, both beautifully illustrated by woodcut artwork.

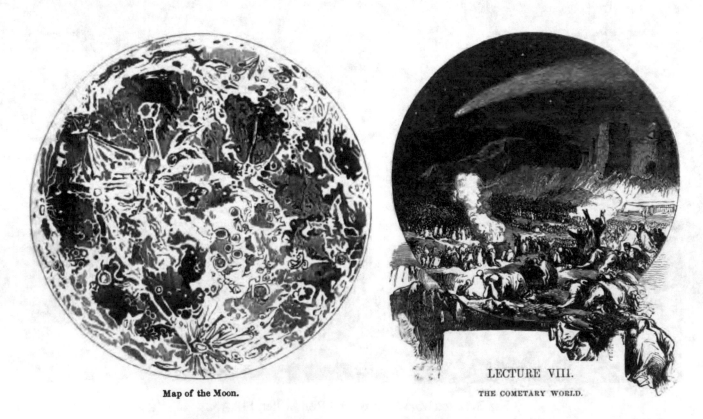

Map of the Moon.

LECTURE VIII.
THE COMETARY WORLD.

Fig. 3.2 Woodcut illustrations from pages 92 and 174 of *The Orbs of Heaven*.

The invention of photography in 1826 and subsequent usage in astronomy marked a change in how the cosmos could be viewed. The Moon was one of the earliest targets to be photographed, as it was large and bright enough to expose early emulsions. The more distant planets such as Mars, Jupiter and Saturn had to wait until nearly the turn of the century for emulsions to become sensitive enough to capture them. The new medium meant that publishers were no longer confined to just using artwork, consequently, photographic plates of bright objects such as the Moon and Sun began to appear in astronomy books. *The Story of the Heavens* (1885) by Sir Robert S. Ball, was an example where artwork was replaced by photography in subsequent editions. Book printing processes advanced to accommodate photography by replacing woodcuts with the halftone process and even on occasion actual photographic prints that were painstakingly added to the pages by hand.

Fig. 3.3 Art and photos from *The Story of the Heavens*, drawing by P. Langley December 23, 1873, photo by M. Jannsen 18 August, 1868.

When Jules Verne published his science fiction novel, *Hector Servadac* in 1877 (published as *Off On a Comet* in English) the illustrated novel was a familiar object. Verne was also riding on an unprecedented wave of popular interest in science and natural history. Books about the sciences were becoming best-sellers and fiction about science, such as the works of Verne, was no less popular. The story of *Off on a Comet* involves the somewhat unlikely premise of a sizeable chunk of the Earth being torn away from the planet by a collision with a comet. Flung into an elongated, elliptical orbit, the fragment – christened "Gallia" by its inhabitants – at one point crosses the orbit of Saturn. Here Verne describes some of the wonders of that planet for his readers:

Another most important contribution to the magnificence of the nights upon Saturn is the triple ring with

which, as a brilliant setting, the planet is encompassed. To an observer at the equator, this ring, which has been estimated by Sir William Herschel as scarcely 100 miles in thickness, must have the appearance of a narrow band of light passing through the zenith 12,000 miles above his head. As the observer, however, increases his latitude either north or south, the band will gradually widen out into three detached and concentric rings, of which the innermost, dark though transparent, is 9,625 miles in breadth; the intermediate one, which is brighter than the planet itself, being 17,605 miles broad; and the outer, of a dusky hue, being 8,660 miles broad.... To any observer stationed on the planet, between the extremes of lat. 45 degrees on either side of the equator, these wonderful rings would present various strange phenomena. Sometimes they would appear as an illuminated arch, with the shadow of Saturn passing over it like the hour hand over a dial; at other times they would be like a semi-aureole of light. Very often, too, for periods of several years, daily eclipses of the sun must occur through the interposition of this triple ring. Truly, with the constant rising and setting of the satellites, some with bright discs at their full, others like silver crescents, in quadrature, as well as by the encircling rings, the aspect of the heavens from the surface of Saturn must be as impressive as it is gorgeous.

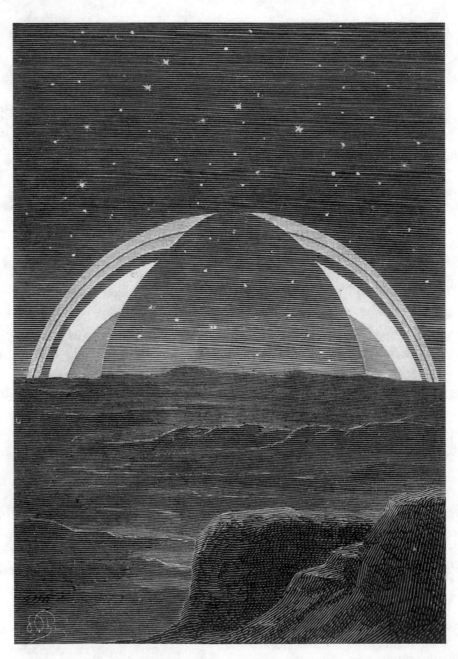

Fig. 3.4 *Rings of Saturn* by Paul Philippoteaux from Jules Verne's "Off On a Comet." 1877.

Accompanying this text was an illustration by artist Paul Philippoteaux depicting just what an inhabitant of Saturn might see from the surface of the planet: the vast arch of the rings looming over a craggy landscape with the midnight shadow of Saturn cast across it. To our best of knowledge, this is the first time anyone had ever attempted to illustrate this kind of scene.

As the genre of space art includes the depiction of spacecraft, Jules Verne can claim another first here as well. His 1870 novel, *Autour de la Lune* (*Round the Moon*), was a sequel to *De la terre à la lune* (1865; published in English as *From the Earth to the Moon*). The earlier novel had had ended with the launch of the projectile and its trio of astronauts. *Round the Moon* picks the story up at that point and describes the long, dangerous flight through space, a loop around the Moon and the eventual return to the Earth, where the projectile splashes down in the Pacific Ocean. (The novel itself is a kind of tour de force, since it takes place almost entirely within an enclosed volume of less than 10 cubic meters [350 cubic feet].)

During the course of the spacecraft's journey toward the Moon, Verne's heroes encounter a meteor that diverts the projectile from its planned trajectory. Realizing that the new course will cause them to miss the Moon instead of landing on it, the astronauts hit upon the idea of using rockets to change their course. These were originally meant to act as retrorockets to brake their descent onto the lunar surface, and even though their use meant the possibility of a fatal crash upon the Moon, the astronauts decide to go ahead and use them. The rockets are loaded into tubes built into the base of the projectile and fired. This scene, illustrated by Émile Antoine Bayard, is the first time anyone had ever depicted a rocket-propelled spacecraft in flight.

Between the publication of Verne's novels and the end of the nineteenth century, the most significant contribution to space art was Camille Flammarion's *Les Terres du Ciel* (Lands in the Sky). Published in 1884, it was the equivalent of Chesley Bonestell's and Willy Ley's classic *The Conquest of Space* (1949) with its scores of illustrations and diagrams provided by more than half a dozen different artists. Among these artists was Paul Fouché, who provided illustrations depicting such scenes as the sun rising above the canals of

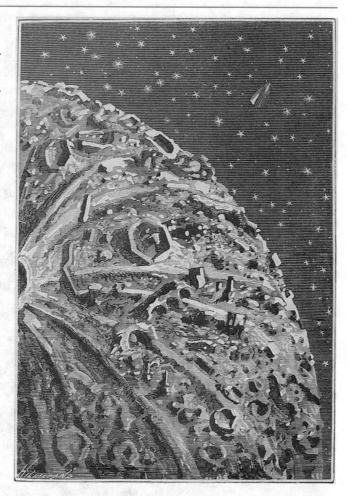

Fig. 3.5 *The Projectile above the Moon* by Emile Antoine Bayard from *Round the Moon.*

Mars, a snowy mountain looming over a Martian sea (this at a time when some astronomers believed that the dark areas on Mars were oceans and lakes), and an enormous Mars rising above the rocky landscape of Phobos, its nearest moon. Fouché also showed readers a swollen Sun rising above craggy, barren mountains into a cloudy Venusian sky, the Earth amidst the zodiacal light as seen from the surface of Mercury, and landscapes on Earth's own Moon, including a view of the Earth eclipsing the Sun above a cratered, mountainous lunar surface.

It is worth mentioning a book published in 1874. While *The Moon* by James Nasmyth and James Carpenter is not illustrated by space art strictly in the sense we have been using here, it is nevertheless an important milestone in the history of the genre. They did this by inventing a remarkable new technique of illustrating astronomical scenes – one which was to have far-reaching effects. The authors wrote in the book's preface:

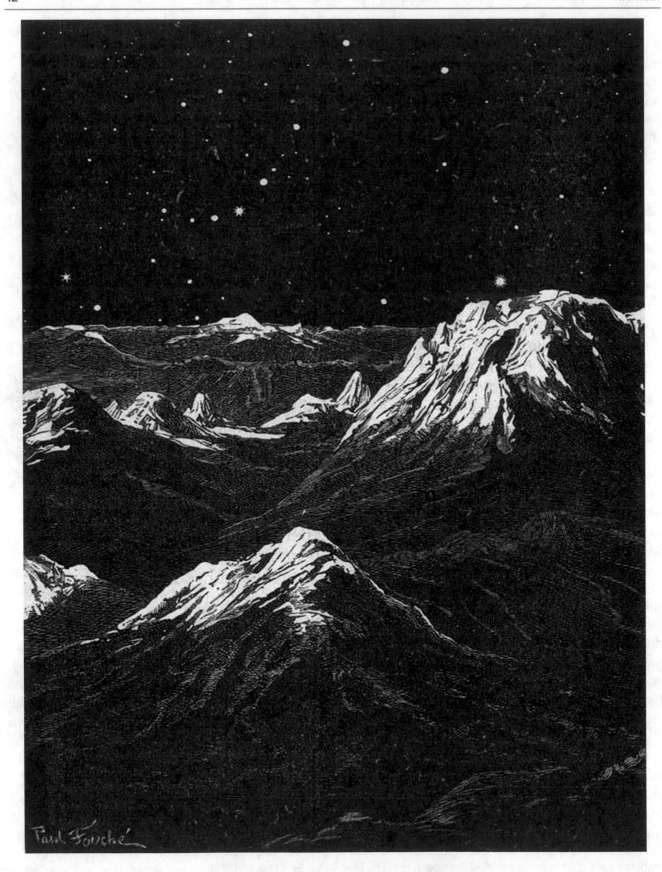

Fig. 3.6 *Lunar Mountains* by Paul Fouché.

During upwards of thirty years of assiduous observation, every favourable opportunity has been seized to educate the eye not only in respect to comprehending the general character of the Moon's surface, but also to examining minutely its marvelous details under every variety of phase, in the hope of rightly understanding their true nature as well as the causes which had produced them. This object was aided by making careful drawings of each portion or object when it was most favourably presented in the telescope. These drawings were again and again repeated, revised, and compared with the actual objects, the eye thus advancing in correctness and power of appreciating minute details, while the hand was acquiring, by assiduous practice, the art of rendering correct representations of the objects in view. In order to present these Illustrations with as near an approach as possible to the absolute integrity of the original objects, the idea occurred to us that by translating the drawings into models which, when placed in the sun's rays, would faithfully reproduce the lunar effects of light and shadow, and then photographing the models so treated, we should produce most faithful representations of the original. The result was in every way highly satisfactory, and has yielded pictures of the details of the lunar surface such as we feel every confidence in submitting to those of our readers who have made a special study of the subject. It is hoped that those also who have not had opportunity to become intimately acquainted with the details of the lunar surface, will be enabled to become so by aid of these Illustrations.

The resulting plaster models included comparisons of lunar and terrestrial volcanoes, views of the lunar Apennines, and many craters such as Copernicus and Plato. But where the book's influence was strongest was when the authors took their readers onto the surface of the Moon itself. Scenes such as those shown in Figure 3.5 gave the public its first real impression of what it might be like to visit the Moon. Some of these last-mentioned photos were reproduced and copied widely, appearing in books and magazines well into the twentieth century.

Although perhaps not space art in the sense we have been speaking, but space art nevertheless, was the following unique audio-visual experience that appeared at the end of the nineteenth century. In 1889, the Urania Astronomical Society of Berlin began taking audiences on a trip to the Moon via an elaborate system of special effects devised by W. Kranz and J. Carl Mayrhofer. Since this was several years before the Lumiere brothers screened the first motion pictures, the effects were all accomplished live, on stage. Entitled *Urania* (after the Greek goddess of astronomy), audiences first witnessed a solar eclipse as seen over Havel Lakes, near Berlin. The sun rose, its disk slowly being covered by the Moon, then the moment of totality and the appearance of the corona and, finally, the return to a normal summer sky.

These effects were achieved by painting the foreground scenery on a transparent screen. The areas to remain opaque were painted black on the reverse side, leaving sky and water translucent. Two projectors – one for the crescent Sun and one for the corona – were used to create the illusion of the eclipse. A third projector reproduced the effect of moving waves in the lake. Specially controlled stage lights reproduced the changing colors in the landscape as the Earth passed through the lunar shadow.

The audience was then taken to a point just 5,000 miles above the surface of the Moon. This was in reality a three-foot plaster model set against a black backdrop. The phases of the Moon were then created by slides in special projectors.

Next, audiences were transported to just above the surface of the Moon itself, where they saw the lunar landscape as it might appear from a height of just two and a half miles (four kilometers), lit by earthlight before the Sun rose above the horizon. Now they saw another eclipse – this time with the Earth passing in front of the Sun – in one of the most technically complex effects in the entire show. The audience was then taken on a tour of the Moon, visiting such sights as Aristarchus, Herodotus, and Cape Laplace. The detailed models were lit by four powerful arc lights that contrasted the "earthly landscapes, softened and harmonized by the presence of air and life, with those of the Moon, which, under a sky of eternal blackness, glitter in a jeweled panoply of death, for the Moon is a dead world" (*Scientific American*, April 9, 1892). The show ended with a return to the Earth and a sunset over the Indian Ocean as a finale.

Urania proved to be so popular that it was imported en mass to Carnegie Hall in New York City in 1892, with a new script written by Garrett P. Serviss, a popular science writer who was the Carl Sagan of his day. An impressed *Scientific American* reported that "These splendid scenes are a triumph of science and scenic art."

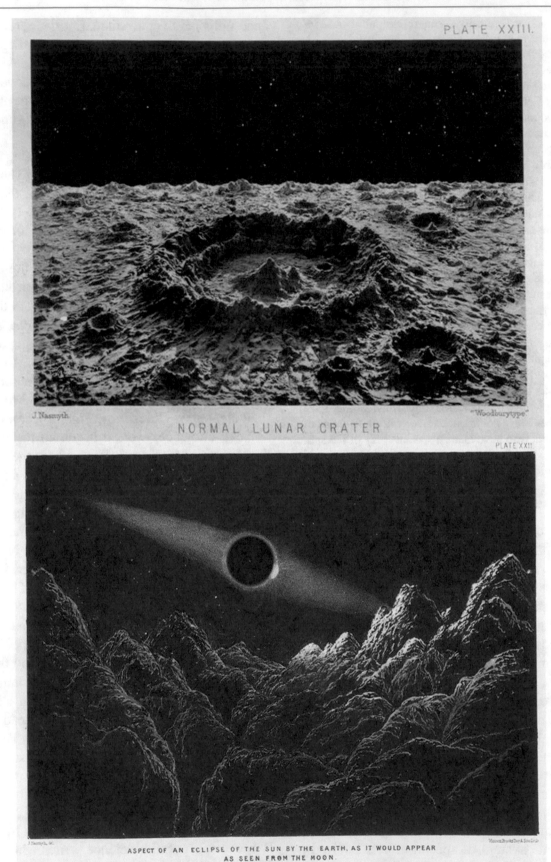

Fig. 3.7 Two illustration by James Nasmyth, *Normal Lunar Crater* and *An Eclipse of the Sun by the Earth*.

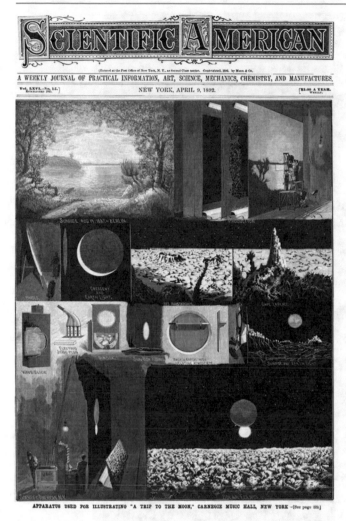

Fig. 3.8 Cover of *Scientific American* magazine from 9 April 1892 depicting the instruments and imagery of *Urania*.

We now turn to the first person whom we might legitimately call a "space artist," the astronomer-priest Louis Théophile Moreux. He was professor of mathematics at the Saint Célestin seminary in Bourges where, in 1899, he had a small observatory built. In the first decades of the twentieth century he produced a plethora of books on subjects ranging from backyard astronomy to speculation about life on other worlds (he was great friends with Camille Flammarion). A great many of these books were accompanied by his own illustrations. For instance, his *A Day in the Moon* (1913) contained ten lunar landscapes, ranging from a scene of the Earth as seen from the Moon to "the interior of a lunar volcano."

Meanwhile, in England, another astronomer-artist was to make an even greater mark on the history of space art. Thomas Simeon Scriven Bolton (c. 1888–1929) was an accomplished amateur astronomer. Although he contributed illustrations on astronomical subjects to *The Illustrated London News* for fifteen years, he made his living as an oil merchant at Bramley, Leeds. He kept a private observatory equipped with an 18-inch reflector in a field next to his home. His personal specialty was the study of variable stars, the results of which were published by the Royal Astronomical Society. In many of his depictions of other worlds – in particular the Moon – he developed a uniquely effective technique (perhaps inspired by the work of Nasmyth and Carpenter): he built detailed plaster models of the surface of the moon or planet. These were then photographed, after which Bolton painted stars and other details onto the final print. His artwork gained him numerous awards, including a gold medal in the 1908 Franco-British Exhibition.

Because of the international prominence of *The Illustrated London News*, Bolton's astronomical illustrations were reprinted widely, including American magazines, newspapers and books. This widespread presence of his artwork made him especially influential.

Another astronomer-artist, and again another Frenchman, began work at about this same time. Lucian Rudaux was a science writer and illustrator for *Nature* and *L'Illustration*. He had joined the French astronomical society in 1892 at the age of 18. He was among the first ever to observe a solar flare in white light and published numerous reports of this and his many other observations in the society's bulletin between 1892 and 1914.

Rudaux built his own private observatory at Donville, near the coast of Normandy. Using its 4-inch reflector, he created pioneering photographs of the Moon and planets as well as a photographic atlas of the Milky Way.

In addition to his commissioned work, Rudaux wrote and illustrated numerous books and magazine articles of his own. Many of the latter were translated and reprinted all over the world. They included topics ranging from "When the Moon Breaks Up" to speculations about the potential dangers of space flight. His masterwork was the

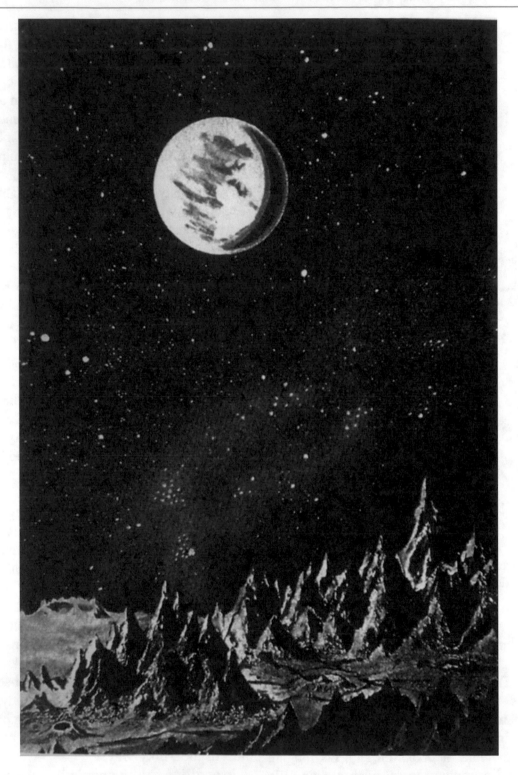

Fig. 3.9 *Earth from the Moon* by Louis Théophile Moreux.

1937 book, *Sur les Autres Mondes* (*On Other Worlds*). A large-format volume, it featured more than 400 illustrations, including 20 full-page color paintings. It was an extraordinary achievement. Never before had the planets and moons been depicted with such realism. In particular, his renderings of the surface of the Moon are especially remarkable. Instead of the craggy, precipitous peaks that had been the norm for artists of the previous half century, Rudaux's lunar

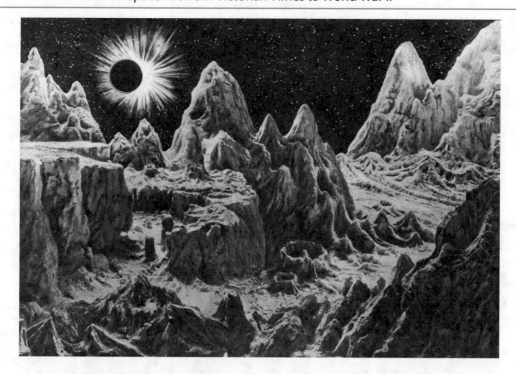

Fig. 3.10 *Eclipse Seen from the Moon* by Scriven Bolton.

Fig. 3.11 *Lunar Mountains* by Scriven Bolton.

landscape was more eroded, the mountains rounded and the slopes gentler. Rudaux explained his reasons for doing this. Many people, astronomers and artist both, he wrote, had been misled by the shadows cast by lunar moun- tains when the sun was low in the sky. Stretched out and elongated, they gave the misleading impression that they were being cast by jagged peaks. But even more compelling evidence could be had, Rudaux said, by simply looking at

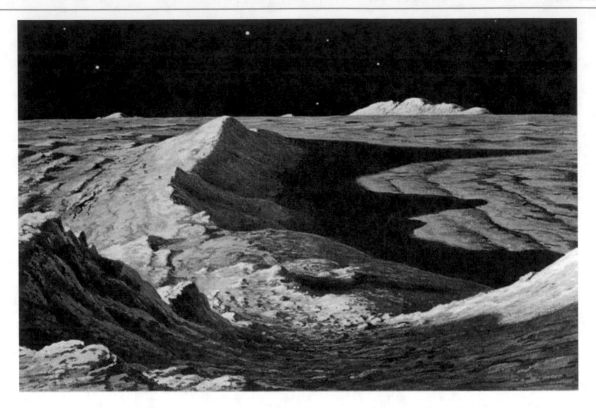

Fig. 3.12 *Lunar Mountains* by Lucien Rudaux.

the limb of the Moon through a telescope: one can see the mountains in profile silhouetted against the dark sky.

Rudaux also depicted Venus as a hot, arid dust bowl and Mars with a pinkish sky. Indeed, Rudaux's paintings of Mars as seen from space even include small, vague, circular features that suggest that he may have seen craters at the very limits of resolution.

Sur les Autres Mondes has in the years since its original appearance been considered to be such a seminal volume that a facsimile commemorative edition was published in 1990. In further commemoration of his work as both an astronomer and an artist, a 107-kilometer- (65-mile-) wide crater on Mars was named for Rudaux in 1973.

At about the same time that Rudaux was working, the first specialists in *hardware art* – the depiction not of other worlds but of the machines that will take us there – appeared in Germany. Rocketry and space travel had gotten its first ardent proselytizer in the form of Max Valier. In books and an

endless stream of magazine articles, Valier argued for the development not just of space travel but of an incrementally developed space flight program, through the step-by-step evolution from ordinary aircraft to a true spaceship. To illustrate his concepts, he employed the services of twin brothers Hans and Botho von Römer, one an architect, the other a graphic designer. They later said, "He [Valier] arrived like a rocket, full of plans and enthusiasm... the enthusiasm of this amiable person had affected us and thrilled us... above all, it was a matter of interesting the public at large, and also science and technology, in the idea of rocket propulsion."

It was through the Römer's artwork that Valier was able to effectively communicate his enthusiasm to his audiences. The brothers said that Valier told them, "...that he was able, just by means of our vivid and technically intelligible sketches which he displayed especially in his lantern-slide lectures, to obtain from his audience the necessary appreciation of his plans, which were very much ahead of their time."

Fig. 3.13 *The Dangers of Space Flight* by Lucien Rudaux.

Valier's articles were translated and republished around the world. They were either accompanied by the original illustrations or copies made by other artists. The Römers also provided the illustrations for the space travel novels of German science fiction authors as Otto Willi Gail. The spacecraft designed by Valier and the Römers were a great influence on the work of the seminal American science fiction artist, Frank R. Paul.

A nearly forgotten space art master was Daniel Owen Stephens, who literally sacrificed his life for his art. Stephens originally trained to be a professional astronomer, but eventually worked as an architect, mathematician, and writer. While work-

ing as an art teacher, he became interested in the possibility of conveying scientific knowledge via art and painted his eyewitness impression of the solar eclipse of 1925, which he was able to see from his native New England. He eventually became a staff artist for the Museum of Natural History's Hayden Planetarium in New York.

Stephen's artwork has an impressive sense of drama and color in a solid style reminiscent of that of Rockwell Kent. In 1937 he was sent to South America as part of the American Museum of Natural History's Hayden Planetarium-Grace Peruvian Eclipse Expedition. This would be the third eclipse that Stephens had observed with the

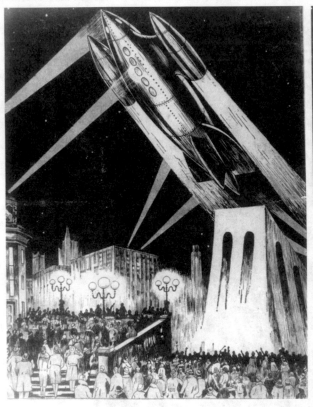 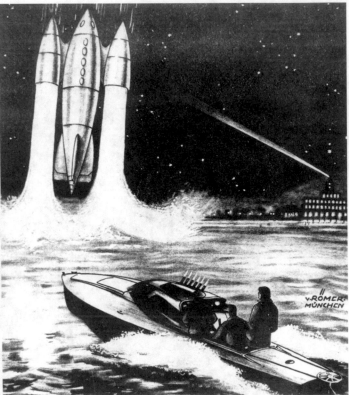

Fig. 3.14 *Take Off and Landing* by Hans and Botho von Römer for Max Valier.

express purpose of accurately recording the event in color. Stephens based his paintings of the eclipse on his own observations as well as sketches made by Dorothy A. Bennett, first assistant curator of the Hayden Planetarium. Stephens observed shadow bands just before second contact and reported being able to see Mars on the eastern horizon as the Moon's shadow receded. In the week following the eclipse, while at the expedition's base in Cerro, Stephens created four paintings for the Junior Astronomy Club. He also did a 30x36-inch painting of the "diamond ring" effect and a 48x72-inch painting of the totality. Another large canvas depicted the retreating shadow with Mars visible in the sky and yet another was an ethereal rendering of the zodiacal light. As beautiful as all of these were, perhaps the most strikingly beautiful was his 48x72-inch painting showing the Milky Way rising vertically over the dark peaks of the Andes. Dorothy Bennett, in her report of the expedition for Popular Astronomy, said of Stephens' work

that "you have before you a beautiful group of paintings as well as a scientific record of which both painter – and astronomer – Stephens could well be proud." Sadly, Stephens died of a stroke on the return trip from the Andes and his paintings were eventually published posthumously.

Scriven Bolton and Lucien Rudaux both appeared regularly in *The Illustrated London News* during the 1920s. At the same time, another artist was employed by the magazine: an American who specialized in architectural renderings, Chesley Bonestell. When Chesley was 17, he hiked nearly 20 miles to visit the Lick Observatory. While there, he was able to view Saturn through the observatory's giant refractor. Bonestell later sketched a picture of the planet as he had observed it – probably his first attempt at space art. Unfortunately, this sketch was lost during the great fire that followed the San Francisco earthquake.

Bonestell eventually became an architectural designer and renderer. After a career that involved

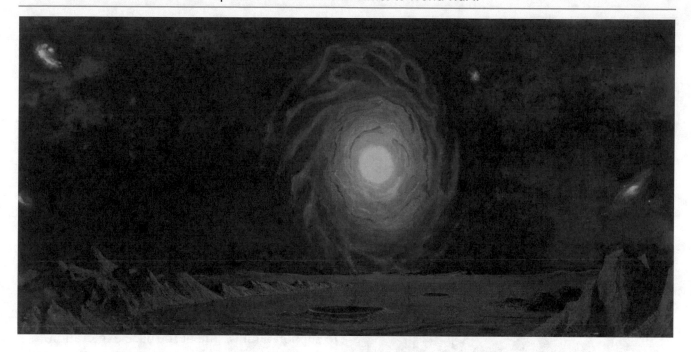

Fig. 3.15 *The Milky Way from a Hypothetical Planet* by Chesley Bonestell.

work helping to design the Golden Gate Bridge and the Chrysler Building, he began a new career in 1938 as a special effects matte painter in Hollywood. The first film he worked on was Orson Welles's *Citizen Kane*. All the views of turn-of-the-century New York and of Charles Foster Kane's mansion, Xanadu, are Bonestell's artwork. He eventually became Hollywood's highest-paid matte artist. During this time, he kept up his interest in astronomy, filling sketchbooks with extraterrestrial scenes. It occurred to him that he could employ what he'd learned as a special effects artist to create astronomical art with a level of realism never seen before. "As my knowledge of the technical side of the motion picture industry broadened," he wrote in a brief autobiography published in *Spaceflight*, "I realized I could apply camera angles as used in the motion picture studio to illustrate 'travel' from satellite to satellite, showing Saturn exactly as it would look, and at the same time I could add interest by showing the inner sat-ellites or outer ones on the far side of Saturn, as well as the planet itself in different phases."

One of the techniques he decided to employ had possibly been inspired by Scriven Bolton: the use of specially created model landscapes. Bonestell, however, took these to a level of realism never achieved by the British artist.

The result was a series of paintings depicting scenes on Saturn's moons. These eventually appeared in the May 29, 1944 issue of *Life*, Bonestell's first published space art. The magazine's readers were astonished and delighted. Among the paintings was an ethereally beautiful view of Saturn seen from its giant moon, Titan. An entire generation of scientists, engineers, and astronauts were inspired in their choice of careers by Bonestell's images, including a young Carl Sagan. Thus, his work was rightly dubbed by the late modern-day space artist Kim Poor as "the painting that launched a thousand careers."

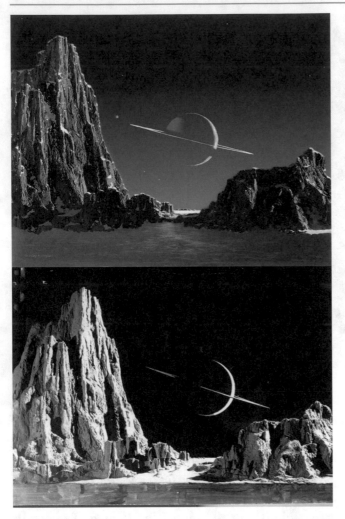

Fig. 3.16 *Saturn from Titan* by Chesley Bonestell (top). Below is the model he used to create the image.

Within a few years, Bonestell had provided art for a host of space-themed magazine articles, both for *Life* and other popular magazines. His success as an astronomical artist combined with his Hollywood experience led to his collaboration with producer George Pal on such classic science fiction films as *Destination Moon* (1950), *When Worlds Collide* (1951), *Conquest of Space* (1955), and *War of the Worlds* (1953).

Bonestell had meanwhile begun a long-term collaboration with Willy Ley, an expatriate German historian and science popularizer who had been a member of the Verein fur Raumschiffahrt (VfR, or the German Spaceflight Society). Bonestell's first book, *The Conquest of Space* (1949), created in collaboration with Ley, featured 48 of his paintings. It became an immediate bestseller.

In addition to the artwork he was creating for books, magazines and movies, Bonestell created a 40-ft-wide mural for the Boston Museum of Science depicting a lunar landscape with breath-

taking realism. Sadly, the mural was removed after the Apollo 11 landing in 1969 because "it was no longer accurate." The mural is now in the collection of the National Air & Space Museum, where it is being restored for eventual display in the aptly named "Destination Moon" exhibit hall.

In 1951 Cornelius Ryan, the associate editor of *Collier's* magazine, invited Bonestell to illustrate a series of five articles on the future of spaceflight. The prime author was to be Wernher von Braun. The resulting series, published between 1952 and 1954, took America by storm. The series was eventually collected in three books: *Across the Space Frontier* (1952), *Conquest of the Moon* (1953), and *Exploration of Mars* (1956). These articles, books, and Bonestell's artwork strongly influenced the American public and, in turn, the US government, to support an investment in space exploration.

Von Braun found himself awed by Bonestell's sharp eye for scientific and engineering accuracy. Shortly after working with the artist on the *Collier's* series, von Braun wrote:

> Chesley Bonestell's pictures... are far more than reproductions of beautiful ethereal paintings of Worlds Beyond. They present the most accurate portrayal of those faraway heavenly bodies that modern science can offer. I do not say this lightly. In my many years of association with Chesley I have learned to respect, nay fear, this wonderful artist's obsession with perfection. My file cabinet is filled with sketches of rocket ships I had prepared to help him in his art work – only to have them returned to me with penetrating detailed questions or blistering criticism of some inconsistency or oversight.

Over the following decades, Bonestell watched manned space exploration become a reality. He expressed disappointment when he saw that the softly rolling lunar hills photographed by the Apollo astronauts bore little resemblance to the craggy, romanticized landscapes he had painted (ironically, he once criticized Rudaux for the way he had painted lunar mountains). But such inaccuracies do little to diminish the primary importance of Bonestell's work. His illustrations gave immediacy and verisimilitude to dry astronomical data. What had once been columns of numbers and blurry telescopic images took on a new, compelling reality.

Bonestell continued to work until he died in 1986, an unfinished painting still on his easel. Asteroid number 3129 and a crater on Mars have been given the name "Bonestell" – a fitting honor for the man whose art contributed to the birth of the Space Age.

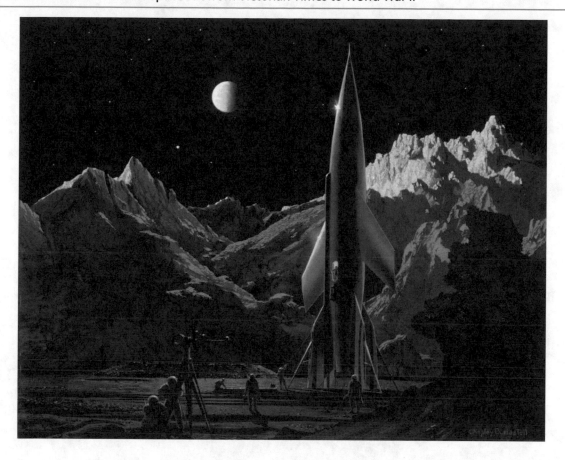

Fig. 3.17 *The Conquest of Space* by Chesley Bonestell.

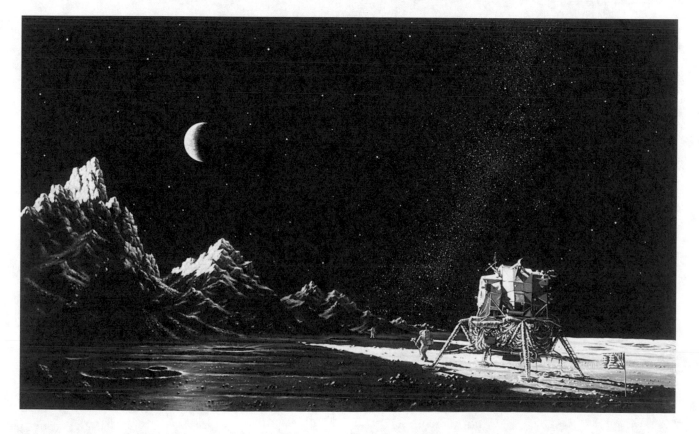

Fig. 3.18 *The Way It Should Have Been* by David A. Hardy, FIAAA.

The Spreading of Astronomical Art: World War II to the Moon Landings

Ron Miller

After World War II, the tremendous advances in printing and the capability to reach masses of people had a dramatic effect on not only how space art was created, but who it was created for.

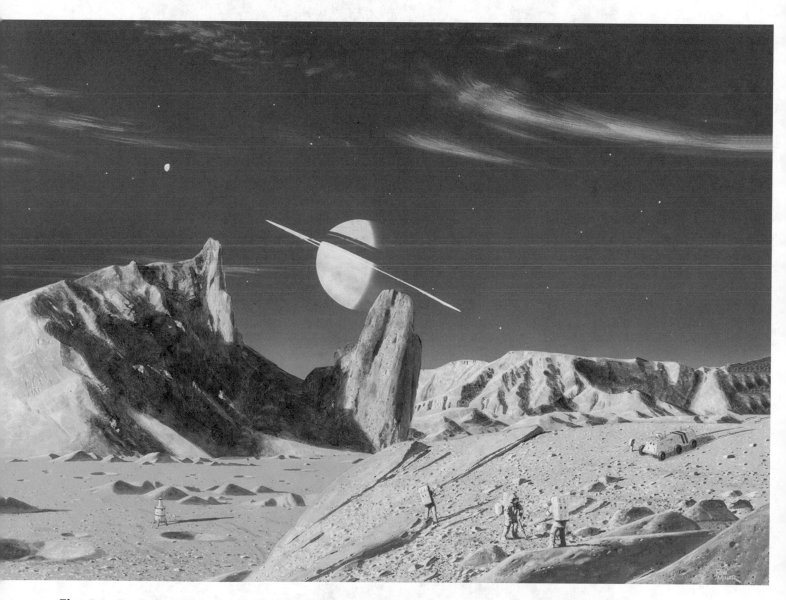

Fig. 4.1 *Exploring Titan* by Ron Miller, FIAAA, 1977. This artwork reflects ideas about Titan as they were known in the 1970s.

R. Miller (✉)
South Boston, VA, USA

© Springer Nature Switzerland AG 2021
J. Ramer, R. Miller (eds.), *The Beauty of Space Art*, https://doi.org/10.1007/978-3-030-49359-2_4

The period following World War II up to the first Apollo flights to the Moon might be called the Golden Age of Space Travel. Not, as might be expected, because of all the space launches taking place (after all, the first Earth satellite wasn't launched until more than a decade after the war), but because no time before or since had there been such public mania over the subject of space travel. Everywhere one looked, there seemed to be spaceships. Space travel was the subject of books, comic books, magazine articles, motion pictures, TV shows, toys, games, and consumer products that ran the gamut from rocket-shaped pencil sharpeners to the Oldsmobile Rocket 88 hood ornament.

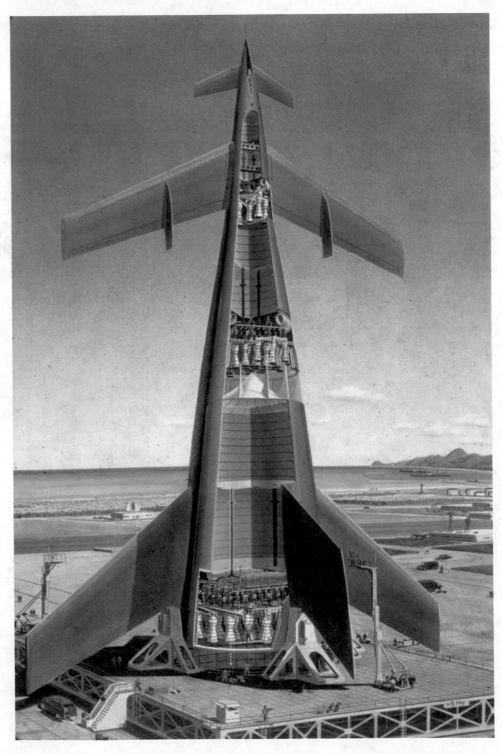

Fig. 4.2 *Three Stage Rocket* by Rolf Klep. From the Collier's "Man Will Conquer Space Soon" series.

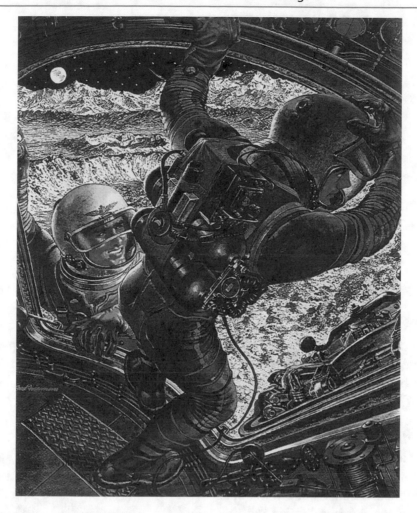

Fig. 4.3 *Grandiose Yet Desolate* by Fred Freeman. From "The First Men to the Moon," by Wernher von Braun, 1960.

And since spaceships didn't yet exist and camera-carrying planetary probes were still in the future, it fell to artists to show what this technology and the places it would someday explore might look like.

As discussed in Chapter 3, Chesley Bonestell was by far the most influential of these artists. Through the Collier's series, he and fellow illustrators Rolf Klep and Fred Freeman (who was to go on to illustrate other books by Werner von Braun) influenced not only tens of millions of American magazine readers, but scores of other artists as well. The illustrations for Collier's were taken to be definitive. The wheel-shaped space station, the winged space shuttle, the lunar lander, were all copied and recopied endlessly. As a result, many more people were probably influenced by Bonestell's art indirectly, having never seen his originals but rather that of his copyists instead.

Most of the illustrators of those two decades did their work and then moved on to their next assignment. There were, however, a handful of professional artists who made a specialty of astronomical and space travel subjects, or who at least made a significant impact on the public perception of space, especially among younger people.

The work of British architect/artist Ralph Andrew Smith appeared almost exclusively in conjunction with the British Interplanetary Society, which had been founded in 1933. Smith, who claimed to have drawn his first spaceship when he was 12 years old, was a meticulous draftsman who brought his not inconsiderable skills as a mathematician and engineer to the depiction of spacecraft. Indeed, he often collaborated with his fellow member scientists in the design of a new spaceship. In this regard, Smith is probably best known as being a co-creator of one of the first serious

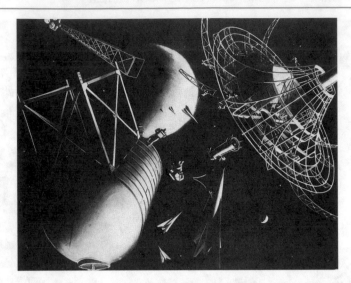

Fig. 4.4 *Space Station* by RA Smith courtesy of the British Interplanetary Society.

space station concepts: The Smith-Ross Station. Forty-five of his more than 100 space paintings were collected in a book accompanied by text by Arthur C. Clarke, *The Exploration of the Moon* (1954), while a more recent book, published by the BIS, *High Road to the Moon* (1979), features virtually all of Smith's artwork.

Perhaps the most important of the American artists working in the immediate post-war era was Jack Coggins. Born in London, he immigrated with his parents to the United States in 1923. He eventually studied art and became a professional commercial artist. Known primarily as a specialist in military subjects, he provided illustrations for numerous magazines throughout World War II. In 1940 he was invited to provide the illustrations for a children's picture book about US warships. This was his introduction to author Fletcher Pratt. Through Pratt, Coggins was in turn introduced to the world of science fiction and after the war became a prolific contributor to the pulp magazines of the era.

Seizing on the growing popularity of the subject of space flight, Pratt wrote and Coggins illustrated two books for young readers: *Rockets, Jets, Guided Missiles and Spaceships* (1951) and *By Spaceship to the Moon* (1952). With texts grounded in hard science and accompanied by dozens of full-color and black-and-white illustrations meticulously rendered in Coggins' realistic, eye-witness style, these books were among the first serious attempts to convey the principles and goals of rocketry and

space travel to young people. And they were immensely successful. The books influenced an entire generation of young American readers, and were translated into several other languages and reprinted worldwide.

Fig. 4.5 *By Spaceship to the Moon* by Jack Coggins.

Fig. 4.6 Cover of the book *Rockets, Jets, Guided Missiles and Spaceships* by Fletcher Platt, illustration by Jack Coggins.

With R.A. Smith, Coggins may have been among the first space artists to specialize in realistic depictions of hardware art – the rockets and spacecraft used to reach and explore space, rather than destinations such as moons and planets. As an artist whose career focused on military history (he also wrote and illustrated books on the subject), Coggins was especially adept at depicting scenes such as the battle of Kai Fung Fu, one of the first recorded instances of the use of rockets in warfare, the battle of Fort McHenry during the War of 1812, one of the artist's finest paintings, or the rockets and missiles used during World War II. His renderings of future spacecraft had a solid, matter-of-fact realism that was unsurpassed until the illustrations that accompanied the Collier's magazine series.

Where *Rockets, Jets, Guided Missiles and Spaceships* was devoted largely to the history and current use of rockets, *By Spaceship to the Moon* was unique in presenting to its young readers a logical, incremental approach to the development of human spaceflight. Pratt and Coggins presented a step-by-step program that began with the launch of unmanned satellites and proceeded to a space station and, finally, a trip to the Moon. Coggins' prescient design for the lunar spacecraft was a non-streamlined vehicle with extendable, spider-like landing legs. Coggins gave his readers two possibilities for a future space station: a rotating von Braun-like torus or, if a weightless environment proved to be no impediment, a cylindrical, non-rotating station, uncannily like the future Skylab.

One of the most prolific of the Golden Age space artists is possibly one of the least-known. Or, perhaps, it might be better said that more people may recognize his art than his name. Specializing in astronomy and space travel, John Polgreen illustrated more than 100 books during his career. His wife, Cathleen Polgreen, was an avid amateur astronomer, and Polgreen himself was a member of the Association of Variable Star Observers. Among the classic books he illustrated are *The Sky Observer's Guide* (1959), *The New Golden Book of Astronomy* (1965), *The Golden Book of Astronomy* (1959), and *The Question and Answer Book About Space* (1965). He may be best known,

however, for a series of books he created with rocket authority Willy Ley. Intended for younger readers, *Man-Made Satellites* (1957), *Space Pilots* (1957), *Space Stations* (1958), and *Space Travel* (1958) were initially introduced to readers as premiums offered for General Mills breakfast cereal box tops and later offered for sale through bookstores. As a result, they saw an immensely wide distribution and had a corresponding impact on young people.

Another artist who produced a large body of work but whose name remains unfamiliar is Helmut K. Wimmer. His work was almost exclusively limited to New York's Hayden Planetarium, where he worked from shortly after immigrating to the United States from Germany in 1954 until his retirement in 1987. Even though the bulk of Wimmer's work was dedicated to the ever-changing planetarium programs, he did enjoy a wider audience through his illustrations for the science books of Franklyn M. Branley and his appearances in *Natural History Magazine*. Trained as both a painter and sculptor, Wimmer created busts of Ptolemy, Copernicus, Galileo, Newton, Einstein, and Edwin Hubble for the planetarium's hallways. "Over the years," said Kenneth Frankin, who was chief scientist at the planetarium during Wimmer's tenure, "Helmut drew so many pictures of the Earth that he could paint it from any point of view, no longer needing a globe or map. He could also represent constellations from memory."

It is worth taking a moment to acknowledge the influence of science fiction – in particular, the science fiction illustrator. Many of the artists already discussed contributed to the covers of many science fiction pulp magazines. While a few of the regular pre-space age professional science fiction artists specialized in depicting spacecraft or extraterrestrial scenes, fewer were able to avoid doing so. They would do their best but would, more often than not, base their designs on contemporary norms. Back when the V-2 was the model, most science fiction spaceships followed its lead. Still, there were some who provided some outstanding examples or who had a significantly broad

Fig. 4.7 Lunar Lander on the Moon by Jack Coggins.

Fig. 4.8 Covers of books by Willy Ley, illustrated by John Polgreen.

influence on the public perception of space flight. First among these was Frank R. Paul. An immensely prolific illustrator, he provided thousands of cover paintings and interior illustrations, primarily for the magazines published by Hugo Gernsback. His baroquely elaborate but well-thought-out spacecraft set a standard for the decades preceding World War II. Deeply influenced at the time by the published work of Austrian rocketry pioneer Max Valier, Paul brought those ideas to life when Valier's articles and stories were published in translation, as well as those of other outstanding German science fiction authors such as Otto Willi Gail. In 1929, Paul had the special distinction of having created the first color illustration of a space station in Earth orbit when he depicted the seminal designs of Hermann Noordung for Science Wonder Stories.

Other science fiction artists might not be quite so identified with the subjects of astronomy and space travel, but artists such as John Schneeman, Howard Brown, Dean Ellis, and especially Mel Hunter did some extraordinary work in creating space art for the pulps, illustrating space exploration scenes with a Bonestell-like realism. Hunter in fact carried his enthusiasm for all things space beyond the pulps to illustrate space age technology for many books, magazines, and institutions, including a series of astronomical paintings commissioned by the Hayden Planetarium in New York and the restaurant at the Transportation and Travel pavilion at the 1964 New York World's Fair.

Perhaps the science fiction artist who was the most enthusiastic supporter of space flight was Frank Kelly Freas. With a career that began in 1950 and continued until his death more than half a century later, his work appeared in virtually every science fiction magazine, as well as on numerous book covers. Although rarely doing anything that might be strictly considered space art, Freas was an unabashed fan of space exploration and NASA in particular. Inspired by the Moon landing and after witnessing a launch at Cape Canaveral, Freas designed and self-published six full-color posters he hoped would inspire and encourage the continued exploration of space. During the development of the Skylab space station program, Freas was invited by mission scientist Joseph Kerwin to design the official patch. After extensive research into the technology and goals of the program and interviews with the astronauts themselves, Freas rejected "Conestoga wagons, cornucopias, galleons" as being too trite or uninteresting, and decided to "let the Skylab cluster become its own symbol." The result has become a classic.

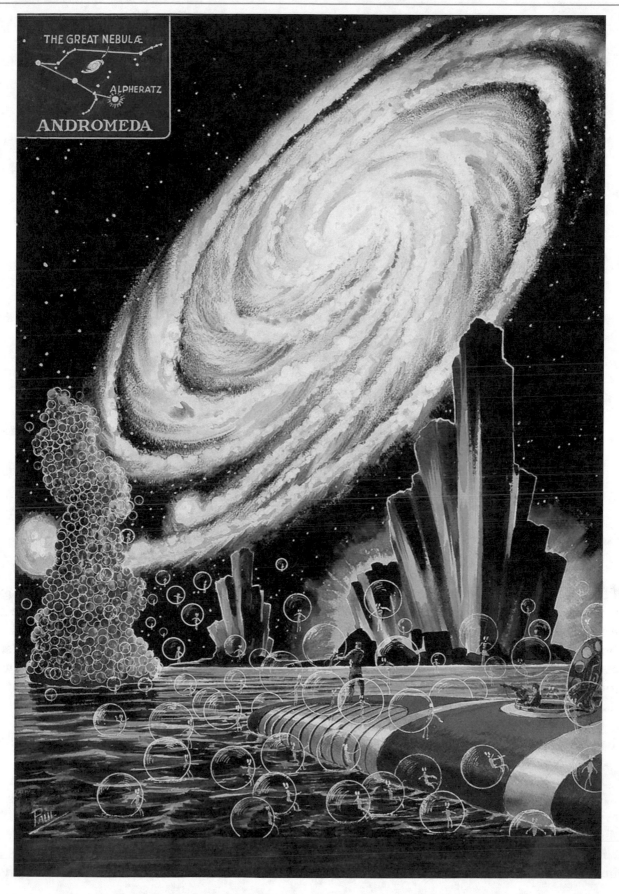

Fig. 4.9 Back cover of Amazing Stories (1945) by Frank R. Paul.

Fig. 4.10 *Space Station in Orbit* design by Hermann Noordung, illustration by Frank R. Paul.

If Lucien Rudaux can be considered the grandfather of space art and Chesley Bonestell the father, then Ludek Pešek might be the godfather. An ex-patriot Czechoslovakian who lived in Switzerland since 1968, when the Soviet army invaded his nation, Pešek had already established a reputation as an outstanding astronomical illustrator by the time he became well-known in the United States. He had been inspired as a youngster by the work of Lucien Rudaux, who Pešek's paintings resemble to a degree stylistically. Pešek's first books, *The Moon and Planets* (1963) and *Our Planet Earth* (1967), were oversize coffee-table volumes translated and published widely throughout Europe. *The Moon and Planets*, for instance, contains 40 black-and-white and full-color illustrations, all reproduced as large, double-page spreads or even three-page fold-outs. These provide a panoramic experience that absorbs the viewer into the scene being depicted. While Pešek did not work in the photorealistic style of Bonestell, his more naturalistic, painterly technique imbued a realism of its own; his paintings look as though they were created on the spot.

"As a middle-aged man," Pešek wrote, "I... began to sketch the lunar landscape. I established the heights and profiles of a terrain from the lengths of shadows on a telescopic photograph of the region around the crater Hyginus. This was the beginning of my series of lunar and planetary landscape paintings. I was fascinated by the thought that I was creating not a fanciful landscape but one that really exists." He "became obsessed with the

Fig. 4.11 *Dreadful Sanctuary* by Frank Kelly Freas.

desire to make them as accurate as possible." He soon ran into the same obstacle that faces all space artists. "Astronomers," he explained, "like to use words like 'perhaps', 'probably', 'it is possible', and 'it seems.' Such qualifications are of little use to one making a realistic painting."

All space artists are confronted at one time or another by the same question: What is the point of painting scenes on other worlds when we have thousands of photos from NASA and other agencies? It reiterates the question asked science fiction authors back in 1969: "Now that people have landed on the Moon, what are you going to write about?" Even though Pešek addressed this in 1972, before the Pioneer 10 and 11, the Viking landers, Magellan, Galileo, or any of the other planetary

Fig. 4.12 *Skylab Mission Patch* by Frank Kelly Freas.

orbiters and landers, his reply is no less valid today. It is, he said,

> ...a superficial question. It is true, there are now close-up photographs of the lunar surface but the number of features that have been photographed is still very small. Close-up photographs of the Martian surface have not as yet been taken. Detailed photographs of other planets and of their satellites cannot be expected for many years. Thus, the landscapes I paint, based on the best information I can obtain, still serve a practical didactic purpose, even if one neglects their aesthetic qualities. *(An Artist in Modern Times: On Extraterrestrial Landscapes by Ludek Pešek, Leonardo, v. 5, 1972)*

Pešek was introduced to Americans via *National Geographic Magazine*, for which he had provided 15 color illustrations to accompany the article, "Journey to the Planets" in the August, 1970 issue. This was followed soon after by an article about Mars, for which Pešek created half a dozen illustrations, including a large print of a Martian dust storm inserted into the magazine.

Fig. 4.13 *Martian Dust Storm* by Ludek Pešek.

Pešek continued to produce books of his own, usually with a text provided by an expert such as Bruno Stanek or Peter Ryan. These included the children's books *Journey to the Planets* (1972), *Planet Earth* (1972), *The Ocean World* (1973), and *UFOs and Other Worlds* (1975), as well as the large format *Solar System* (1978) and *Bildatlas des Sonnensystems* (*Picture Atlas of the Solar System*) 1974. Between 1981 and 1985 he created 35 paintings of the planet Mars, most of which have unfortunately remained unpublished. He was also an accomplished author who wrote several novels, including science fiction about space travel.

In the last decades of his career, Pešek created a large number of striking, surrealistic paintings, many of which with a strong astronomical theme. Perhaps the best-known of these might be *Presence of God*, a large rendering of a Gothic cathedral dominating the center of a lunar crater. Another series borrowed an idea from Rene Magritte in order to directly juxtapose lunar and terrestrial landscapes. Another, and one of this author's favorites, depicts a rock having rolled down a barren

lunar slope only to stop short just before crushing a daisy. "I paint as simply as possible in order to be understood," Pešek explained. "I am not interested in developing new painting techniques or new artistic visual conceptions and the opinion of art critics give me neither pleasure nor pain. Perhaps, after many years of thinking in terms of extraterrestrial space, I may have lost contact with earthly dimensions but, if I have, I do not suffer from the loss."

In 1962, immediately following NASA's first successful human spaceflights, James Webb, then administrator of the agency, established the NASA Artist's Cooperation Program. The goal was to document not only the images of spaceflight but its spirit and emotional impact. Over the following decades, outstanding American artists and illustrators from Norman Rockwell and Robert McCall to James Wyeth, Fletcher Martin, Robert Rauschenberg, and even Andy Warhol were invited to cover all aspects of the Gemini and Apollo programs, from astronaut training to launches. A special group of science fiction illustrators, including Frank Kelly Freas, John

Fig. 4.14 *Uranus* by Ludek Pešek.

Schoenherr, and Vincent Di Fate, were invited to document the Apollo-Soyuz launch. Hereward Lester Cooke, the former Curator of Painting at the National Gallery of Art, guided the program during the Apollo program along with artist James Dean, who took over and was in charge of the program up to the late 1970s. The late Robert Schulman administered the program during the Space Shuttle era. Bert Ulrich took over the helm in the late 1990s and was instrumental in expanding the scope of the program to include music, poetry, and creative photography by people ranging from Ray Bradbury to Annie Leibowitz.

To date, more than 3,000 works of art created by more than 200 artists have become part of the documentary history of the American space program. Although much scaled back today, the program still exists and is still active in recording the human impact of space exploration.

Schulman tried to answer the natural question: why should NASA, "...an agency known for *technological* expertise, have an *art* program?" Especially when hundreds of cameras were recording every moment and every detail of every flight. Schulman found his answer in something Honor Victorin Daumier said when asked a similar question shortly after the invention of photography: "the camera imitates everything and expresses nothing." It is the artist, Schulman explained, who "makes the significant difference.... It is the emotional impact, interpretation and hidden significance of these events that lie within the scope of the artist's vision." What the artist observes has "gone through the catalyst of his imagination and has been transformed in the process."

"Perhaps," Lester Cooke said, "the existence of the NASA Fine Arts Program will help to prove that the US produced not only engineers and scientists capable of shaping the destiny of our age but also the artists worthy to keep them company."

The United States was not alone in realizing how the arts could be used to not only record the history of space flight but to promote it as well. Probably the most fortunate space artists, at least in respect to the support they received from their government, were those in the old Soviet Union. Although their work was strictly controlled in

many ways, they were at the same time provided access to government facilities and personnel to a degree unprecedented in the US and Europe. In the USSR, space art as a genre was a division of the USSR Union of Artists, an organization of some twenty thousand individuals. While membership in the Union was not mandatory, it was hard for an artist to earn a living, let alone get their work exhibited, without the aid and consent of the Union. The Union's Committee on Science and the Cosmos was dedicated to those artists whose special interest lay in space and space exploration. The Union actively subsidized the development of space as a theme, commissioning artists to create works for exhibition in museums or permanent public art such as murals and sculptures displayed in libraries and government buildings.

Working closely with Glavkosmos and the USSR Federation of Space Exploration, the Committee provided a liaison between its members and scientists and cosmonauts. Union artists were able to visit such facilities as the USSR Academy of Science's Institute of Space Research. As part of the celebration of the 25th anniversary of Yuri Gagarin's historic flight, nearly a dozen Union artists visited Baikonur, the Soviet space flight center. This event, like many other visits to similar high-tech sites, was sponsored by the Union of Artists. Some Soviet space artists were even able to have sketches carried into earth orbit by cosmonauts, who then added their own notes to the sketches, allowing the artists to create their final works with the accuracy of an eyewitness. Also subsidized by the Union were numerous "houses of creativity." Scattered across the USSR, these were large complexes of studios and apartments made available to member artists. There, they could work, participate in seminars and prepare their work for display in exhibitions, which were, of course, organized exclusively by the Union. Members of the Union included cosmonauts Alexei Leonov and Vladimir Dzhanibekov who, like American astronaut Alan Bean, are extraordinary artists in their own right.

As Vitaly Myagkov, the Secretary of the Board of the Union of Artists, explained in an essay he

Fig. 4.15 *Phobos* by Yuri Pochadaev, a member of the USSR Union of Artists Committee on Science and the Cosmos.

Fig. 4.16 *Duel* by Vladimir Dzhanibekov.

wrote for *In the Stream of* Stars (1990), the Soviet Union encouraged the active participation of the arts in its space program because space art "is beneficial in that it allows works of various styles and tendencies to be successfully combined in a single exhibition that is interesting for the viewer, while providing the artist with freedom of choice in terms of theme, subject, form, style and figurative language. The exuberance and boundless fantasy that result is as unending and diverse as the galaxies."

Sadly, with the demise of the Soviet Union came the dismantling of the Union of Artists, including its Committee on Science and the Cosmos, leaving no official encouragement, support, or outlet for space art in the region.

The newest space agency to embrace the arts as a means of both creating a human record of space

Fig. 4.17 Image of the Aral Sea taken by the Sentinel-1a satellite. Image Copernicus Data/ESA.

Fig. 4.18 Image of the Andes Mountains taken by the ASTER instrument on board the Terra satellite. Image NASA/GSFC/METI/Japan Space Systems ASTER Team.

flight and engaging the public is the European Space Agency. Almost from its inception in 1975, the ESA has sponsored art and artists as an effective way to reaching out to the public. In its earliest years, this was largely accomplished through competitions as a method of involving children and students in ESA's activities. These ongoing competitions are usually themed, such as the "Humans in Space Youth Art Competition" of 2010. This strategy also eventually evolved into inviting professional artists to participate, even to the extent of creating murals at ESA facilities. These artists are encouraged to visit ESA centers and observe the work being done there. Artist-in-residence programs enable creative individuals to work alongside ESA scientists, engineers, and technicians. Artists have even been invited to take part in "freefall" flights similar to those of the famed "Vomit Comet" used to train US astronauts. Like the art produced by the NASA Fine Arts Program, ESA artists have created space-inspired works in every imaginable medium, from painting, animation, and sculpture to music and dance. Additionally, ESA has released a series of images taken by satellites as objects of art themselves. When processed, some views of the Earth from orbit are truly beautiful works of art in their own right.

Space Art as a Modern Movement: From the Moon to Today

5

5

Lois Rosson and Ron Miller

Once humans had successfully stepped onto another world, the public demand for ever more accurate views of other planets became nearly insatiable. Museums, exhibits, magazines, books, and television shows all clamored for inspirational astronomical art.

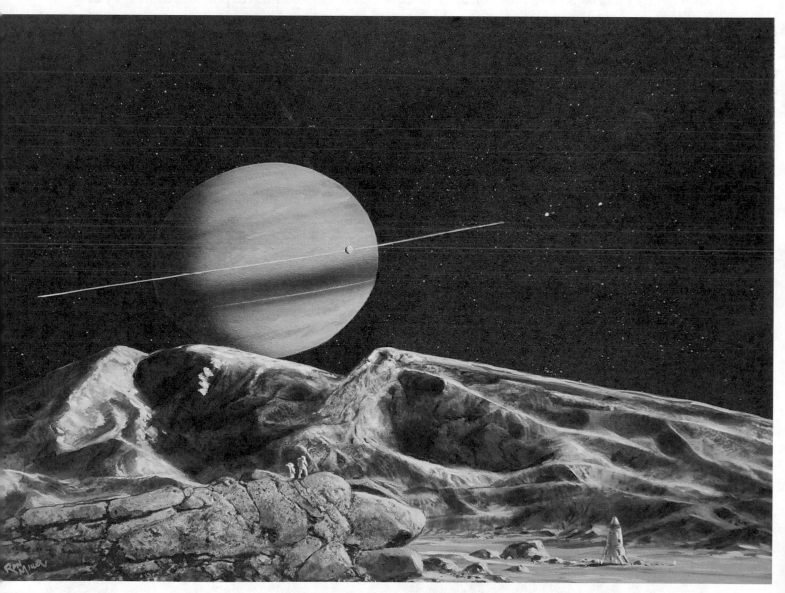

Fig. 5.1 "Saturn as seen from Mimas," by Ron Miller, FIAAA.

5

L. Rosson
Berkley, CA, USA

R. Miller (✉)
South Boston, VA, USA

© Springer Nature Switzerland AG 2021
J. Ramer, R. Miller (eds.), *The Beauty of Space Art*, https://doi.org/10.1007/978-3-030-49359-2_5

On March 13th, 1972, Chesley Bonestell sent a letter to the director of the NASA Art Program, James Dean, thanking him for his complimentary copy of the recently published NASA book, *Eyewitness to Space*. The book – a hefty volume filled with 258 paintings, drawings, and prints – was a survey of art work produced for the NASA Artists' Cooperation Program between 1964 and 1969. Even though Bonestell never participated directly in the NASA Art Program, he was certainly recognized by its leading contributors as the "old master" of space painting. Bonestell's "Surface of Mercury," produced more than twenty years before its circulation in Eyewitness to Space, was positioned in the book as an epilogue to a historically significant collection of fine art.

In his letter to James Dean, Bonestell praised the body of work generated by the NASA Art Program, but singled out the work of a few artists as particularly compelling. "Paul Calle, in my judgement, bears the palm," he wrote, and "although his work is new to me, his draughtsmanship is both beautiful and delicate.... He will go far in this business and I would like to see him move into the field of astronomy." Bonestell also pointed to "a brilliant painting" by Robert McCall, and noted that his work was encouraging to see, especially at a time when "so many 'artist' frauds succeed." There was a clarity in the pictorial style of this work that resonated with Bonestell, even if the subject matter diverged from the astronomical landscapes for which he was known. McCall, Calle, and Bonestell are all typically memorialized as pillars in the history of space art as a genre, but their respective bodies of work only fit together because they made art about outer space. In the early years of the NASA Art Program, McCall and Calle mostly focused their representational efforts mostly on the people and infrastructure of the space program itself.

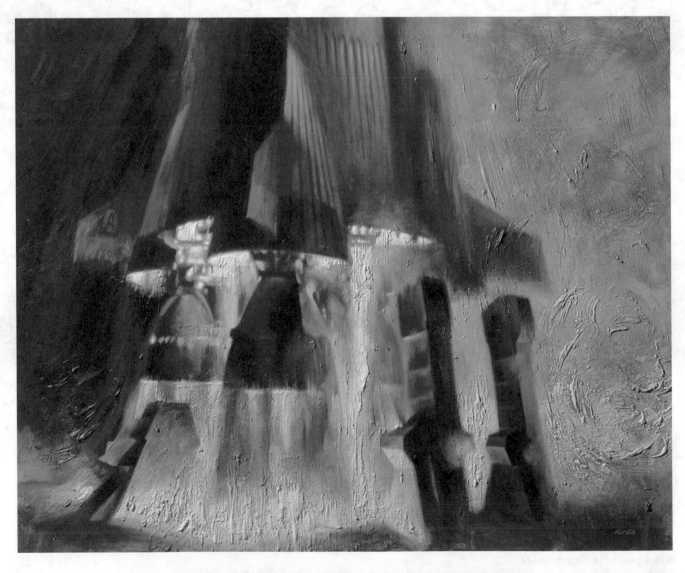

Fig. 5.2 *Power to Go!* by Paul Calle, from the Calle Estate.

Chesley Bonestell's praise for Calle and McCall represented an important expansion in the types of subject matter that could be identified as space art. At the peak of Bonestell's career in the late 1950s, astronomy was still the primary vector for visual observations of outer space. As a result, pictorial conventions associated with astronomical illustration dominated the visual culture of the early Space Age. Over the course of the next decade however, attempts at manned space exploration expanded the number of disciplines concerned with the human experience of outer space.

Bonestell's analysis of the work of other artists was not always charitable. Of Norman Rockwell's contributions to Eyewitness to Space, he wrote:

> Here is an artist who is superb in picturing the uncultured mediocrity of America but is in deep quicksand, in fact has sunk, when it comes to space. He depicts a crescent earth where the Sun obviously must be below the horizon while he lights the Moon by a Sun obviously high in the sky, showing that he is incapable of using his head in dealing with problems of space, and should confine his efforts to the field where he is appreciated.

"Space art" is a challenging term in that it refers to a genre bounded loosely by subject matter rather than style. And perhaps we know what space art is today, but what did it look like in earlier periods, before its practitioners used that terminology? Prior to the onset of NASA's participation in the Space Race, the images we might situate in space art's aesthetic genealogy often took the form of paintings or illustrations guided by astronomical principles. Illustrations circulated in popular magazines and periodicals weren't always produced with astronomical accuracy in mind, but they borrowed heavily from the visual iconography established there. The broadening of American space art to include other space-related subjects and styles reflected the expansion of activities in space spurred by the creation of NASA. Though the term "American space art" is in this case anachronistic, the trajectory of the genre can be said to have undergone dramatic changes in the years between 1946 and 1958. In the pre-Space Age moment, space art circulated primarily in print, whereas by the late 1960s, it had expanded into a fine art suitable for galleries.

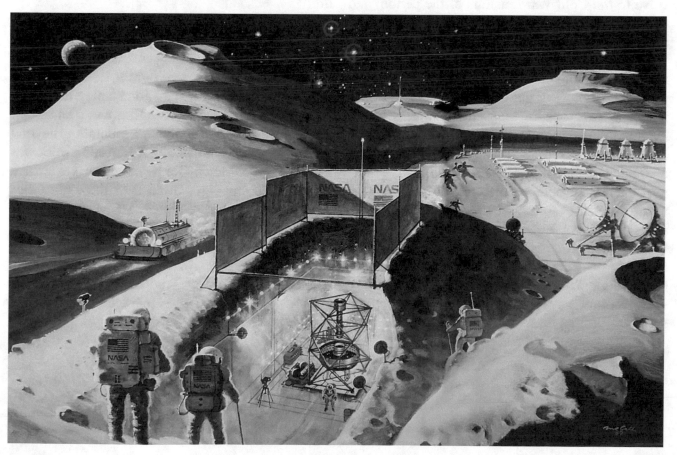

Fig. 5.3 *Eye in the Lunar Sky* by Robert McCall. Courtesy of the McCall Estate.

The most direct conduit between the space program and fine art came in the form of the NASA Artists' Cooperation Program, which was conceptualized in 1962, just four years after the agency's creation. The idea for the program first emerged when James Webb, NASA's second-ever director, encountered a portrait of Mercury astronaut Alan Shepard painted by Bruce Stevenson. Webb was struck by the way the portrait captured Shepard's likeness, and he quickly envisioned a group portrait of all the Mercury astronauts as a way to emphasize the collective effort necessary for success in human spaceflight. While this particular group portrait never materialized, Webb was still invested in using fine art as a form of documentation with more lasting power than traditional press coverage.

Despite this initial enthusiasm, Webb recognized that not everyone would see the value in adding the commission of fine art to the agency's already long list of objectives. The political climate at this time added another hurdle. Government agencies in the early 1960s were particularly sensitive to the Cold War tensions of the period, and the fine art world was one of the places where so-called communist sympathies were said to abound. Webb knew he'd have to tread carefully and work with well-established institutional channels if the program was ever to get off the ground. Hereward Lester Cooke, one of the senior curators at the National Gallery of Art, was brought on to help him compile a list of reputable artists. James Dean, a trained painter and NASA employee, was appointed the program's director. The two of them worked together to model the architecture of the program after the US Air Force Art Program, which selected artists in conjunction with the Society of Illustrators. The NASA Artists' Cooperation Program reserved the right to make all selections, but it used the USAF Art Program roster to form its invitation pool.

Established in 1950, the USAF Art Program was created to both document and memorialize the people and aircraft that helped the United States win the Second World War. Because the mission of the USAF Art Program was so similar to that of the NASA Art Program – and because many of its artists already had experience working within government agencies – many of the artists that matriculated into the NASA Art Program came from the US military. The connection between the NASA Artists' Cooperation Program and a much older tradition of military painting is rarely pointed out, but it's one worth keeping in mind.

One of the artists that spanned both programs was also one of the most visible. Robert T. McCall, a native of Columbus, Ohio, began his career as an illustrator before joining the Air Force in 1942. McCall produced work for a range of popular national magazines before joining the military, including publications like LIFE and Popular Mechanics. It was as a bombardier instructor that McCall took to painting airplanes, and he remained active in the field of aviation art for much of his life.

During his time with the NASA Art Program, McCall's work became synonymous specifically with paintings of outer space. As a result of his affiliation with the space program, he was hired to produce the promotional art for Stanley Kubrick's *2001: A Space Odyssey*. The film was a smash hit and helped propel his art and reputation beyond images of terrestrial machines. McCall's work was a central part of Metro-Goldwyn-Mayer's extensive advertising campaign. In each of the eight cities where the film was premiered, MGM ran four full-page color advertisements featuring his work, appearing together as an insert or as single full-page ads, on successive Sundays in leading newspapers. That McCall served as "official artist for NASA" added to the marketability of his paintings.

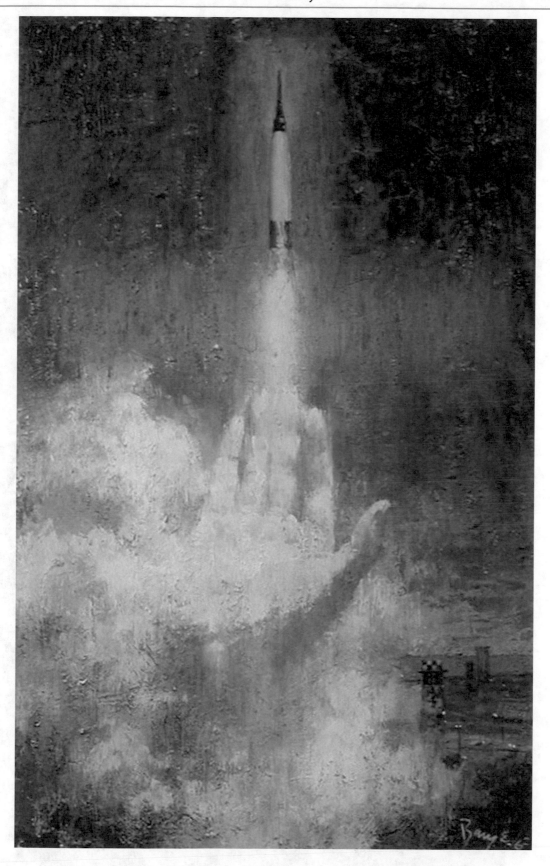

Fig. 5.4 *In the Hand of God* by Barye Phillips, USAF Art Program image.

Fig. 5.5 *Return to the Moon* by Robert McCall. Courtesy of the McCall Estate.

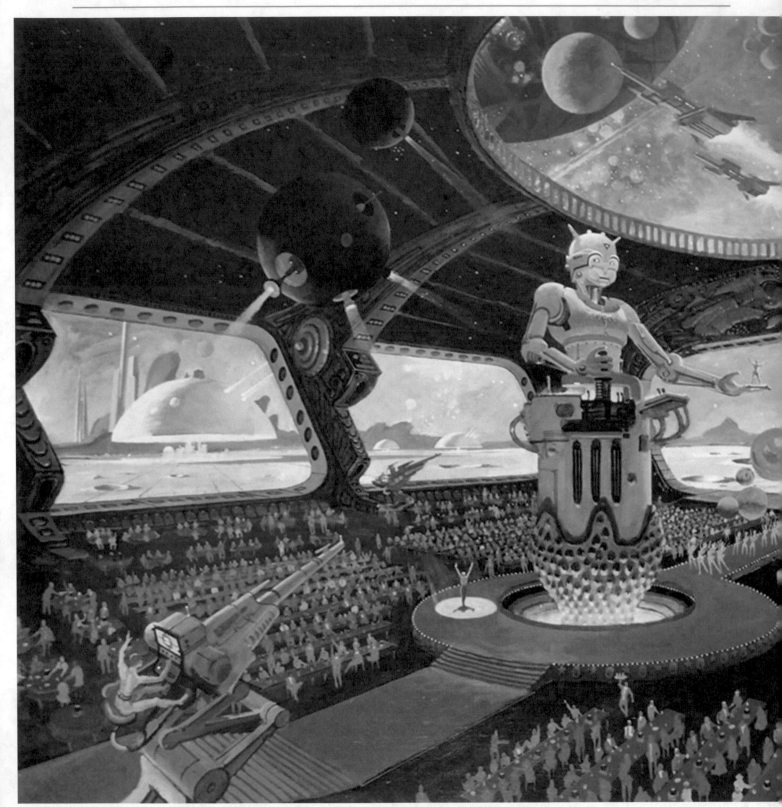

Fig. 5.6 *Caesar's Universe* by Robert McCall. A previously unpublished McCall image. This work was part of a proposal for a dinner theater experience to the Caesar Palace group in Las Vegas, developed on the heels of the release of two box office successes *Close Encounters of the Third Kind* and *Stars Wars*. Image courtesy the Randy and Yulia Liebermann Lunar and Planetary Exploration Collection.

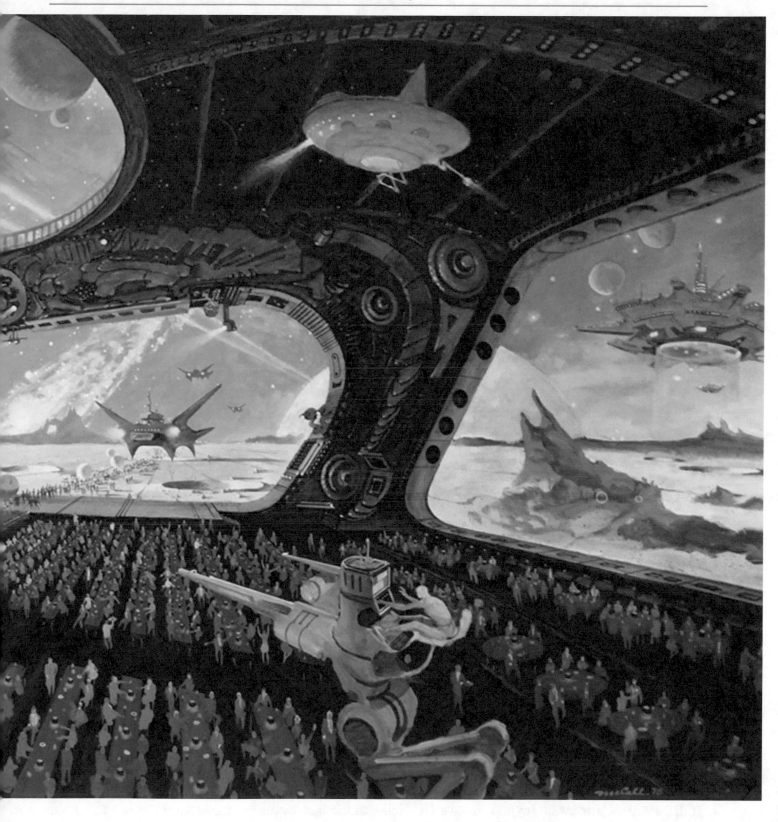

Paul Calle, born in New York in 1928, also became synonymous with space art due to his time in the NASA Art Program. Like McCall, Calle worked as an illustrator with a range of subjects before joining the US Army. Trained at the Pratt Institute, Calle joined the first cohort of NASA Art Program painters in 1964. Along with McCall, Lamar Dodd, John McCoy II, Peter Hurd, Robert Shore, George A. Weymouth, and Mitchell Jamieson, Calle traveled to Cape Canaveral to sketch scenes from Gordon Cooper's flight aboard the Mercury Atlas-9. The sketches were intended to be preliminary so that artists could then return to their studios to produce more polished works, but the immediacy of from-life observation was what characterized some of Calle's best-known works for the program.

Fig. 5.7 *Armstrong Suiting Up* by Paul Calle, courtesy the Calle Estate.

Calle collaborated with the NASA art program over the course of the 1960s, and he produced some of his most iconic drawings in the days leading up to Apollo 11. On the morning of July 16th, 1969, Calle was invited to watch Neil Armstrong, Edwin Eugene Aldrin, and Michael Collins prepare for their historic voyage to the Moon. Though Calle's sketches looked very different from the types of images that characterized traditional space art up until this point, they fit precisely with the vision James Webb had articulated back in 1962. Calle's drawings were documentation, reminiscent of courtroom watercolors or the figure studies used to train artists in human anatomy. He recorded the event in a way film could not, rendering ordinary gestures with a heroic elegance. Calle's son Chris became an artist of some caliber, too.

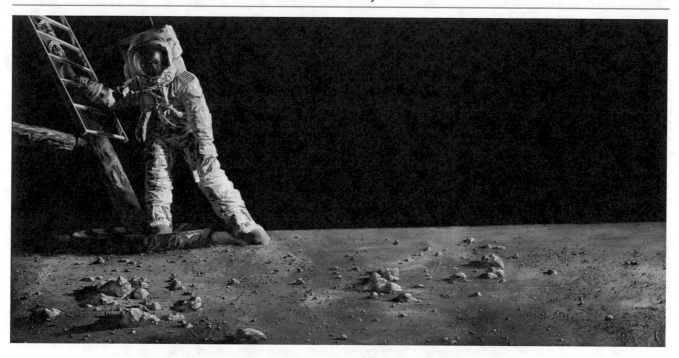

Fig, 5.8 *The Great Moment* by Paul Calle, courtesy the Calle Estate.

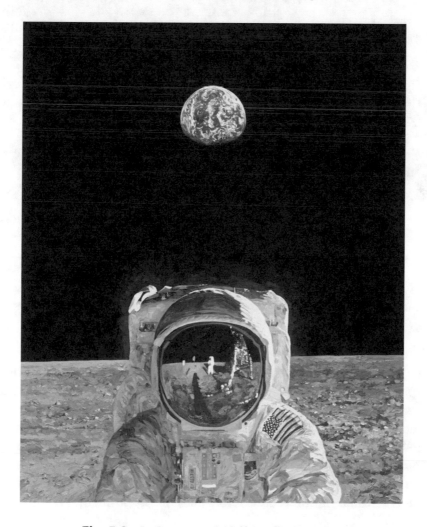

Fig. 5.9 *Reflections of 1969* by Chris Calle.

While Paul Calle and Robert McCall weren't necessarily the most famous artists to participate in the NASA Art Program, their work helped attract the attention of new audiences to space-related images. Their work, and most of the art produced for the NASA Artists' Cooperation Program over the course of the 1960s, was included in several high-profile exhibitions. In 1965 the National Gallery of Art organized a show titled "Eyewitness to Space," which was understood to be one of the most successful in the museum's history. Anne Collins Goodyear, one of few Art Historians to write about the NASA Art Program,

points out that turnout for the show was second only to the museum's 1963 display of Leonardo da Vinci's *Mona Lisa*.

Viewership of the exhibition wasn't just restrained to the District of Columbia, either. After its closing at the National Gallery, the show was packed up and sent to various institutions around the country for display. In 1969, the National Gallery of Art prepared a second exhibition in tandem with the NASA Art Program, titled "The Artist in Space." Designed to coincide with the Apollo 11 Moon landing, the show was likewise sent around the country once it finished in Washington.

Fig. 5.10 The book *Eyewitness to Space*, art from the NASA Fine Arts Program, by Hereward Lester Cooke and James D. Dean, cover art by Norman Rockwell and Robert McCall.

As a function of the NASA Artists' Cooperation Program's existence, museum-going Americans were exposed to space art as a coherent genre appropriate for the gallery setting. This was critical for its development into a meaningful term – but it was also short-lived. In 1974, the same year that *Eyewitness to Space* was published as a book documenting the work of the NASA Art Program, James Dean sent a frustrated memorandum to

NASA's Assistant Administrator for Public Affairs. Citing a lack of institutional support for the Art Program he'd spent a decade cultivating, Dean recommended, with "extremely great regret," that the collection be given to the newly built National Air and Space Museum. There, he noted, it could be properly stored and cared for. No new art program activity would be started, and, he continued, "if this decision cannot be

reversed, we should not prolong its agony – and mine – any longer." Dean's request was taken to heart, and later that same year he left his position at NASA to shepherd the collection as the National Air and Space Museum's chief curator of art. While the NASA Art Program was eventually re-implemented under a new director, it never enjoyed quite the same level of activity or access as it did during the buildup to Apollo.

The impact of the NASA Artists' Cooperation Program on the recognition of space art as a type of fine art beyond commercial illustration was critical, but it didn't encompass the entirety of the genre over the course of the 1960s. Aerospace proliferated as a robust industry beyond the parameters of government, and illustrators enjoyed plentiful work in advertising for companies like Rocketdyne and Northrup Grumman.

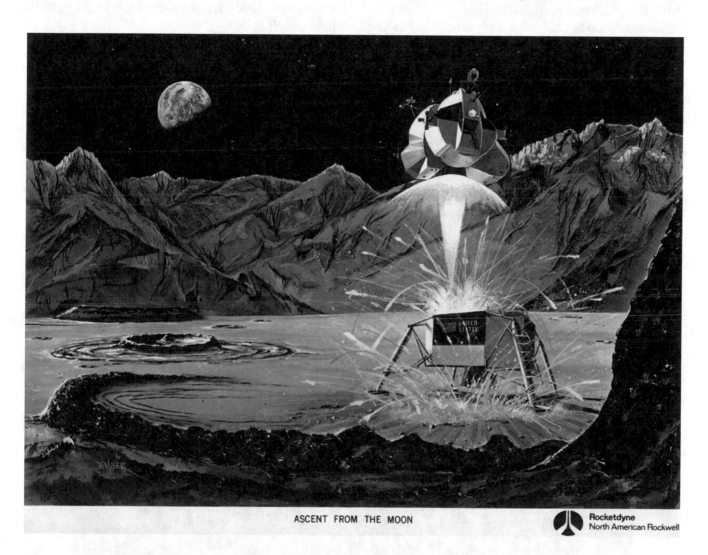

ASCENT FROM THE MOON

Rocketdyne
North American Rockwell

Fig. 5.11 Cover of Rocketdyne Press Kit by Saul Dember, source https://www.apollopresskits.com/apollo-presskit-directory.

The NASA Artists' Cooperation Program made "space art" a term that was meaningful to museums and collectors, even if the functional parameters of the genre had not yet been worked out. Over the course of the 1970s, this budding status as fine art merged with space art's historic adjacency to commercial art, scientific illustration, and concept design to create what is arguably the genre's contemporary form. Similar to the Apollo Program, the unmanned robotics missions of the 1970s reinforced the need for illustrations that could help make sense of distant and sometimes unseeable scientific subjects.

It is also important to note that this period in NASA's history was characterized by budget reductions across the board. This dynamic was reflected in the agency's pictorial output just as it had been in the decade prior. The NASA Artists' Cooperation Program was a centralized mechanism for the commission of fine art, and it functioned as evidence of an agency with a large budget and clear, unified goal. The smaller unmanned missions of the 1970s were often administered at different NASA facilities and occasionally competed with each other for funding. As a result, images intended to help publicize individual projects and scientific objectives were often commissioned by individual research centers.

While the NASA Artists' Cooperation Program was designed to produce "art objects" created by individual artists, the commission of scientific illustrations introduced a more complicated relationship between the final image and its creator. Illustrations describing scientific subjects were sometimes anonymized as an "artist's impression," to emphasize that what was on display was known scientific information. Whereas a painting by McCall or Calle would have prominently foregrounded the artist's identity, images billed as scientific representations focused on the subject matter. This convention has often posed significant challenges in determining the origin of illustrated astronomical works produced over the twentieth century, and thusly makes it difficult to give credit where credit is due.

Some of the best-known work produced during this period of the agency's history is that of space artist and contributor to this book, Don Davis. A member of the International Association of Astronomical Artists (see Chapter 6), he may be perhaps best known for the suite of illustrations he created for NASA during the agency's exploration of the possibility of future space colonies.

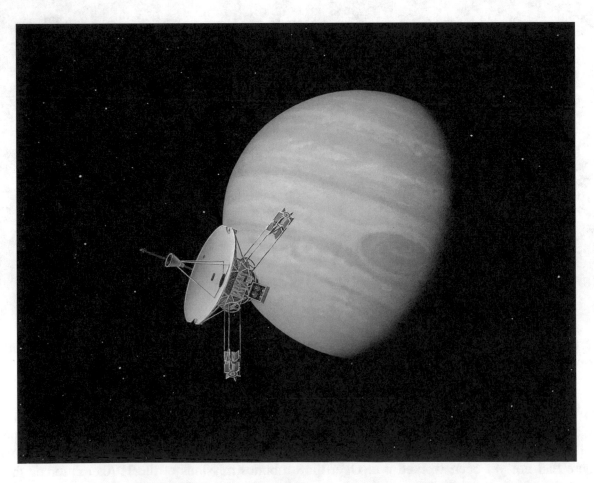

Fig. 5.12 *Pioneer 10 at Jupiter* by Don Davis, FIAAA

A specialist in visual effects, Davis created planetary texture maps in the 1980s for use in the Jet Propulsion Laboratory's computer graphic simulations of Voyager flybys. He also contributed to the 1977 NASA Space Settlement design study produced in conjunction with Stanford University and Princeton physicist Gerard O'Neill.

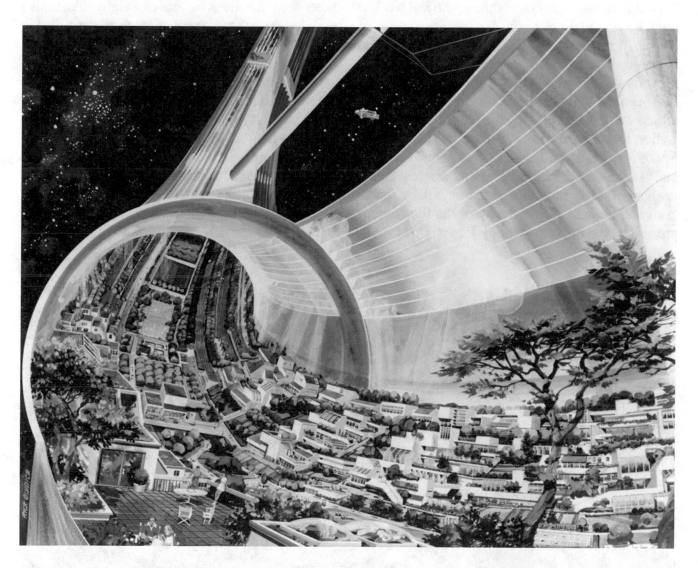

Fig. 5.13 *Space Torus Cutaway* by Rick Giudice and Don Davis, FIAAA

While the genre of space art has boomed since the 1960s, with scores of artists, both amateur and professional, contributing to the field today, there are several whose work has bridged the transition from pre-spaceflight to the era of space exploration. Don Dixon is another IAAA space artist whose career began during the first years of space exploration, with his first astronomical art being sold in the early 1970s. He began his career as an animator, depicting NASA's early missions to the planets. Dixon has also created cover and interior art for numerous magazines, such as *Scientific American*, *Astronomy*, and *Sky and Telescope*. He has also been a prolific contributor to science fiction, with cover art for *The Magazine of Fantasy & Science Fiction* as well as novels such as Kim Stanley Robinson's *Mars* trilogy. In 2006 he directed and co-wrote the immersive animated film *Centered in the Universe*, which premiered at the Samuel Oschin Planetarium at the Griffith Observatory, where Dixon has served as Art Director since 1991. Like many other space artists with long-lived careers, his first work was created in traditional media, oils and acrylics, while today his illustrations are mostly digital.

While John Frassanito may not strictly be a space artist, his work – and the work of his associates – is certainly familiar to both space enthusiasts and the general public, even if his name is not. An industrial designer by training who had worked with Raymond Loewy on the interior design of Skylab, Frassanito founded his own firm in San Antonio, Texas, in 1975. A few years later he moved to Houston in order to be closer to one of his primary clients, the Johnson Space Center, which was then developing the design for the space station Freedom, the precursor of the International Space Station. In the decades since, John Frassanito and Associates has contributed to the conceptual designs of a large number of future NASA spacecraft and habitats. While many of the illustrations created by the firm are done by Frassanito himself, he also depends on a staff of talented illustrators and animators.

Among living space artists, IAAA member David A. Hardy has likely enjoyed the longest running career and functions as an especially illustrative segue between the two eras of space art described in this chapter. Hardy started working in this genre before the advent of the first Earth satellites, and continues today in a time of probes to planets, moons and other bodies. Born in 1936, Hardy produced his first space art at the age of 14 and illustrated his first book – *Suns, Myths and Men*, with Patrick Moore – in 1954. He would become a frequent collaborator with Moore, working with him to illustrate projects like *The Challenge of the Stars* (1972), as well as the immensely popular and long-running BBC television series, *The Sky at Night*.

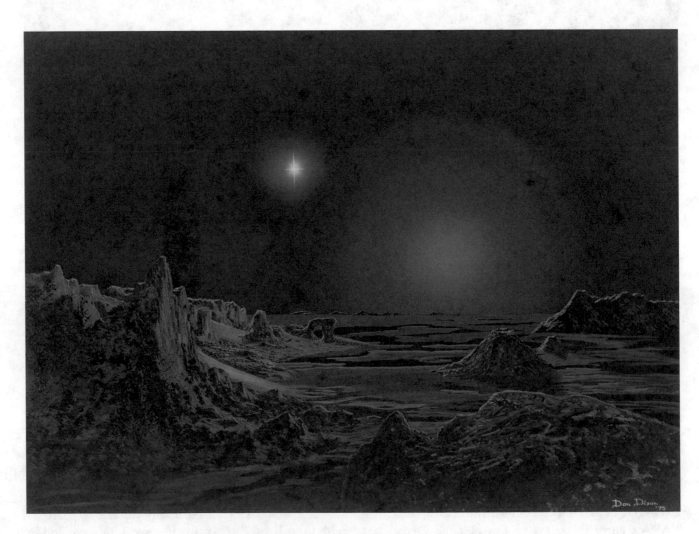

Fig. 5.14 *Zeta Aurigae* by Don Dixon, FIAAA, 1975.

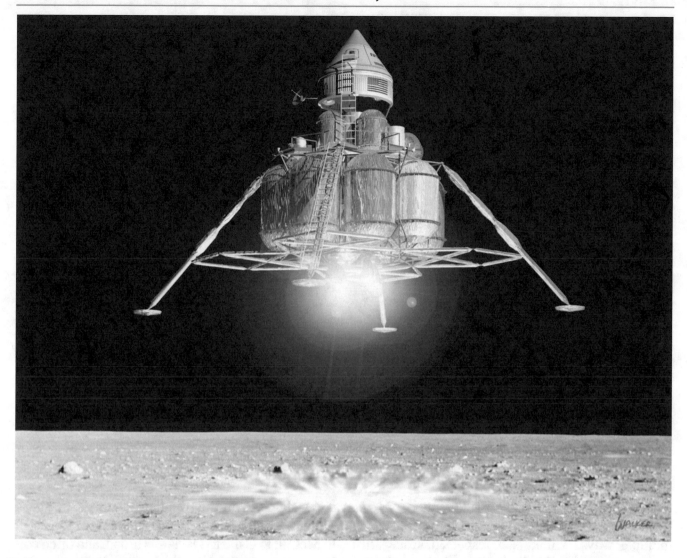

Fig. 5.15 Concept art of possible lunar exploration program. Image produced for NASA by John Frassanito and Associates for NASA's Planetary Projects Office (PPO), Johnson Space Center (JSC), NASA image S92-38479

Dr. William K. Hartmann is another space artist, also part of the IAAA, with a long career in art and science. Trained as a planetary scientist at the University of Arizona, Hartmann worked under Gerard Kuiper to develop new techniques for representing the topographical features of the Moon. Over the course of his career, Hartmann consistently combined his careful draftsmanship with his adeptness as a scientist. In fact, as Oliver Morton has pointed out,

Hartmann was one of the researchers responsible for the now widely accepted theory that the Moon was actually formed by way of impact collision. In 1981, Hartmann collaborated with Ron Miller on *The Grand Tour*, a book that enjoyed both broad circulation and lavish praise. The view of Mars as it was articulated in this volume was used as conscious reference material for the depiction of Mars in the DC comic book series, *The Watchman*.

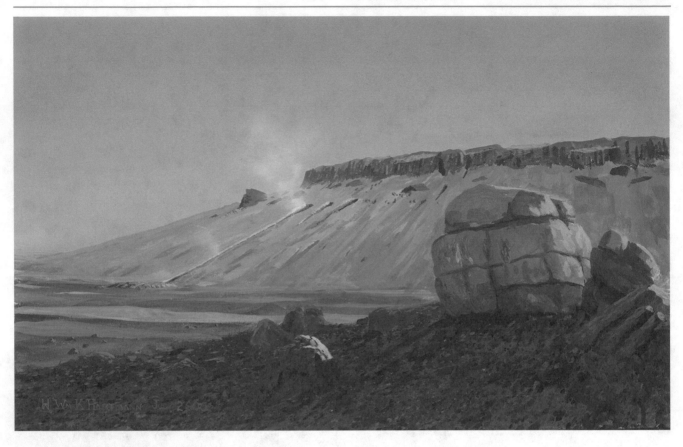

Fig. 5.16 *Mars Hillside with Water Vapor Release* by William Hartmann, FIAAA

Ron Miller, Hartmann's collaborator on *The Grand Tour*, has impacted the history of the field in multiple ways. Miller is a respected space artist that's cultivated a rich body of work, but he's also been instrumental in preserving its history; a prolific writer, Miller has published many books on the topic of space art and helped preserve the legacy of many of its foundational artists, including collaborating with Hartmann on four other astronomical art books, *Out of the Cradle* (1984), *Cycles of Fire* (1987), *In the Stream of Stars* (1991), and *The History of Earth* (1994). In 2001, Miller and Durant published the most thorough accounting of the career of Chesley Bonestell currently in print, *The Art of Chesley Bonestell* (2001). Miller has produced a lot of work in the genre of space art, but also thought critically about the historical parameters of it as a practice.

While "space art" does describe a wide body of work, it's one that should be of great interest to historians concerned with the intersection of culture and technology in the twentieth century. The scope of images outlined here – everything from Bonestell to McCall to Calle to Davis – is broad, and often collapses the superficial distinctions made between fine art and illustration. The coherence of the genre comes mostly from its subject matter, an area that itself underwent profound changes in the years between 1958 and 1975.

The next decade would also be one of critical importance. Television programs like *Cosmos* and *Star Trek* drew huge audiences, meaning work for those with experience representing cosmic landscapes. Nonprofits like The Planetary Society were founded as a response to large amounts of public interest in the future of space travel. By the early 1980s, those employed in the field of astronomical art had gained enough critical mass to form their own professional body, the International Association of Astronomical Artists (IAAA).

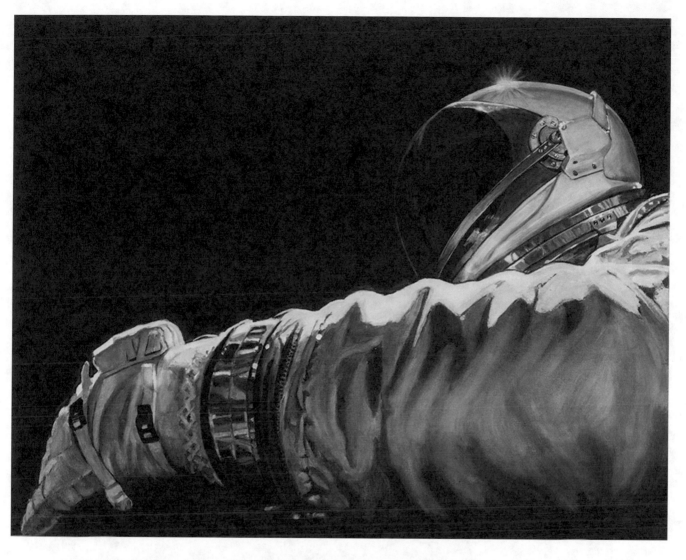

Fig. 5.17 *Gemini* by Simon Kregar

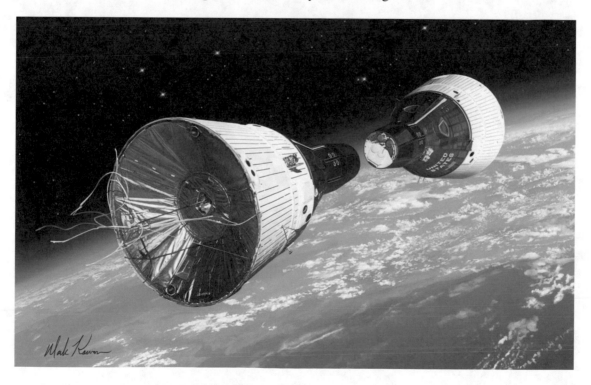

Fig. 5.18 *Gemini Rendezvous* by Mark Karvon

The Founding of a Guild

Kara Szathmáry, Ron Miller, and Jon Ramer

There is only one guild of artists in the world dedicated to creating art inspired by space: the International Association of Astronomical Artists (IAAA). This chapter tells the history of that organization.

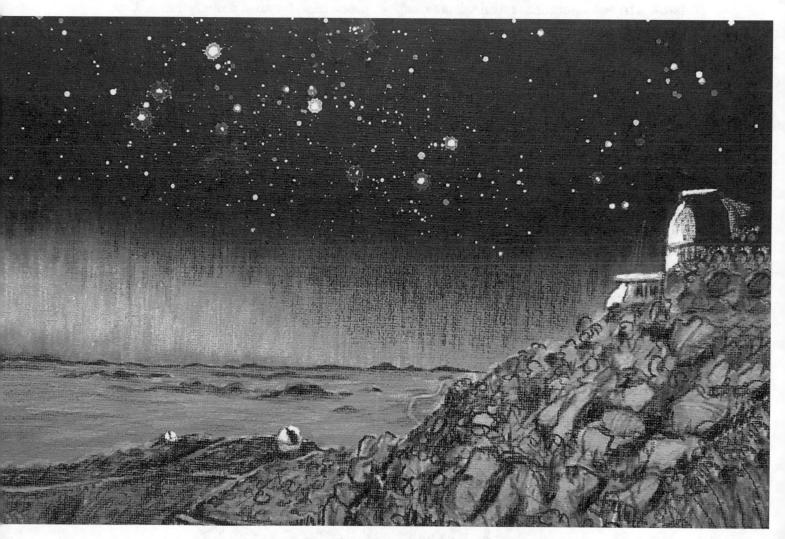

Fig. 6.1 *Kitt Peak Observatory #8* by Kara Szathmáry, FIAAA.

K. Szathmáry
Panama City, FL, USA

R. Miller (✉)
South Boston, VA, USA

J. Ramer (✉)
Mill Creek, WA, USA

© Springer Nature Switzerland AG 2021
J. Ramer, R. Miller (eds.), *The Beauty of Space Art*, https://doi.org/10.1007/978-3-030-49359-2_6

Throughout history, the sciences and the arts have shaped and expanded the thinking of humankind. As time passes, we become more and more creative in our use of tools and materials that allow us to express ourselves artistically. As a result, new styles of artistic expression are constantly evolving.

There is a long history of artist-naturalists in America. Perhaps the best known was John James Audubon and his illustrated series *The Birds of America* (1827–1839). Among the early American scientist-artists – or at least artists who had an interest in natural history – were Thomas Moran and Albert Bierstadt. They accompanied several scientific expeditions sent to explore the territories that eventually became Yellowstone and Yosemite National Parks. Both artists were part of a group that began in the 1880s and became known as the "Hudson River School," since many of its earliest practitioners were artists who specialized in depicting the landscapes that surrounded that river. Some of the most memorable images ever made of the Western American frontier were done by Moran and Bierstadt. Mt. Moran in the Grand Tetons was named in honor of the artist, who specialized in depicting the scenery of

Yellowstone and the local region. Many of the locations the pair painted later became protected national parks, due in no small part to the incredible popularity of their paintings. Some of these works were of enormous size. Bierstadt's largest, a painting of the domes of Yosemite, is 10x15 feet (3x5 meters). These paintings toured the eastern states like a road show might today. People flocked to see them by the hundreds of thousands, mesmerized by the incredible scenery which, up until then, had been accessible only through the wild descriptions of trappers and explorers. Moran and Bierstadt gave these places a visual reality in the public mind they had never before had.

The artists of the Hudson River School, such as Bierstadt, Moran, Frederick Church, and Thomas Cole, created a practical national fervor for images of wild and untamed distant lands, setting the stage for art from even more distant realms. The inspiration created by these artists drove people to want to see these places for themselves, and eventually, to protect them. Many have made the parallel argument that in the twentieth century, much of the inspiration to explore space was generated by the work of artists like Chesley Bonestell (see Chapter 3).

Fig. 6.2 *Saturn From Rhea* by Lucien Rudaux, 1937.

By the opening of the twentieth century, explorers had mapped the coastlines of every continent on Earth except Antarctica. Few places were left that were labeled "unknown." Telescopes were becoming ever more sophisticated and science was revealing more of the universe's secrets every day. It was thus only natural for humanity's exploring eye to look upward. Artists looked upwards, too, creating visions of the new lands being discovered in the universe.

The probes, landers, and satellites of the Space Age fed humanity's deep-seated desire to explore as massive amounts of scientific information on other bodies in the Solar System were sent back to Earth. This new data bolstered the development of modern space art.

Fig. 6.3 *Moonrock* by Lynn Perkins.

In 1981, a group of astronomical artists who had been involved in Carl Sagan's production of the *Cosmos* television series attended Planetfest, a convention sponsored by The Planetary Society. They were impressed by the mixture of art styles exhibited at the event, ranging from representational realism to outright science fiction. These artists got along famously, talking shop and sharing common interests about their expressive art styles. It was at this event that the idea was conceived for a space art workshop. The idea was to gather at some place in the world that had a geology similar to that of some other planet, in order to study the scenery and paint more believable extraplanetary landscapes.

The following year, 1982, Dr. William K. Hartmann organized the very first astronomical art workshop on the island of Hawaii. The group was enthusiastic about visually capturing the volcanic formations of the Big Island, since they were analogous to the mysterious geologies found on the Moon, Mars, and Jupiter's volcanic moon Io. The workshop was so successful that a second one was organized in 1983 by artist Michael Carroll to explore the barren landscapes of Death Valley, California, which shared many characteristics with the surface of Mars. There, in the hot analogue of Mars, the idea of creating a formal guild of artists dedicated to the genre of astronomical art was germinated.

Fig. 6.4 1983 Group Painting by William Hartmann, Don Davis, Don Dixon, Joel Hagen, Kim Poor, Marilynn Flynn, Michael Carroll, Pam Lee, Rick Sternbach, Robert Kline, Ron Miller, and Andy Chaikan. The IAAA has developed a tradition of all artists who attend a workshop contribute to a group painting inspired by the location of the workshop. This set of paintings was inspired by scenery around Death Valley in California.

Fig. 6.5 *Rigel Kentaurus Canyon* by Marilynn Flynn, FIAAA (top). Bottom is her source photo of Golden Canyon in Death Valley.

After the success of a second Hawaiian workshop, interest in creating a guild rapidly grew until the International Association of Astronomical Artists (IAAA) was formally registered in the state of California in 1986. The steering committee then elected its first president, artist Kim Poor. The newsletter *Pulsar* was launched as a means to keep the membership informed about what was happening at the organizational level, and another newsletter, *Parallax*, was created for the publication of information and techniques essential for rendering space art landscapes.

The new organization was a unique one. Perhaps its closest relatives might be the Guild of Natural Science Illustrators and the Association of Science Fiction and Fantasy Artists (ASFA). The former is a group of artists who specialize in "communicating **science** visually and clarifying scientific ideas," to slightly paraphrase its own self-description. But the membership of the IAAA went far beyond such a strict definition. An artist member of the IAAA needed only to be *inspired* by space or space flight. There was no restriction put upon *how* an artist interpreted the cosmos. It could be with the strict attention to accurate science of a Bonestell or Davis, or it could be wholly abstract impression. And this inspiration could be expressed in any medium, from oils to music. All that really matters is the *source* of the artist's inspiration. This mix of styles and approaches, amateur and professional, is one of the qualities that sets the IAAA apart.

Similarly, while some members of ASFA occasionally deal with space-related topics, there are few if any who specialize in them. As the name of the organization suggests, its members are almost exclusively illustrators who provide artwork for book and magazine covers and interior illustrations. As it describes itself, ASFA's "membership is made up of amateur and professional **artists**, art directors, art show managers, publishers and collectors involved in the visual arts of **science fiction**, **fantasy**, mythology and related topics." Like the Guild of Natural Science Illustrators, ASFA may welcome space artists but is not specifically focused on the inspiration of space and space travel on the arts.

When the IAAA first began to come together, there were but a scant handful of people working professionally as space artists. That is, artists who not only created space art for a living but did so almost exclusively. One result of this was that most of these artists either knew or knew of one another – one of the reasons it was relatively easy to create the first workshop. Once that core had been established it acted as nucleus, attracting both other professionals and, importantly, amateur artists who by and large had little idea that they were in fact part of a larger community. The IAAA also opens its doors to those whose interest in space art lies beyond creating it: for instance, art directors, collectors, and curators.

Largely because of the way it grew – from a kernel of devotees to an organization of several hundred members world-wide – the IAAA is unique. There is no other similar group simply because the IAAA absorbed virtually every potential member in the process of its growth. And, because space art is still a very specialized niche in the world of art, artists interested in depicting astronomical subjects tend to gravitate towards it.

Activities of the newly created guild increased and the group quickly became internationally known. In the summer of 1987, NASA hosted the fourth IAAA workshop at Johnson Space Center. With the chance to study firsthand the hardware used to explore space, the participants were treated to exclusive tours of the facility, including a space station mock-up and a Space Shuttle simulator. Workshop members, led by Apollo 12 astronaut and eventual IAAA Fellow member Alan Bean, were allowed to try on actual space suits and operate space station equipment. The attendees also heard addresses by astronauts Joe Allen and Jon McBride.

Fig. 6.6 *Return to Utopia* by Pat Rawlings, FIAAA.

A few months later, seven IAAA artists were invited to attend the Space Future Forum in Moscow at the USSR Academy of Sciences along with a contingent of astronauts and scientists. The event was part of the celebration of the 30th anniversary of the launch of Sputnik. The artists brought some of their artwork with the idea of participating in a joint exhibition with their Soviet counterparts. During this time, The Planetary Society initiated a collaboration between American and Soviet astronomical artists by inviting the Cosmic Group of the Soviet Union of Artists to attend a workshop in Iceland in the summer of 1988.

The first genuinely international space art workshop was attended by 33 artists from countries around the world including the US, USSR, Canada, and Great Britain. With the Planetary Society's sponsorship of the Cosmic Group of the Soviet Union of Artists, the historic joint venture enabled a group of like-minded artists to rise above political ideology and transcend borders. For two weeks they explored and studied exotic terrains of fire and ice, volcanism and glacial ice fields, creating as they went not only

science-based art about other planets and moons of the Solar System, but also a special friendship among the artists of the several different nations.

The success of the venture lead to a five-year agreement between the IAAA, The Planetary Society, and the Cosmic Group to hold joint workshops in Senezh, Russia; Moab, Utah; and Ghost Ranch, New Mexico. These were to include group exhibitions in Moscow, Kiev, Europe and the US, culminating in an art show at the Smithsonian National Air and Space Museum in Washington, DC.

Since these beginnings, workshops have been held in exotic locations around the world nearly annually, starting with the east slopes of California's Owen Valley in 1996, where the landscapes resembled those of Iceland and Mars, then on the volcanic island of Tenerife in the Canary Islands, which brought together astronomical artists from the US, Great Britain, Germany, Belgium, and France. Mount St. Helens in the state of Washington was selected because it featured large lava tubes, wondrous lava flows, and eerie blast zones. NASA hosted another hardware workshop to Kennedy

Fig. 6.7 *A View of Venus in the Wind* by Kara Szathmáry, FIAAA.

Space Center where the participating artists photographed, drew, and painted at locations throughout the Center, including the International Space Station complex. Workshop participants were invited to display their art beneath the Saturn V rocket in the Visitor's Center while thousands of visitors streamed by. The exhibition attracted many curious observers wanting to learn more about the IAAA, view the artwork, talk to the artists, or simply marvel at the creativity on display.

Fig. 6.8 *Origins of Life on Mars* by William Hartmann, FIAAA, painted during a workshop at Yellowstone National Park.

Fig. 6.9 View of hot springs in Yellowstone National Park taken while William Hartmann was painting, photo by Jon Ramer.

The group went back to its roots with a workshop meant to paint and retrace the footsteps of Thomas Moran and Albert Bierstadt: Yellowstone National Park in Wyoming. More than two dozen artists spent a fantastic week hiking and painting "en plein air," viewing massive canyons, giant waterfalls, and erupting geysers. The next few workshops alternated between hardware-centered and landscape-centered locations. At the two ends of the spectrum, IAAA artists were able to tour the inner circle of ancient Stonehenge and the rugged coastline and impressive rock formations of the Dorset coast in the United Kingdom followed by visit to the Stevenage division of Astrium, one of Europe's foremost aerospace manufacturers.

The Mars-like canyons, salt flats, rugged hills, and cinder cone formations of Death Valley, California drew the group back for another visit, followed by a trip to Nicaragua to see the bright, lava-filled calderas of volcanoes in Masaya Volcano National Park and the Somoto Canyon, an enormous 650-feet deep geological formation that flanks the Rio Coco River. Then it was off to paint in more exotic terrain amongst the red, ochre, gray, and magenta rocks of Utah's Capitol Reef and Bryce Canyon.

All of these adventures were certainly fun for the participants, but they also served an important purpose: the more the artists learned about what the scenery of other worlds might look like to a first-hand visitor, and how and why these landscapes look the way they do, the better their art became.

The southwestern United States has not only many analogues to other worlds, but also unique technological sites. As has already been suggested, IAAA workshops have focused on not just studying alien geology but also learning about the technology needed to explore other worlds in space. At the Kitt Peak Observatory near Tucson, Arizona

Fig. 6.10 2005 Death Valley Workshop strip painting by Kara Szathmáry, David A. Hardy, Joel Hagen, Dan Durda, Robert Kline, William Hartmann, Michael Carroll, and Pam Lee.

Fig. 6.11 2007 Nicaragua Workshop strip painting by William Hartmann, David A. Hardy, Betsy Smith, Bettina Forget, Mitch Bentley, and Kara Szathmáry.

Fig. 6.12 2016 Biosphere II Workshop group painting by Erika McGinnis, Jim Scotti, Theresa Hentz, William Hartmann, Marilynn Flynn, Jon Ramer, Earl Billisk, Reid Silvern, Mark Pestana, Michelle Rouche, Rick Sternbach, and Aldo Spadoni.

1 *(signature)*
2 Eric *(signature)*
3 *(signature)*
4 *(signature)*
5 Willie K Hartmann
6 MARK PESTANA
7 *(signature)*
8 Earl Bathurst
9 Reid Silvern
10 Mark Pestana
11 Michelle Rouch
12 Rick Sternbach
13 ALDO SPADONI

Fig. 6.13 *Selfie* by Aldo Spadoni, FIAAA. A humorous self-portrait taken at the Barringer Meteorite Crater workshop with members of the IAAA in the background, all of whom are "too busy painting" to see the obvious....

Fig. 6.14 *Eclipse Over Idaho* by Erika McGinnis.

IAAA artists were given access to the facility's telescopic equipment and got the chance to directly observe many of the astronomical phenomena they often painted. This workshop culminated in an art show – Visions of the Cosmos – at the Kuiper Atrium of the Lunar and Planetary Laboratory of the University of Arizona. From Flagstaff, Arizona, artists explored the south rim of the Grand Canyon, the Barringer Meteorite Crater, the red rock canyons of Sedona, and the Lowell Observatory, from where Pluto was discovered. And just north of Tucson, a group of IAAA artist-explorers had the delight of spending a week at the fantastic Biosphere II facility, where they were permitted behind-the-scenes access. They studied the replicated rainforest, prairie, swamp, farmland, desert and ocean habitat regions of Biosphere II in order to paint and photograph what it might be like to live in the sealed, terrarium-like environment of a starship or space colony.

Fig. 6.15 Photograph of Total Solar Eclipse of 2017 by Dan Durda, FIAAA. Note the solar prominences in the photo.

Fig. 6.16 *Wide Binary* by Dirk Terrell, FIAAA.

Tenell

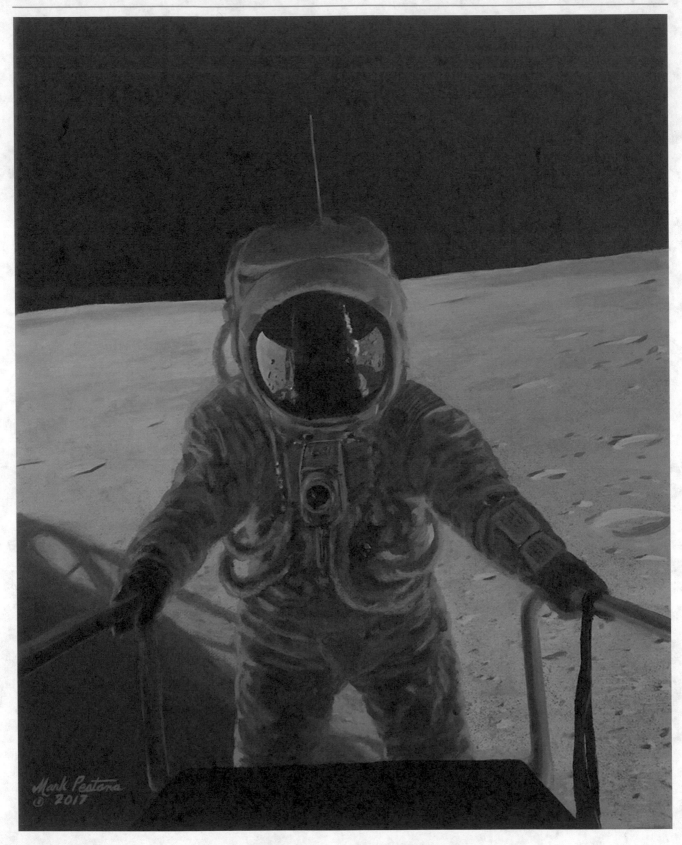

Fig. 6.17 *The Moonwalker* by Mark Pestana.

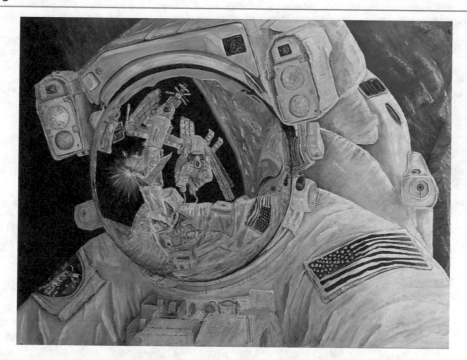

Fig. 6.18 *Perspective* by Ron Garan.

Whenever there is a significant astronomical event, IAAA members often gather to study it. The Great Solar Eclipse of 2017 was the perfect reason to not only see a total eclipse, but to also visit the Craters of the Moon National Park and the City of Rocks State Park in the state of Idaho. There are good reasons why the park is called "Craters of the Moon" – its rugged landscape of ancient volcanic craters resembles the surface of Earth's satellite – and space artists wanted to go there for the same reasons NASA sent Apollo astronauts to rehearse lunar exploration. Future workshops will visit the rock formations west of the Grand Canyon and to witness total solar eclipses in Chile, South America, and Texas.

Public interest in space art grew so rapidly that the IAAA eventually created a series of themed exhibitions that were displayed at over two dozen venues within the span of ten years. At the same time, Kim Poor launched the first convention dedicated to space memorabilia and art. Called "Spacefest," the event was attended by astronauts from every US space flight era, including Buzz Aldrin and Alan Bean. That first convention had nearly a thousand linear feet of hanging space and included a large work area where several artists produced works during the conference. The number of astronomical artworks exhibited has continued to increase at every convention since. Spacefest

conferences are usually held annually in Tucson, Arizona.

Of the multiple billions of people who have ever lived, only twelve have walked on the surface of another world, and fewer than a thousand have seen our home planet from orbit. But out of that exceedingly rare group of people, five of them have also been artists – and four of those are or have been members of the IAAA: Alexei Leonov, the cosmonaut who made the first spacewalk in March 1965; Apollo 12 astronaut Alan Bean, who was an IAAA Fellow; Ron Garan and Nicole Stott, NASA astronauts, both of whom spent several months on board the International Space Station (ISS); and cosmonaut Vladimir Dzhanibekov, veteran of five Soyuz missions.

Leonov was the first traditional artist to travel in space and often transformed pencil sketches done in orbit aboard his flights into finished paintings. He also often worked in collaboration with Russian space artist Andre Sokolov. The latter would prepare sketches of regions of Earth seem from space. Leonov would take these with him into orbit and make notes on the sketches where they differed from what he saw. Sokolov would then take these revised sketches and create finished paintings from them. Leonov's art has been displayed all over Russia as well as at the National Air and Space

Fig. 6.19 Astronaut Nicole Stott painting onboard the ISS. Photo by Bob Thirsk.

Fig. 6.20 *The Wave* by Nicole Stott.

Fig. 6.21 *Voskhod 2* by Alexei Leonov.

Fig. 6.22 *Collision Course* by Tariq Shaar.

Museum in Washington, DC. Bean was an accomplished artist who specialized in images of his and his fellow Apollo astronaut's experiences on the Moon. His works are highly sought after and hang in museums and galleries around the world. He was the first NASA astronaut to retire to full-time work as an artist. Garan paints in oils, creating works inspired by the perspective he experienced while in orbit. His goal is to share not only his experience of living and working in space but also the awe-inspiring emotion he felt. His art stems from a deep desire to share what he calls the "Orbital Perspective" with as many people as possible.

Stott was the first artist in history to paint with watercolors in space. She brought a small watercolor paint set with her on her first mission to the ISS and painted an image she saw through the ISS window of Isla Los Roques, a small chain of islands off the northern coast of Venezuela that she thought resembled a wave. This painting, titled *The Wave*, is now on display at the National Air and Space Museum. According to Stott, there were a lot of unique and fun things about painting in microgravity:

Everything floats (including you), so you have to be very organized with all of your stuff. Instead of a cup of water to dip your brush into, you squirted little balls of water out of the straw of a drink bag. The balls seemed attracted to the tip of the brush (which was donated by Ron Wood) – not sure if it was micro-g surface tension related or maybe some kind of static or charge thing – and they floated around on the tip of the brush instead of mixing with the bristles. If I touched the tip of the brush to the paper, the paper would absorb all of the ball of colored water at once, so the technique involved lightly dragging the ball of colored water along the paper. Pretty cool because you could see the separation between the paper and the tip of the brush that was gapped by the colored water as it was dragged along.

Each of the artist members of the IAAA provide their own perspective on humanity's initial steps off of our home world. Eventually, humankind will make permanent colonies on the Moon, Mars, and other worlds. We will no longer be restricted to a single home as the ancient urge to explore pushes us farther and farther into the cosmos. And as we explore those distant vistas, our innate desire to express our imagination and create works of art will go with us. In some far distant future, art depicting the wonders of our cosmos will be the most important genre of all – and the IAAA will be part of that history.

Patrons of the (Space) Arts

7

Steve Hobbs

Historically speaking, art has almost always been created for someone or for a specific purpose. Like everyone else, artists need to eat, and so their sponsors and patrons often play a critical role in the creative process.

Fig. 7.1 *Curiosity Climbs Mt Sharp* by Steve Hobbs.

S. Hobbs (✉)
Queanbeyan, Australia

© Springer Nature Switzerland AG 2021
J. Ramer, R. Miller (eds.), *The Beauty of Space Art*, https://doi.org/10.1007/978-3-030-49359-2_7

Fig. 7.2 *Tail Star Above Rotterdam* by Lieve Verschuier, 1680, image # 11028-A-B, courtesy Museum of Rotterdam. The scene was painted by the Dutch artist after the famous sighting that year of Kirch's Comet.

Almost from the very beginning, artists have depended upon patrons in order to work. The lucky artists who could survive on the sporadic sale of their work were all too rare. For the rest, it was necessary to find some entity who would be willing to support them, giving them the freedom to work – though often, if not usually, that "freedom" meant providing the art the patron demanded. Sometimes these patrons took the traditional form of royalty, governments, or the wealthy, who had the wherewithal to support the arts, and sometimes patronage took more subtle forms. For example, when a book or magazine publisher commissions an illustration, they are very much acting in the role of a patron.

By the time of the Renaissance, commissioned artwork reflected a patron's education, power, and political influence. Artwork was used to bolster the patron's authority and display their affluence. This heavily impacted the subject matter being painted, which when not of portraits of the patron and family, largely focused on religious themes until about the 1500s, when scenes from non-Christian mythology began to gain acceptance. Regardless of subject matter, the system of patronage worked both ways. If being able to commission and display spectacular works of art reflected well upon the patron's status, an artist's status could likewise rise from an unknown craftsman to a gifted, sought-after creator – and they could raise their fees accordingly.

As telescopes came to the scene in the early 1600s, early astronomers such as Galileo Galilei began sketching what they saw. Since photography would not be invented for another two centuries, sketches, woodcuts, and, later, paintings, began illustrating the newest, most detailed depictions of the Solar System's bodies. Galileo published his sketches in a series of books, which, thanks to the recent invention of the printing press, meant that many others besides the artist had an opportunity to see his work. The introduction of a new profession – the publisher – created a new market and a new type of patronage for the artist.

As knowledge of the solar system increased, authors began writing about what would be involved to actually fly to other places in the Solar System. One of the most famous of these works was Jules Verne's *From the Earth to the Moon* (1865) (see chapter 3). Verne's publisher, Hetzel, was the patron who commissioned illustrators Emile Bayard and A. de Neuville to create space art depicting a manned lunar trip. Other artists illustrated subsequent early science fiction books about journeys into space, such as Paul Philippoteaux's images in Verne's *Off on a Comet* (1877) (see figure 3-4), George Roux's illustrations for André Laurie's *Conquest of the Moon* (1887), and George Griffith's *A Honeymoon in Space* (1901), illustrated by Stanley Wood. The illustrations to Laurie's novel even included figures wearing spacesuits. These images inspired the public to feel that not only did the cosmos possess real places, but that someday, advanced technology would allow for their exploration.

Fig. 7.3 *BIS Moonship Leaves Earth* by David A. Hardy, FIAAA.

Probably the major patron of space art between the turn of the last century and the onset of World War II were the pulp magazines – if by "space art" one includes ray gun-wielding women in brass bikinis fighting off tentacled monsters on one of Saturn's moons. Still, there were scores of these magazines devoted to science fiction alone, the first, *Amazing Stories*, hit newsstands in 1926. Its popularity inspired many other publishers to follow suit and by the time the war broke out there were nearly thirty different titles. Most of these were published monthly and all of them required both covers and interior illustrations. Certainly not all of these depicted anything relating to space travel or astronomy, and there was also just as certainly a wide range in artistic ability displayed. Some artists took considerable care to make their paintings and drawings as reasonably accurate as they could – given the current state of the art of astronautics – while others were more interested in creating something exciting and flashy. But there *were* rockets and spaceships and there *were* scenes on distant worlds of this Solar System and others, however they were depicted. Literally thousands of them. Some of the artists became as well known to readers as the authors: names such as Frank R. Paul (who created the first color rendering of a space station to be published in the United States), Virgil Finlay, H.V. Brown, and Earle K. Bergey, among a score of others. And their artwork was immensely exciting and immensely inspiring to the young readers who had been reading about the achievements of Robert Goddard and the German experimenters, about which science magazines such as *Popular Science* and *Science and Invention* were publishing regular reports. Here, on one hand, were the brave explorers of the future and here, and on the other hand, were those scientists and engineers who were working to make it happen.

But without the patronage of the pulp publishers, this inspiration would have never occurred and the artists themselves – in a time when the nation was only just beginning to recover from a devastating depression – would have had to find other work. Some, if not many, may have had to abandon art entirely.

Following the end of World War II, increasingly advanced rocketry finally made it possible to launch objects out of the Earth's atmosphere. For the first time, science fiction dreams of exploring the Moon and other planets could be practically realized, heralding the start of the Space Age. Spaceflight, though, was – and remains – expensive. This cost had to be paid by someone. Just launching a rocket was not enough, as much of the financial expenditure needed to be paid up front long before the rocket ever saw a launch pad. Something else was needed, something to guarantee cash investment to pay for design, build, test and finally launch a space mission. Groups of people needed to be sufficiently motivated to part with hard-earned cash that could have been spent on other pursuits. Space art was instrumental in this inspiration, just as the artists themselves were inspired in large part by the prospect of lucrative commissions from both the government and private industry.

Artwork depicting crewed missions to the Moon and other locations around the Solar System, created by artists either side of the Iron Curtain, inspired the public to imagine that such spaceflight was possible. This added to the momentum that lead to the launch of Sputnik from the Soviet Union and the creation of NASA in the United States. The new space agencies became patrons for space art, using it to promote the promise of space exploration as the future of humanity.

Book and magazine publishers continued to be important patrons of the blossoming genre of space art, just as they had been in the nineteenth century. *Collier's, Life, Coronet, Pix, Popular Science* and *Mechanix Illustrated* were among the popular magazines that commissioned artists such as Chesley Bonestell to illustrate non-fiction articles about space flight. The respected *National Geographic* also commissioned space art to illustrate astronomy and spaceflight articles, the earliest being Charles Bittenger, who provided eight paintings for an article published in 1939. Pierre Mion provided technical work on a 1964 article about the first crewed landing on the Moon; Douglas Chaffee worked with Carl Sagan on a painting depicting hypothetical Martian life for an article in 1967; and Ludek Pešek took readers on an imaginary journey across the Solar System in 1970. Lavishly illustrated books and magazine articles aimed at inspiring the next generation of space explorers exploded in popularity between World War II and Sputnik.

Fig. 7.4 *Other Worlds in Space* by Terry Maloney.

Fig. 7.5 *Voyager at Jupiter* by Mark Pestana.

Like many other arts, space art was affected by the arrival of digital technology. Around the time digital photography was becoming mainstream, rendering and visualization software matured enough for artists to create near-photographic quality images of the cosmos. For some this change was about saving time; before the change artists were painting futuristic subjects using the same media that had been used for centuries. As with photography, the opportunities for new creators of space art vastly increased. Digital software allowed for realistic animation, bringing space art into the domain of entertainment.

Hollywood had used paintings of space scenes as backdrops in movies and television shows for years – such as the Bonestell-designed lunar backdrop in *Destination Moon* (1950) or the otherworldly landscape of Altair 4 in *Forbidden Planet* (1956) – and even in animation, as in the Disney "Man in Space" series. Digital software gave artists the ability to quickly render highly detailed and scientifically accurate extraterrestrial scenes. And these scenes no longer had to be static, as

were the old Hollywood cycloramas. This new scenic art could be moved around in, providing directors with an unprecedented realism. As a result, documentaries and television shows became amenable to including space art to enhance their content, in effect becoming the modern-day patron and developing another market for the genre.

Some artists have specialized in creating space art animation, filling a gap that current spacecraft sensors are unable to achieve. At present it simply requires too much bandwidth and power for spacecraft to shoot live video; even the Curiosity Mars descent video had to be stored on board and painstakingly transmitted well after the landing event. Videos are particularly useful in visualizing how a spacecraft might operate *in situ* for these reasons, or illustrating environments where imaging sensors would be destroyed. An example would be animating scenes deep within the atmospheres of gas giants of our solar system, where temperatures and pressures would crush and vaporize anything currently on NASA's drawing boards.

Fig. 7.6 *Exploring Jupiter* by Ron Miller, FIAAA.

NASA and other space agencies have become significant patrons of this new form of space art, particularly during mission design and development. Engineering drawings have come to life on the artist's digital canvas, and such still or animated artworks help engineers and the general public "see" how a planetary mission would unfold in other parts of the solar system. Very occasionally, an artist might even assist with the design of the mission itself. This occurred during the development of the UK Beagle 2 Mars lander mission.

While using 3D software to illustrate Beagle 2's landing and deployment sequence, the firm hired to create images of the probe, Denman Productions, realized that some of Beagle 2's subsystems would not physically fit inside the lander as designed. Consultation with the mission engineers brought about necessary subsystem redesigns, showing that artwork can directly influence the design of a mission.

Aerospace industries also took advantage of the promise of space flight. Starting in the early 1950s, Grumman, Boeing, Lockheed Martin, Convair, and other corporations commissioned paintings and drawings by freelance and in-house illustrators to advertise their image to the public. Flights around and even to the Moon seemed a possibility for commercial providers, and magazines advertised aerospace industry art. These advertisements from the '50s and '60s were in part to enhance their public image but mostly to sell themselves to prospective government sponsors. In current times, versions of this process continue, with concept art from dedicated space companies such as SpaceX and Blue Origin on display in conferences and on websites.

Space artists are often directly involved in space exploration when they generate artwork for mission proposals. The proposal can be to illustrate a complete mission or, as in the case of the Mars 2020 rover, just instruments carried on board a larger craft. In this instance, the patron is the proposal designer, and the artwork may be the vital piece that makes the concept more attractive to the space agency for acceptance. There can be significant benefits of being part of the patronage process of designing, illustrating, and "selling" the mission to the public.

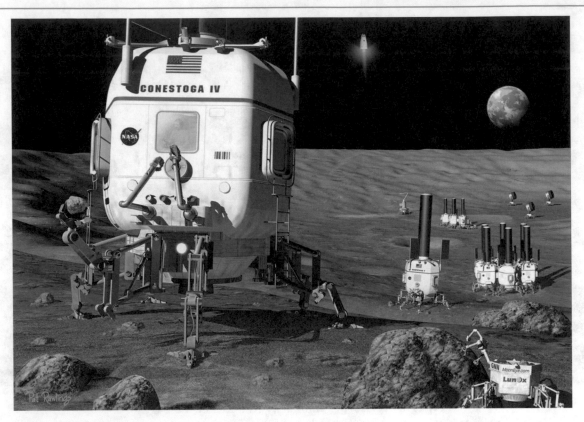

Fig. 7.7 *Conestoga Habot* for NASA by Pat Rawlings, FIAAA.

Digital art, like photography before it, has allowed a creative outlet for many more participants who did not see themselves talented with paintbrush or easel. Many of these new artists brought other industry skills, such as computer aided design and rendering to the art world. One obvious downside to the digital art revolution is increased competition. As more artists turn out computer-aided artwork, at a rate that outpaces traditional media, the "perceived" value of artwork has dropped. Many emerging artists have sold their work at rock bottom prices, or even contributed works for free, in order to break into the field. This can further add pressure on professional artists, where client expectations of cheap or free space art have increased. Additionally, as some artists have found to their cost, some potential patrons do not perceive digital art as "real" art. Accusations of the computer doing all the work or creating sterile art often discourages hopeful artists wishing to display their works at a local gallery.

Despite the opposition of these folk, there are numerous magazines dedicated to science and astronomy, such as *Scientific American*, *Astronomy*, and *Sky & Telescope*, who actively patronize space art and accept both digital and traditional artwork. As astronomic discoveries are made and astronomers generate articles, these magazines typically need accompanying illustrations. Many of these discoveries are impossible to photograph, such as closeups of colliding black holes, and the skills of the space artist are called on. Artists regularly work with magazine editors and work to tight publishing deadlines. Other magazines will contact artists through a web search and still others will source work the artist has placed in a stock image library. Personal preferences on the editors' part dictates how the work will be created, ranging from the artist having a free hand to tightly directing the format and layout of the art. Cover art often falls in to this latter category, where space needs to be made for text layout.

Fig. 7.8 *Gliese 581e* cover of *National Geographic*, 5 October 2009, by Dana Berry.

Not only do magazines frequently use art to illustrate new concepts, they also show art for the sake of the art itself. Over the years, almost every single science and astronomy magazine in print has published extensive articles on the genre of space art complete with a gallery of amazing works. These issues are almost always the most popular and best-selling issues of the year.

Perhaps the most diverse form of a patron of the arts are artists committing works to space itself.

Some of these works were commissioned, others were freely created for all of humanity to be the patron. In a twist on traditional methods of creating artwork to be viewed by people of Earth, some artists have created work specifically for viewing in space. An example is *The Cosmic Dancer*, a three-dimensional sculpture launched to the MIR Space Station in 1993. Free from the bonds of Earth's gravity, the sculpture was able to float freely, to be oriented and admired at any angle.

Fig. 7.9 *Cosmic Dancer onboard the MIR Space Station* by Arthur Woods.

Some artwork has left Earth's orbit entirely, unlikely to be seen by anyone alive today. Little more than a decade after the start of the space race, the Moon Museum, the development of which was patronized by the non-profit group "Experiments in Art and Technology," was sent to the Moon. The tiny ceramic plate featuring engravings from six art-ists of the 1960s, Robert Rauschenberg, David Novros, John Chamberlain, Claes Oldenburg, Forrest Myers and Andy Warhol, hitched a ride to the Moon on Apollo 12. *The Fallen Astronaut*, an aluminum sculpture of a human figure by artist Paul Van Hoeydonck and commissioned by Apollo 15 astronaut Dave Scott, was left on the Moon in 1971.

Fig. 7.10 *Fallen Astronaut* by Paul Van Hoeydonck.

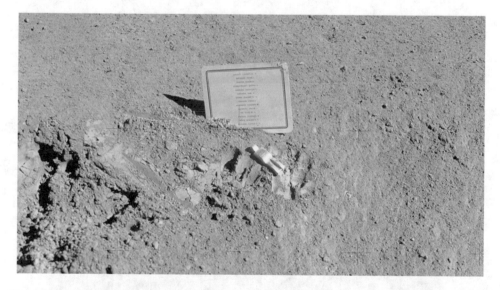

Fig. 7.11 Fallen Astronaut sculpture on the Moon, NASA photo AS15-88-11894.

Artist Pam Lee has had artwork flown into space on shuttle flights and the MIR space station. Pam also got to send comment cards along with some of the art and asked astronauts to answer questions on the details of the image while in orbit, directly comparing her work to the view out the window to get feedback regarding what is "visible" to the human eye from space.

Fig. 7.12 *51L Terminator* by Pam Lee, FIAAA.

Fig. 7.13 Color calibration target designed by Damien Hirst, photo © David Johnson.

In 2003 Damien Hist became the first artist to have work land on the surface of Mars. Hirst's iconic dot art was to be used as a calibration target for cameras on board the Beagle 2 Mars lander. Unfortunately, the mission was never heard from again following preparation for landing, however,

subsequent Mars orbiter imagery showed the lander, containing Hirst's artwork, at least made it to Mars intact. The sponsors for this work were the spacecraft designers, who required controlled colors in order to calibrate imaging and remote sensing instruments.

Later that decade, The Planetary Society arranged to have a space-qualified DVD encoded with twentieth century Mars literature and artwork placed on the deck of the Phoenix Mars lander. Rick Sternbach's Mars-related artwork used to illustrate an *Analog Magazine* cover was among the selected artworks. The artwork, DVD, and Phoenix lander now rest near the Martian north pole, awaiting rediscovery by a future generation of explorers.

Fig. 7.14 *Velikovsky* by Rick Sternbach, FIAAA. Image launched on-board the Phoenix lander.

Fig. 7.15 *Phoenix Mars Mission* by Michelle Rouche.

In these latter cases of art in space the patron has deviated from the typical terrestrial-bound collector. While spacecraft designers or the space agencies are definitely patrons of space art, the placement of artwork on other worlds speaks to something deeper. Only a tiny fraction of Earth's population has travelled in space, whereas artwork from humanity is able to travel the cosmos. Just as artwork decorating the walls of the Egyptian pyramids and inside the great cathedrals of the previous millennia have long outlived the artists who created them, art committed to space adds orders of magnitude to the lifespan of the work. In theory, the art left on the Moon will endure for not just thousands, but hundreds of millions of years – or more. Creations sent out into the Solar System will outlast the Pyramids,

cathedrals, and all other earthly monuments. They will burn up in the swollen, dying Sun, along with everything else on the home planet. And art that travels beyond the Solar System will outlast our star itself.

Space-based artwork, resting on alien soils or floating through the cosmos may perhaps be the only evidence that human art ever existed. None of this art, none of these records of human creativity, would exist if it weren't for the patrons who sponsored it – those wealthy donors of the Renaissance, the publishers willing to pay the extra cost to insert illustrations in their books, the space agencies and contractors wanting to advertise and sell their efforts, the magazines and television shows wanting to entertain and educate, and the individual artist with a dream of illustrating the cosmos.

Fig. 7.16 An artistic expression often overlooked are patches worn by crew members of various space missions. Here are several space mission patches designed by Tim Gagnon (top row, ISS Mission 11, STS-133, and Shuttle Program Completion) and Mark Pestana (bottom row, STS- 89, STS-86, and STS-123).

How Artists Changed Our Perceptions

Jon Ramer

Art has always had an effect on the progress of human civilization, sometimes positive, and sometimes negative. Space art is no different, except that the scale of that effect is like the art itself – astronomical.

Fig. 8.1 *Earthrise* by Jon Ramer, FIAAA.

J. Ramer (✉)
Mill Creek, WA, USA

© Springer Nature Switzerland AG 2021
J. Ramer, R. Miller (eds.), *The Beauty of Space Art*, https://doi.org/10.1007/978-3-030-49359-2_8

Humans are amazing animals. We often compare ourselves to other creatures on our planet to try to define the "one thing that makes us different," but most of the time, that "unique" trait really isn't unique. Chimpanzees laugh, orangutans make tools, fish kiss, elephants cry, dogs dream, wolves socialize, ants wage war, termites build massive structures, dolphins talk to each other, birds sing, and crows not only have a higher brain-to-body weight ratio than humans but they can problem-solve almost as intelligently as people do.

So, what *really* makes us different? Truly, there isn't any one thing that makes humans unique on this world – it's *everything* – it's the cumulative effect of everything we can do that sets us apart.

The human brain is staggeringly complex, having approximately 86 billion neurons. Our nearest primate relative, the chimpanzee, has only 28 billion. The African elephant has about 257 billion neurons total, but only 5.6 billion of them are in the cerebellum, or the forebrain, where intelligent thought occurs. The human cerebellum contains about 16 billion neurons. We are unique in the makeup of our brains and what we do with them.

We imagine things about ourselves and the universe around us and we communicate those thoughts to others. We tell stories. We think in abstract ways, connecting disparate ideas via mental symbology. The mere act of reading these words shows that your brain has developed a symbolic representation of what each letter means, then can combine those letters into words and sentences in a complex structure thousands of symbols long. This structure communicates an abstract thought from the time and place the author created it to this very moment of you reading it. We process and communicate information in quantities and ways that no other creature we have ever encountered on Earth does.

As information-rich as letter symbols are, they cannot compare to the sheer amount of data that a simple drawing can convey. Picture the following in your mind: a black rectangle. Draw a line across the rectangle near the bottom and make everything below that line gray. Place a white crescent shape in the upper black section. Now place a bunch of small white dots randomly all over the black area. What does this image represent? Quite probably you are thinking a moon in the night sky (that is the intent!). It probably took you about 10 to 12 seconds to read and follow the above instructions. It took somewhat longer than that to write them. Yet if you were to look at the actual image as described, you most likely would have come to the same conclusion in a few tenths of a second.

Fig. 8.2 Drawing of crescent and dots.

Fig. 8.3 *Tunguska* by Don Davis, FIAAA.

Now imagine how many words it would take to describe a meteor falling to Earth. You need to describe the meteor, its size, its shape, its composition, the angle of entry into the atmosphere, its speed. What does the ground below look like? Time of day? Clouds in the sky? What effect does the passage have on the air. Or to the ground below?

It would take literally thousands of words to accurately describe such a scenario, even if you know the date is 30 June 1908 and the location is Tunguska, Russia. Thousands of words, several minutes of reading, and a massive amount of mental symbology to contemplate. Yet the scene and much of its scientific insights can be conveyed in an instant, with just a few strokes of paint.

Notice the curved line around the detonation in Figure 8.3. This represents the shockwave from the explosion expanding outward. Notice also how it is reflecting off the ground. This shock-wave is what caused trees to be flattened in a pattern radiating away from explosion in a 70-kilometer- (43-mile-) wide by 55-kilometer- (34-mile-) area long. The trees in the five-kilometer diameter zone of the reflection were stripped of leaves and left standing. You can see why this would occur in the image, because the shockwave came straight down from above. But in an even more amazing combination of science and art, examine the upper left of the image. Not only is the vapor trail left by the object as it entered the atmosphere clearly visible, but you can also see how the shock wave from the detonation is propagating back up that trial.

This image was hand-painted in 2008, five years *before* a meteor was seen by millions streaking across the sky and exploding over Chelyabinsk, Russia. The similarities between the artistic illustration of such an event and the later photographs of its reality are stunning.

Fig. 8.4 The Chelyabinsk meteor trail. Photo by Alex Alishevskikh/ESA.

Art can convey more than just vast amounts of information; it can also cause chemical reactions in the portion of our brain called the limbic system, which is key to our sense of self and the seat of our emotions. Some images can fill you with wonder, some can bring tears to your eyes. Some can be so pervasive and persistent that the collective human consciousness believes what is shown in the image, despite all evidence to the contrary.

As human technology advanced, we naturally turned our eyes to the wandering stars in the sky. In the late 1800s astronomers began to observe details on Mars and did what people naturally do – tried to give them familiar identities. Italian astronomer Giovanni Schiaparelli observed Mars during the opposition of 1877 and believed he saw features crisscrossing the planet. Being Italian, Schiaparelli gave them the Italian name of "canali" which in English means "channels." Because the Italian word "canali" sounds so similar to the English word "canal," which is an *artificially constructed* waterway, many assumed that the latter is what Schiaparelli meant. The misunderstood word "canal" stuck, and other astronomers quickly claimed to have seen these features too. Some even speculated that the canals were deliberately constructed waterways. Thus was born a flawed belief that lasted nearly 100 years.

Fig. 8.5 Map of Mars by Giovanni Schiaparelli, published by Camille Flammarion.

One astronomer who believed in the existence of such canals was Camille Flammarion, who was also an incredibly popular author (see Chapter 3). Over his lifetime Flammarion published more than seventy books and numerous magazine articles on a wide range of topics, but most about astronomy. Flammarion's works did more to popularize the subject of astronomy than any other author of his time. This is quite probably because his books were filled with amazing illustrations of what other worlds could look like up close. Mars, Venus, Jupiter, Saturn, the Moon, all were depicted by dozens of artists. His book *Les Terres du Ciel* (*Lands in the Sky*) is 800 pages long and has literally hundreds of illustrations covering every aspect of every celestial body known in the Solar System at that time.

Fig. 8.6 Four images from *Les Terres du Ciel*.

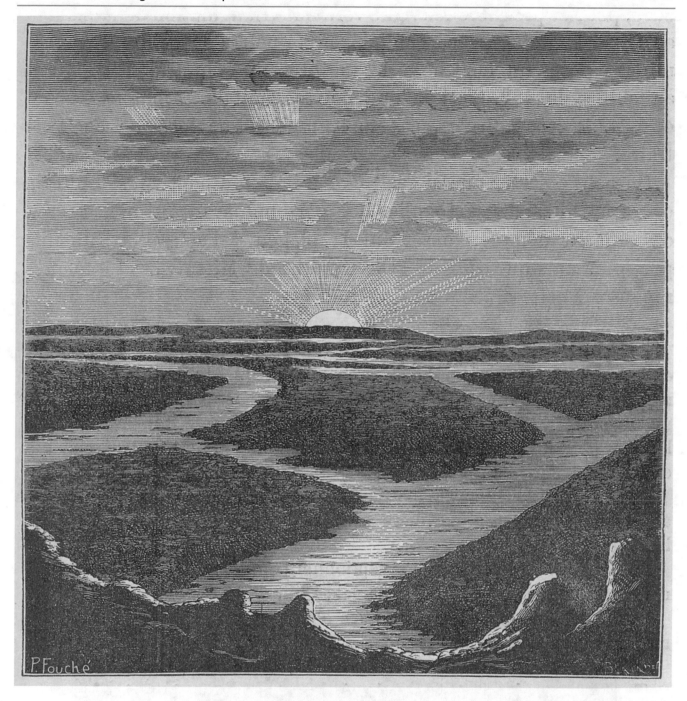

Fig. 8.7 Mars canals from *La planète Mars* by Paul Fouché.

Fig. 8.8 *Martian Life* by William R. Leigh from "The Things That Live on Mars."

Little is known today of many of the artists who illustrated Flammarion's books beyond their names – Paul Fouché, Motty, B. Lanapet, J. Blandet, C. Kemplen, and others – but there is no doubt they were artistic visionaries who created some of the first art of locations *not* on Earth. Flammarion was absolutely obsessed with the idea of life beyond the Earth, and almost all of his books emphasized the belief that life existed on all the worlds of the Solar System.

Flammarion's bestselling work was first published in 1880 as *Astronomie popularize* and again in 1894 in an English translation as *Popular Astronomy*. It too is replete with art and speculation about extraterrestrial life. After Schiaparelli's observations were publicized, Flammarion began studying Mars and came to believe the canals were real. In 1889, he published a book titled *Uranie*, in which he wrote extensively on how the canals of Mars had to be deliberate constructs of an ancient and dying civilization. Flammarion confidently claimed that Mars inhabitants, "... have straightened and enlarged the watercourses and made them like canals, and have constructed a network of immense canals all over the continents."

The idea that intelligent life could be living on Mars fired the imaginations of people around the world. In 1892 Flammarion published the most comprehensive book written to date about Mars, titled *La planète Mars et ses conditions d'habitabilité* (The planet Mars and its conditions of habitability). In this book Flammarion reported in detail every known observation made of Mars since the year 1636 and furthered his belief it was inhabited. He stated, "[I]t would be wrong to deny that [Mars] could be inhabited by human species whose intelligence and methods of action could be far superior to our own. Neither can we deny that they could have straightened the original rivers and built a system of canals with the idea of producing a planet-wide circulation system."

Several of Flammarion's books have drawings depicting what the canals of Mars could look like from the surface of the planet itself. *La planète Mars* is filled with maps and drawings of the extensive canal system made by numerous observers and was updated in 1901 and again in 1909. The book was immensely popular and positively enthralled thousands of people, including astronomer Percival Lowell.

Flammarion's enthusiasm about intelligent life on Mars paled in comparison to that of Lowell's. After reading *La planète Mars,* Lowell decided to become a full-time astronomer and study Mars extensively, especially the canals as drawn by Giovanni Schiaparelli. He established an observatory in Flagstaff, Arizona, specifically selecting the location for its frequent clear nights far from the light pollution of a city. For the next fifteen years Lowell observed Mars, making detailed drawings of the "non-natural features" he thought he saw. He published three books on his observations, *Mars* (1895), *Mars and Its Canals* (1906), and *Mars As the Abode of Life* (1908). More than any other astronomer/author – even Camille Flammarion – these books popularized the idea that Mars was the home of intelligent life.

Lowell described extensive features across the planet, including single and double canals and oases that changed with the seasons, all created by a desperate, advanced civilization trying to cling to life on a dying planet. The thought of life on other worlds truly excited the general public; newspaper and magazine articles discussing the possibility flourished. In fact, between the start of "Mars fever" with publication of Flammarion's book in 1892 and Percival Lowell's death in 1916, there were *over 160,000* newspaper articles printed across the United States that discussed canals on Mars.

For example, in March 1907, *Cosmopolitan* magazine (a very different magazine back then!) published an article by none other than H. G. Wells. Titled "The Things that Live on Mars: A description, based upon scientific reasoning, of the flora and fauna of our neighboring planet, in conformity with the very latest astronomical revelations," the article was a well-thought out, logical discourse on what life on Mars could be like across the varying ecosystems on the planet, and why they were that way. The illustrations by William R. Leigh are just as mesmerizing as the best space art of today. Another example: In May of 1907 the *Los Angeles Times* printed a full-page spread on how the Martian civilization distributed water from the polar ice fields across the planet. And yet another: In January 1915 the *Washington Herald* printed an article asking, "What do the Martians think of us now?", which suggested that an advanced Martian civilization looking down on Earth would disapprove of the warfare and violence being done all over the planet at the time.

Fig. 8.9 Article from the *LA Times*, May 5, 1907.

However, some in the astronomical field were not as fervent believers. By 1909 better telescopes began casting doubts on the existence of the canals. New techniques from new sciences and new observations showed Mars's atmosphere to be thin and mostly carbon dioxide, the ground temperature to be far colder than Earth, too cold to sustain liquid water. By the 1930s few believed the canals to be real. Despite these observations though, some still clung to the thought that Mars was the home to intelligent beings. Paintings of the canals continued to be created throughout the controversy. Even Chesley Bonestell painted a view of a Martian canal in 1954.

Fig. 8.10 *Canal on Mars* by Chesley Bonestell, 1954.

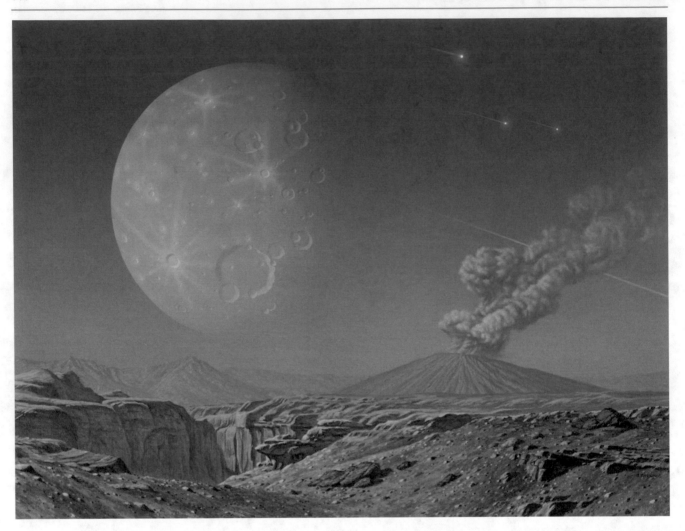

Fig. 8.11 *Early Moon* by Joe Tucciarone, FIAAA

It wasn't until the Mariner 4 probe returned photos of the surface of Mars in 1964 showing a crater-strewn surface similar to the Moon's that the nearly century-old dream of intelligence on Mars was finally quashed. This shows how powerful seeing something is to the human brain. A deeply held belief and well-crafted art images had swayed all of humanity's perception for generations. Some of the most influential stories in human history were spawned by this mistaken belief. H. G. Wells' *The War of the Worlds* has been in continuous print for more than 120 years, as well as having been made into several movies and infamously broadcast as a live radio show in 1938. Edgar Rice Burroughs wrote of canals on Barsoom (Mars) in his 1912 *A Princess of Mars*. C. S. Lewis depicted

a vast network of rifts on Mars filled with water, air, and life in his 1938 *Out of the Silent Planet*. Robert Heinlein's 1947 story "The Green Hills of Earth" described canals on Mars. And the 1950 classic *The Martian Chronicles* by Ray Bradbury was filled with artificial waterways built by ancient Martians. Even though the science behind Martian canals proved to be wrong, the concept and art depicting them made a lasting impression on human thought for good and bad.

Now, let's turn to changing depictions of an even closer celestial body: the Moon. The Moon has been in the sky since the formation of the Earth as we know it. Its very presence has had a significant impact on evolution of life on our world. It reflects light from the Sun and illuminates the

night, its gravity pulls on the oceans of Earth and raises tides, its drag has slowed the spin of our planet and created the 24-hour day we now enjoy. Yet despite its permanent presence in the heavens, we have only begun to truly learn about our companion in the past few hundred years.

Innumerable observers over the eons have made naked-eye drawings of the Moon, but it wasn't until the invention of the telescope in 1608 that true advances in our understanding of the Moon began. Galileo Galilei himself created some of the first lunar drawings done while looking through a telescope. The first map of the Moon's various maria, mountain ranges, and craters was created by Dutch cartographer Michael Florent van Langren in 1645. Two years later, Polish astronomer Johannes Hevelius created the first lunar atlas, titled *Selenographia*. Four years after that (1651), a Catholic priest from northern Italy named Giambattista Riccioli published *Almagestum Novum* in which he created the Latin nomenclature that is still used to this day for naming features on the Moon.

For as long as people have looked up, we've seen the same face of the Moon looking back. We now know that this is because the Moon is tidally locked with the Earth, i.e. it spins on its axis once each time it goes around the Earth, so we never get to see the far side. You might think this means that we've only seen half of its surface, but you would be wrong. Until the telescope was invented, we simply couldn't tell that the Moon goes through something we now call "libration." The Moon's orbit isn't a perfect circle – it waggles a tiny bit as it goes around the Earth. This orbital waggle lets us see a small sliver more of the Moon around the edges. Also, when you look at the Moon when it rises, you see a tiny bit more of one side than you do when it sets, as your perspective angle is different. In the early 1700s, these effects were finally measured, and because of them, we have been able to see 59 percent of the Moon's surface from Earth.

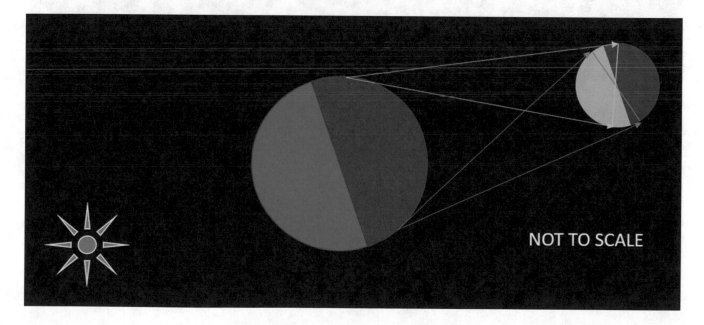

Fig. 8.12 Libration of the Moon.

As telescopes grew more powerful, more astronomers made more detailed drawings of the Moon. Eventually, the newly invented process of photography was turned to the Moon, and the first photo of its surface was successfully taken by British chemistry professor John W. Draper on March 23, 1840 at New York University. Sadly, that first image of astrophotography has been lost, but the image he took on March 26, 1840 still exists.

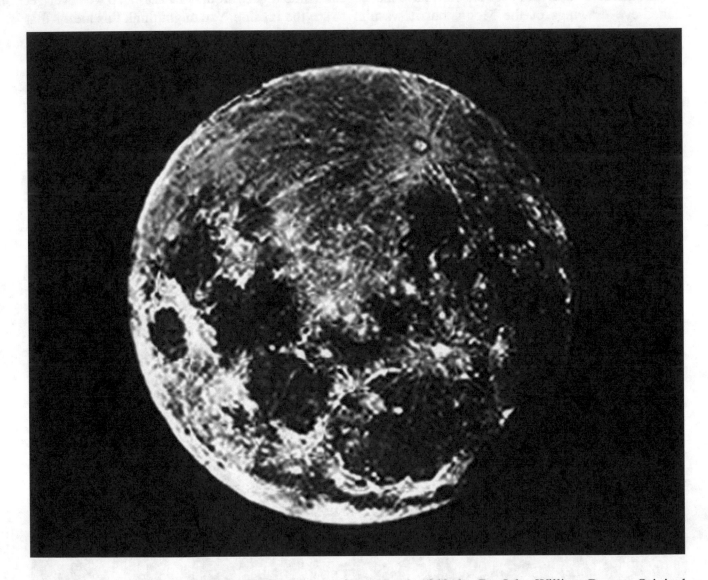

Fig. 8.13 Daguerreotype photograph of the Moon from March 1840, by Dr. John William Draper. Original image courtesy of Prof. Baryd Still, NYU Archives.

Just like with telescopes, the technology of photography improved over time, and consequently, so did the details of lunar maps. However, we still had no idea what much of the far side of the Moon looked like until October 7, 1959 when the Soviet probe Luna 3 took 29 photographs of its surface from approximately 65,000 kilometers distance. This was considered a Soviet "victory" in the Space Race – which is somewhat ironic, given that the temperature-resistant and radiation-hardened film used to take the photos was actually American-manufactured! The Soviets had recovered it from crashed balloons launched under the American "Genetrix" spy program.

Though the pictures transmitted back to Earth covered about 70 percent of the far side surface, there were still wide swaths that had not yet been viewed, especially on the edges that had just barely been seen from Earth due to libration. Getting data on those regions was difficult because of the low viewing angle. They could not be seen full-on from above. This is where IAAA member Dr. William Hartmann's artistic perspective came into play.

As a young graduate student at the University of Arizona in 1961, Hartmann was assigned to a project by famed astronomer Gerard Kuiper (discoverer of the Kuiper Belt). His task was to take photographs of a "rectified" projection of the Moon for a new atlas. The idea was to project a photograph of the Moon not onto a flat white screen, but onto a white globe. By projecting onto a three-dimensional globe, the details in the projection would be stretched out to nearly what they actually looked like, instead of seeing a difficult to examine, low-angle view of the "limb" of the Moon (the edge as seen from Earth). Then Hartmann would place a camera directly "above" the globe and take new photos.

Fig. 8.14 William K. Hartmann taking a rectified picture of Mare Orientale, 1961.

One day, as Hartmann was viewing a projection of a very good photo, he noticed something peculiar in the Mare Orientale region. In his words, "I saw portions of bullseye-like concentric arcs barely protruding onto the front side. Some other people who passed through the room thought of them as just curiosities, but having read books about the lunar surface, and having an interest in geologic patterns, I immediately recognized the arcs as the outer edge of a big, beautifully preserved impact basin structure, most of which must be on the Moon's far side – an important discovery."

Mare Orientale is difficult to observe from Earth, as it lies right on the limb of the western edge of the near side. Because of the low viewing angle, all that can be seen are the rough mountain ranges named Montes Rook and Montes Cordillera and some dark mare beyond. But from Hartmann's different perspective, he saw something no one had ever seen before. He took a set of pictures that displayed the feature and showed them to Gerard Kuiper. In 1962, Hartmann and Kuiper published a paper on the discovery, with Hartmann as first author.

Fig. 8.15 Photograph of Mare Orientale by Lunar Orbiter 4, NASA image.

As with most scientific discoveries, there are always skeptics who disagree with a hypothesis, a lesson well-learned from the belief in Martian canals. Even the best lunar maps had shown Montes Rook and Cordillera as isolated ranges of mountains, not concentric arcs. Shortly after publication, Nobel prize-winning geochemist Harold Urey (who was not an artist) wrote a letter to Hartmann and denied that such rings existed. But in the case of Mare Orientale, 1967 photos taken by Lunar Orbiter 4 showed the majesty of the full impact basin rings. Once the concentric ring pattern was a proven fact, it helped clarify the mechanics of impact crater formation not only on the Moon but across the entire Solar System.

Fig. 8.16 *Evening Among Orientale Ring-cliffs* by Dr. William K. Hartmann, FIAAA

In this chapter, we have seen two very different cases, where one person's visual perspective led to a century-long misconception, while another's led to an important discovery. The human brain is capable of amazing leaps of logic, given the right information. Sometimes all it takes is the perspective of an artist to make the difference. Bill Hartmann summed it up beautifully:

I realized years later that the Orientale discovery experience shaped the way I look at things, both as a scientist and artist. In the early 60s, after Kennedy's announcement that we'd go to the Moon, almost all lunar scientists focused on trying to study smaller and smaller details of the Moon. But it hit me one day – how amazing it was that we could back off from the Moon and discover an 800 km-scale structure that no one had realized was there. It was a good lesson in art and in life: Don't get lost in details. Back off and look at the big picture. If everyone else is inside their own box concentrating on one aspect of things, back off and look at other sources of information from outside that box. Back off and look at your artwork as a whole.

Part II

Styles and Techniques of Space Art

Rocks & Balls: Classical/Naturalistic Paintings

Michael Carroll

Like every genre of artistic expression, space art also has many different facets, or subgenres. The first and most common one is the realistic depiction of a rocky scene with a different globe than the Earth or Moon in the sky – the rocks and balls.

Fig. 9.1 *Uranus Sunset* by Michael Carroll, FIAAA.

For the newcomer to astronomical art, it is important to understand what it is and what it is not. The term "space art" is sometimes used to describe this genre; however, that term encompasses a much broader scope of artistic expression. "Astronomical art" is more likely to depict purely landscapes and/or objects and bodies in space, such as planets, moons, stars, galaxies, nebulae, etc. Because many of these works by their very nature contain a rocky landscape with a planet, moon, moons, or some astronomical object in the sky, this type of art has earned a nickname of *Rocks & Balls*.

Space art would seem to be the new kid on the artist's block, but it has its roots buried deep in history. Painting a scene or object that no one has seen first-hand is a process that reaches far into the past. Albrecht Durer did one of the first illustrations of a rhinoceros – at the time, a creature that had not been seen by anyone in northern Germany. In 1515, the naturalist Valentin Ferdinand saw one at the Royal Zoo in Lisbon and sent a description and rough sketch to Durer, who made a detailed ink drawing and later a woodcut based on the scant information. Many artists have depicted visions of Heaven and Hell in religious works, and many others have painted scenes based solely on the imaginative descriptions from the reports of explorers.

M. Carroll (✉)
Littleton, CO, USA

Fig. 9.2 *Rhinoceros* by Albrecht Durer, 1515. Courtesy WUSTL Digital Gateway Image Collections.

In fact, explorers throughout the ages have brought artists along to document discoveries and foreign vistas, like Conrad Martens, who accompanied Charles Darwin on the Beagle expedition. The paintings of Albert Bierstadt and Thomas Moran helped to convince the US Congress to found the first two national parks at Yellowstone and Yosemite (see Chapter 6). Frederick Catherwood – an architect by trade but with the heart of an artist – documented the discoveries of Maya, Aztec, and Incan ruins by John Lloyd Stephens. Frederic Edwin Church mounted expeditions to Antarctica, South America, and other environs to create some of the most beautiful natural science paintings in history.

Botanical artists hang out at the local gardens, or – if they are highly motivated – travel to tropical islands to depict flora in their native habitat. Wildlife artists journey to the Serengeti or the Rocky Mountains to hone their skills. Today we have new kinds of explorers, venturing into a new, vast frontier studded with burning stars, spinning worlds and swirling galaxies. Some of these explorers wear space suits, while others wear solar cells and foil. The farthest humans have ventured is to the Moon, but astronomical art calls for artistic voyages to the frigid moons of Jupiter, or even the desolate landscapes of planets circling other stars. So, what's a space artist to do? The challenge presents some horrific travel expenses!

Vast amounts of data are returning to Earth from space exploration. We have recently seen the moons of Pluto through the eyes of the New Horizons spacecraft, and the exotic landscapes of a comet through the eyes of ESA's Rosetta spacecraft. Mars rovers like Spirit, Opportunity, and Curiosity continue to explore the sands of the red planet Mars, revealing vistas of alien deserts, mountains, and craters. The problem is that most data from spacecraft is not visual, but rather numerical. Streams of numbers come to scientists, who then must turn these numbers into something the rest of us can understand. It is the artist who must translate these tales into something on a human, aesthetic scale.

When the Galileo craft charted sheets of invisible radiation and a vast torus of energy cocooning Jupiter, computer artists and painters could show us what these fields and particles might look like, and how they relate to the king of planets. Information beamed back by the Mars rover Opportunity indicated that an ancient ocean washed across what is now rolling sand and rock. The artist can show us how this ancient Martian seascape might have appeared.

Fig. 9.3 *The Last Waters of Mars* by Kevin Davies.

Indeed, it is an interesting reflection upon the workings of modern science that scientists and astrophysicists are often amazed when they see how an artist is able to interpret the results of their studies visually. Yet it is only through such visualizations and reconstructions that the public is able to understand what is being discovered "out there."

Probably the most familiar face of astronomical art are those works that realistically depict celestial objects: the work of Chesley Bonestell, for instance, or Ludek Pešek. The essential thing about this subset of astronomical art is that it is based on an informed knowledge of the universe. That is, the artists have a working familiarity with astronomy and a fair knowledge of other scientific disciplines, such as chemistry, physics, meteorology, and geology.

A great ally to the space artist today is comparative planetology, or the comparison of Earth geology to other worlds. The most Earth-like planet we know is Mars. Mars is a cold, desert world. No liquid water can exist on its surface due to both the low temperatures (summer heatwaves scarcely reach the melting point of water) and its low air pressure (equivalent to Earth at 100,000 feet). Despite Mars's alien environment, its wide expanses bear striking resemblance to our own planet's arctic and subarctic regions. Mars has been scoured by winds, sculpted by floodwaters, torn apart by volcanoes, ripped by meteors and asteroids, yet looks like the Earth in many places.

Terrestrial desert regions are a natural analog to Martian landscapes. In California's Mojave Desert, Death Valley has a specific region named by artists "Mars Hill" (the name was later officially adopted by NASA and the Park Service, thanks in part to efforts of The Planetary Society). This rise is peppered with rocks which look strikingly like rocks found at the first landing site on Mars, examined by Viking I in 1976. In the late 1970s, Don Davis took panoramic snapshots of the Mars Hill area and from these created a beautiful Martian vista hauntingly similar to views we would see 25 years later by the Mars rover Spirit.

One especially Mars-like region is found in the Canadian arctic. Devon Island is a cold desert crossed by water-carved valleys. Orbital views of the island show valley networks virtually identical to those on Mars. Like the astrogeologist, the space artist can study these valleys up close.

Another otherworldly area is Iceland. While being an arctic region, Iceland has the added advantage of harboring a host of active volcanoes. Volcanism has played an important role on Mars, Venus, possibly Jupiter's moon Europa, and famously on Saturn's geyser-ridden Enceladus. Cryovolcanoes even seem to be present in several forms on distant Pluto, including a massive mountain with a sunken summit caldera called Wright Mons. The interaction of volcanoes with icy conditions makes for unique scenes ripe for the artistic eye. Since Iceland provides a fine example of volcanic action in the presence of cold conditions, and it is far less expensive to visit Iceland than Saturn, space artists travel to this island nation for excellent field experience. IAAA artist Marilynn Flynn painted in the field at a site called Viti, using what she sketched and photographed there to paint her masterpiece of an Ionian landscape.

A common theme in space art is "Planet A seen from its satellite B." A rocky or icy landscape of a moon lies beneath a giant planet in the sky. This format is how the term Rocks & Balls became popular. Nowadays, computer programs make it relatively easy to see how big, say, Jupiter will appear from Europa. This is called the *angular diameter* of an object in the sky. The Moon's angular diameter is about one half of one degree in the sky; from the Moon, Earth occupies about two degrees. Think of your eyes as a camera that allows you to view a scene through an imaginary lens, usually with a field of view of about 40 degrees. But the lens could be wider, like 80 degrees, or longer-focus, say 30 degrees, to give a special effect. It is the artist who controls this. The whole effect is that not just the sky but also the landscape will be changed by this angle. Interestingly, Chesley Bonestell often included the angular field of view of his paintings in their captions when they were published – 40 degrees was his favorite.

Fig. 9.4 *Exploring Nanedi Valles* by Don Dixon, FIAAA.

Fig. 9.5 *Mars Hill* by Don Davis, FIAAA.

Fig. 9.6 *A Little Hell on Io* and the inspiration image taken in Viti, Iceland. By Marilynn Flynn, FIAAA.

Fig. 9.7 *Bonestellian Sunset* by Dan Durda, FIAAA.

Taking a 40-degree view, if you are painting on a board or canvas that measures 20x40 centimeters (8x16 inches), you could use a scale of one degree to one centimeter to give a natural effect. Most people find it surprising that the Moon would occupy only one hundredth of such a picture! The illusion of the apparently larger size of a rising full Moon is well known. Reducing the angular diameter would be like zooming in on a scene. With a 10-degree angle, the Moon would cover a full 5-centimeter (2-inch) circle.

Fig. 9.8 *Alien Titan* by Justinas Vitkas.

The next thing you have to do is decide where the Sun is. In space subjects where there is often no atmosphere, light and shade are very harsh, and the shadows are relieved only by the glow reflected from a planet or other object in the sky. You have to decide at the outset how high the Sun is in the sky, what other bodies will be visible, how much if any of the Milky Way will be visible, and so on. You will also need to calculate, based on the height and angle of the Sun, where your shadows will fall and how long they will be.

The easiest way to work out shadows is to draw a vertical pole of the same height as your mountain or whatever, draw an imaginary line from the Sun (or other source of illumination) to the ground, and then draw in the shape of the formation that is casting that shadow. Quite complex shapes can be simplified into cubes or pyramids and treated in this way. The angles, shadows, and reflected light of Saturn and its ring system would require an entire lesson in itself.

One dilemma that faces space artists – the answer to which is really down to individual choice – is whether to show stars. No stars appear in the Apollo photographs taken on the Moon or in space, but this is because of the shortcomings of film, which does not have the latitude to handle a brightly lit landscape and faint objects like stars. If you try to expose for the stars, the rocks become a washed-out glare. Even the astronauts did not see stars when they were on the surface of the Moon, unless they were standing in the shadow of the Lunar Module. Apollo 12 astronaut and talented artist Alan Bean compared the effect to standing in a harshly lit parking lot at night. No stars are visible above because the light causes the eye to close down, adapting to the high levels of illumination, despite the fact that the stars are there. Yet the stars can be seen if the eyes are shielded. The artist has an advantage here, as he or she can show both in the same picture.

Fig. 9.9 *Terramoon* by Michael Holzinger.

Fig. 9.10 *Encke Gap* by Don Dixon, FIAAA.

As we move farther out into the Solar System, we find more bizarre landscapes. These environments are driven not by conventional geology, but rather by super-cold conditions. These worlds give the artist the chance to use small amounts of science to guess at what might be out there. This was certainly the case in 1988, when the author was commissioned by *Astronomy* magazine to paint the surface of Neptune's moon Triton. At the time, scientists knew that this Pluto-sized moon had some kind of atmosphere, but how much was not known. It was also known that Triton orbited its primary planet, Neptune, in the opposite direction to the planet's spin (a *retrograde orbit)*. This means that the moon was probably captured by Neptune's gravity, rather than forming with Neptune. Scientists guessed that violent forces affected the moon as it settled into its current orbit. Another clue the author had as to Triton's surface conditions had to do with its interaction with Neptune and Neptune's other moons. Many moons in the outer Solar System are affected by gravitational forces in ways that cause volcanic activity. This push and pull of gravity generates internal heat, which is released through volcanoes. Could it be that Triton had an icy version of volcanism? The author decided to put little volcanic vents on the surface.

Fig. 9.11 *Frozen Plains of Triton* by Michael Carroll, FIAAA.

As a model for his landscape, the author used a rift valley in Iceland called Thingvellir. This valley is at the northern tip of the great Atlantic rift zone which splits the ocean floor nearly from pole to pole. The author also used textures of glaciers he visited in Iceland and Alaska. The resulting painting, *Frozen Plains of Triton*, was soon to be tested. In 1989, Voyager 2 flew past Neptune and its family of moons, returning detailed images of Triton. Triton had less atmosphere than the author had guessed in his painting, but it did have strange valleys and cryovolcanism. Triton's alien volcanoes are powered by liquid nitrogen. After the encounter, the author did an updated view showing the actual form of Triton's super-chilled volcanic plumes.

Fig. 9.12 *Rhea's Sigh* by Marilynn Flynn, FIAAA.

As probes and people continue to explore the cosmos, artists continue to have opportunity to not only portray new discoveries, but to anticipate them. Chesley Bonestell and Ron Miller painted dust devils on Mars decades before they were confirmed. Orbiting cameras aboard the Viking I and II glimpsed mysterious plumes in the late 1970s, but the resolution was insufficient to understand their nature. Then, in 1997, the Pathfinder lander caught several dust devils on its imager, and actually charted them moving over the craft with its meteorology instruments. A few years later, the Mars Global Surveyor discovered trails left in the Martian sand by massive dust devils – a beautiful, almost whimsical calligraphy – confirming what artists had predicted with the paint brush decades earlier.

Fig. 9.13 *Martian Exploration* by Ron Miller, FIAAA.

Space artists are also venturing into the realm of digital art. Some use programs such as Terragen or Vue to generate fractal landscapes, often over-painting with software like Photoshop or Illustrator. *Tradigital painting* combines a foundation of acrylic or other media done traditionally with digital techniques of Photoshop or other software. And software is now sophisticated enough to generate original art "from scratch" within the mind of a computer.

Fig. 9.14 *Iapetus Ice Cave* by Walt Myers.

Fig. 9.15 *Super Earth* by Justinas Vitkas.

The traditions of space art parallel other genres and movements in the history of natural science illustration. While space subjects are more difficult to paint firsthand than are other natural subjects, artists continue to immerse themselves in the natural wonders of this world, creating views of other planets that await future generations of artists who will actually paint Rocks & Balls there.

Hardware Art: Space Art Meets Rocket Science

Aldo Spadoni

Hardware space art is extremely popular. Enthusiasts of engineering and rocket science in particular enjoy this subgenre, as it touches on the deep human fascination with building elaborate machinery.

Fig. 10.1 *Get Ready for a Little Jolt Fellas... BAM!* by Aldo Spadoni, FIAAA.

A. Spadoni (✉)
Rancho Palos Verdes, CA, USA

© Springer Nature Switzerland AG 2021
J. Ramer, R. Miller (eds.), *The Beauty of Space Art*, https://doi.org/10.1007/978-3-030-49359-2_10

The spacecraft!

Throughout history, spacecraft concepts in fact and fantasy have been the technological magic carpets that have carried humankind's imagination to the far corners of the universe.

As the frontiers of knowledge expanded, artists kept pace and refined their methods of envisioning humanity's spacefaring future. Jules Verne's novel *From the Earth to the Moon* (1865) might be rightly said to contain the first genuine space hardware art. Verne was among the first to carefully consider the physical necessities of spaceflight. In fact, he was the first person ever to define spaceflight on a strictly mathematical basis, which enabled his illustrators to not only accurately depict his space vehicle but even include a detailed cross section, the first such schematic in space art history. And in the sequel, Verne's illustrators provided the first-ever depiction of a rocket-powered spacecraft in space.

Fig. 10.2 *Deimos* by Roy Scarfo 1967.

Fig. 10.3 Interior of Jules Verne's projectile, from *From the Earth to the Moon.*

So, it can be argued that space hardware art was born more than 165 years ago. *Space hardware art* is a subgenre of space art that focuses on envisioning the technological methods that allow or will allow humans to travel, live, and work in space. Space hardware artists are those who specialize in depicting spacecraft, satellites, space stations, planetary bases, spacesuits, and all of the associated hardware. Space hardware art can also be viewed as somewhat parallel to aviation art, with similar demands and challenges. While there are certainly many ways of depicting space hardware, many of the artists attracted to the demanding world of space hardware art are realists – that is to say, their depictions are representational and realistic. The artists who specialize in capturing the wonder and allure of space vehicles must create art that is aesthetically pleasing as well as technically accurate.

In addition to artistic skills, the successful space hardware artist usually has a grasp of design and basic engineering principles. Space hardware art is frequently created to document significant events in aerospace history. It is extensively used by the global aerospace industry to illustrate spacecraft design proposals, concepts of operation, and to generally imagine the exciting possibilities of the future.

Ideally, space hardware art should communicate some key aspect of the hardware subject being depicted. How does it work? How will it be used? What is intriguing about it? Why is it better than a competitor's idea? The best space hardware art always manages to convey a sense of the wonder and adventure awaiting humanity as we set sail upon the vast ocean of space.

Fig. 10.4 *ISS* by Robin Pleak.

The modern era of space hardware art began after World War II. This was the Golden Age of hardware art. Rapid developments in aviation and related technologies such as jet propulsion, the V-2 ballistic missile, the atomic bomb, and others made the eventual development of spacecraft a real possibility to the general public. The United States emerged from World War II as a superpower, especially in terms of its enormous industrial capacity and ability to develop advanced technologies and complex systems. Science fiction stories focused on space adventures became increasingly popular at this time. Human spaceflight appeared to be just around the corner, and space hardware artists played an important role in making it appear real and possible.

Fig. 10.5 *Moon Expedition* by Chesley Bonestell.

This was the time when the great Chesley Bonestell rose to prominence. In the early 1950s, editor Cornelius Ryan conceived and produced a series of lavishly illustrated articles in *Collier's Magazine*, which presented to the public an astounding and compelling vision of humanity's spacefaring future and how we would get there. To do this, Ryan assembled a group of visionaries that included Wernher von Braun, Willy Ley, Chesley Bonestell, and others. Bonestell's work exhibited a startling realism, making it easy to believe that this was an actual glimpse of our future in space. One reason for the great success of this endeavor was the strong collaboration between engineers, scientists, and artists.

Fig. 10.6 *Glenn Reentry* by Aldo Spadoni, FIAAA.

Von Braun himself was a good sketch artist and developed numerous engineering drawings and rough sketches of his spacecraft concepts as well as their methods of operation. These were used by Bonestell and the other artists to create working drawings of possible illustrations for von Braun's review. They would then incorporate von Braun's comments and corrections and execute the finished paintings. The results of von Braun's engineering genius and the powerful visions created by this multidisciplinary team would have a profound influence on NASA, the aerospace industry, space

hardware artists, and the public for decades to come. Though Bonestell is much better known, artists Rolf Klep and Fred Freeman were also key contributors to the success of the *Collier's* series and subsequent books. Much of their work can be described as diagrammatic in nature, and their detailed cutaways and other explanatory illustrations gave the sense that this space vision was not merely a pipe dream – it was engineered and methodically planned. It could actually be built. Their work beautifully complemented that of Bonestell.

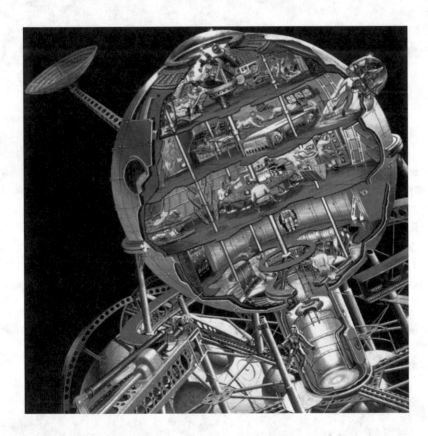

Fig. 10.7 *Moonship Cutaway* by Fred Freeman.

In a similar manner, British artist Ralph Andrew Smith worked closely with members of the British Interplanetary Society (BIS). In the late 1930s, BIS developed a credible and detailed proposal for a crewed lunar rocket and lander, which was illustrated by Smith. Following World War II, he continued this work and was also a co-designer of the BIS space station concept developed in the 1940s. In the early 1950s, his work appeared in several books such as *The Exploration of the Moon* (1954) by Arthur C.

Clarke. Chronologically, Smith's work for the BIS actually predates the *Collier's* series.

It is interesting to note that the now-classic image of the spaceship as a sleek, finned aerodynamic vehicle existed long before World War II. But in the postwar period, the influence of the German V-2 as a real rocket capable of flight above the atmosphere popularized the idea that all spacecraft would have a similar appearance, such as the classic spacecraft painted by Bonestell and shown on the cover of Willy Ley's *The Conquest of Space* (1950).

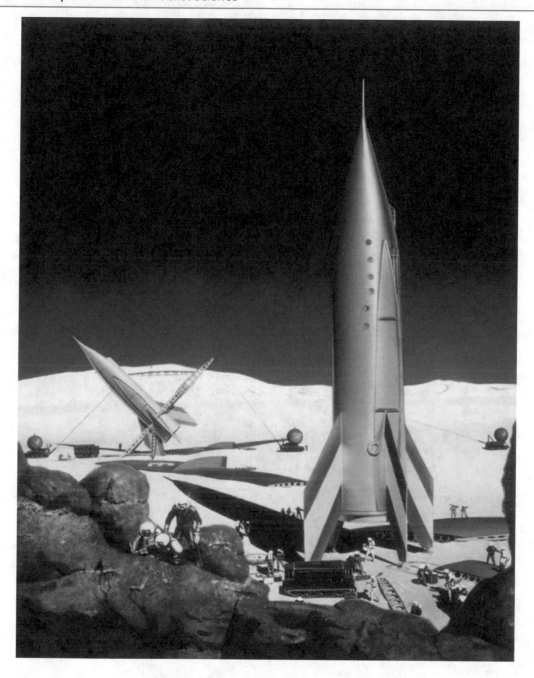

Fig. 10.8 *Mars Ship* by Chesley Bonestell.

Space hardware artists of that time created many variations of this basic winged rocket design. However, both von Braun and the BIS team understood that vehicle mass would have a profound influence on spacecraft engineering design. They also realized that specialized spacecraft would have to be developed to operate in the unique vacuum environment of space, which would bear little resemblance to atmospheric craft and not be encumbered by the weight of unnecessary aerodynamic/thermal protection systems. The BIS lunar lander in particular was strikingly prescient in that it bore a remarkable resemblance to the Apollo Lunar Module, which succeeded in taking men safely to the lunar surface, and all the more so because it was designed in 1939! The BIS design was not much larger than the LM and even incorporated the same two-stage mode of operation.

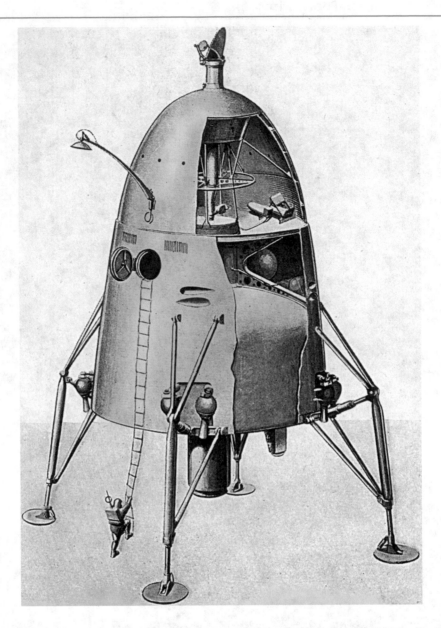

Fig. 10.9 *Moonship* by RA Smith, courtesy of the British Interplanetary Society.

As the world entered the 1960s, space hardware art was strongly influenced by the race to the Moon between the United States and the Soviet Union. This was an exciting time for conceptual space hardware art, because there appeared to be no limits – not even the sky – to what the human race could accomplish in space. Visions were bold during this time. Aircraft companies became aerospace companies. Spurred on by the rapid expansion and success of the American space program, the aerospace contractors presented visions of robust human expansion into space, featuring large space stations, asteroid colonies, and large-scale expeditions to the planets. A number of space artists who excelled at hardware art followed in Bonestell's footsteps, such as Robert McCall, Pierre Mion, Roy Scarfo, Frank Tinsley, and Ed Valigursky. These artists created space hardware art for NASA, the aerospace contractors, and book and magazine publishing companies. They envisioned the many space exploration concepts being developed at that time by space futurists such as Ernst Stuhlinger, Kraft Ehricke, Dandridge Cole, and others.

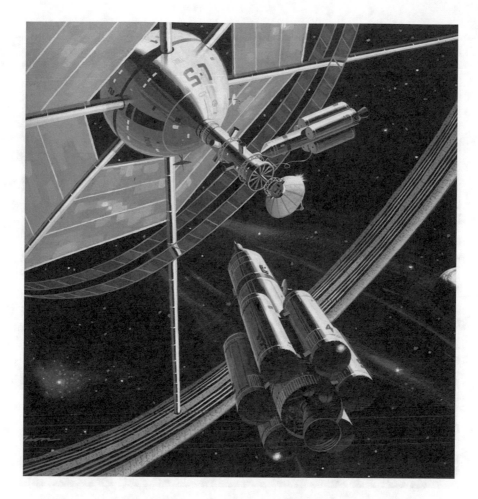

Fig. 10.10 *L5 Colony* by Pierre Mion.

Fig. 10.11 *Asteroid Ship* by Roy Scarfo.

Fig. 10.12 *Mars Snooper* by Frank Tinsley.

Fig. 10.13 *Shuttle* by Ed Valigursky.

While many people could envision and understand the technological challenges to spaceflight, few at the time could really foresee the economic barriers that would greatly constrain the human exploration of space, even when the technology became available to do so. This fiscal reality hit hard in the 1970s post-Apollo era, as the United States was wrapped up in geopolitical turmoil. During this time, NASA conceived and struggled to develop the Space Shuttle. The Russians abandoned their own dreams of human lunar exploration and focused on crewed operations in low earth orbit. During the 1970s, futurists such as American physicist and space activist Gerard K O'Neill kept the dream of robust human spacefaring alive. His popular science book *The High Frontier: Human Colonies in Space* (1976) combined fictional accounts by future space settlers along with explanations of his proposals for human space colonies. This influential book included amazing visual impressions of life in a space colony created by space artists Don Davis, Rick Guidice, and others.

Fig. 10.14 *Stanford Torus* by Don Davis, FIAAA.

While the prospects for near-term human exploration of the Solar System dwindled, the program of un-crewed robotic exploration expanded dramatically with an astounding record of systematic achievement in the decades following Apollo. As of 2020, every planet in the Solar System has been visited at least once, and our robotic explorers have visited a number of asteroids, comets, and deep-space objects in the Kuiper belt. Several spacecraft have penetrated the heliopause and are outbound across the depths of interstellar space, bearing messages from humanity. A number of exciting, complex deep space missions are currently underway, in development, or in the early planning stages by the international space community. Space hardware artists are intimately involved in all of these endeavors.

Fig. 10.15 *Space Shuttle Launch* by Michael d'Albertis.

Despite all of these accomplishments and advancements, humans have not ventured beyond low earth orbit (LEO) in the fifty years following the end of the Apollo program. Nevertheless, space visionaries have persevered and continued to expound the vision of a robust human spacefaring civilization with the aid of space hardware artists. Few artists have had as much impact on creating a compelling vision of the future of human space exploration as master artist and Fellow of the IAAA, Pat Rawlings. Since being published in the 1970s, Rawling's works have been featured in hundreds of books, magazines, films, and television programs. He has consulted for NASA for many years and produced photorealistic artwork of such great detail and design forethought that many viewers are struck by a strong sense that the images are actual photographs.

Fig. 10.16 *Lander Over Lunar Base by Earthlight* by Pat Rawlings, FIAAA.

Today, we are experiencing an exciting "Second Golden Age" in space exploration with the rise of commercial spaceflight operations lead by private companies such as SpaceX, Blue Origin, and others. Demonstrated reusability of large launch vehicle components is finally yielding a real reduction in the cost of lofting cargo into orbit. Advances in information technology have led to a drastic reduction in the size and mass of spacecraft electronic systems, enabling developments such as miniature spacecraft

called CubeSats. The prospects for space tourism are becoming more realistic as a number of companies are developing the means for people to safely travel into space. Several commercial crewed spacecraft are being developed for LEO operations and are approaching operational status. NASA struggles to define a clear long-range path forward for human spaceflight but continues to develop launch vehicles and spacecraft for human deep space operations beyond LEO. Other companies are developing ambi-

tious plans for human operations on the Moon, Mars, and beyond. The road ahead remains challenging, but humanity is moving forward. Throughout it all, space artists are helping to show the way.

Fig. 10.17 *Galileo at Jupiter* by Michael Carroll, FIAAA.

Fig. 10.18 *Stormy Descent* by Mark Garlick, FIAAA.

Fig. 10.19 *Starship* by Douglas Shrock.

Even in the world of space art, there is considerable specialization. Not all space artists are adept at successfully handling hardware as well as astronomical subjects, while others are quite versatile. Artists who create space hardware art generally fall into four categories:

1. Artists who have created some space hardware art, but it isn't their specialty.
2. Artists who are very good at illustrating historical or existing space hardware.
3. Artists who create science fiction spacecraft and hardware for the purpose of visual effect and entertainment, but who generally have little or no knowledge of real space hardware engineering or astronomy.
4. Knowledgeable artists who are specialists in designing as well as depicting realistic conceptual space hardware.

This section is focused on space hardware artists as defined in the fourth category. How do these artists go about creating a representational spacecraft artwork? First, regardless of the subject matter, the space hardware artist must be able to handle a representational illustration technique. This does not necessarily mean that the resulting artwork must look like a photograph. The work of artist Robert McCall is an excellent example of this. His work was extremely "painterly" but at the same time totally believable. The real purpose of the artwork is to convey information in a compelling and believable manner. Photographic realism is merely one method of attaining this goal. Assuming the space hardware is to be envisioned in an astronomical setting, the artist must also master the skills required to create an effective astronomical artwork to serve as a backdrop for the space hardware.

Fig. 10.20 *Starship Departure* by Dan Durda, FIAAA.

Then we come to the hardware itself, which will typically be the primary focus of the artwork. For a space hardware artist, the spacecraft is usually the star of the show. As space artist Ron Miller describes it, there is a special "anatomy" to hardware, just as there is to the human figure or even landscapes. Rendering convincing hardware requires a certain understanding of mechanical and engineering design principles. The more an artist understands why machinery looks and operates in a certain fashion, the better the resulting artwork will be. A firm grasp of these considerations is especially important when artists are called upon to invent and design their own hardware, since the appearance, features, and operational modes of this hardware must appear to be technically credible and convincing to a very sophisticated and knowledgeable audience.

Even in situations where the space hardware artist is working with a spacecraft engineering team,

it helps enormously if the artist is also a capable designer. When speculating about future spacecraft configurations, the engineers may not have time to work out all the details. So, they leave it to the artist to incorporate all of the expected features required to make the vision realistic and technically credible. In such cases, the hardware artist's work is similar to that of the industrial designer, who must combine artistic imagination and talent with a broad understanding of the physical appearance, functionality, and manufacturability requirements of a given product. Also, many scientists and engineers involved in spacecraft development are specialists who are focused on their particular area of expertise, such as propulsion, structures, guidance and control, communications, power subsystems, etc. Thus, they may not really be capable of designing a believable overall spacecraft configuration as well as the skilled space hardware artist.

Fig. 10.21 *Tricentennial - Daedalus* by Rick Sternbach, FIAAA.

Creating convincing renditions of complex space hardware requires mastery of perspective and mechanical drawing techniques. One traditional method of getting the perspective right is to build a model of the hardware and photograph it with appropriate lighting from a desirable viewpoint to use as a reference. Chesley Bonestell frequently used rough models that gave him the information he required to paint a spacecraft in appropriate perspective.

The creation of serious space hardware art has largely moved into the digital realm. Since all real space hardware is now designed using computer-based 3D CAD and virtual reality tools, it's only natural that artists would follow suit. The rapid development and availability of powerful computer-based 3D modeling and rendering tools have enabled many new possibilities for space hardware artists. The artist can take advantage of numerous existing 3D models and databases available from NASA and many other online resources. Mastery of 3D tools and techniques allows the artist to design and render complex spacecraft in a convincing manner. Even if the artist chooses to create artwork using traditional hand painting techniques, 3D modeling and rendering can provide excellent reference imagery for making sure that the perspective and lighting are correct for a given view of the space hardware. The possibilities are endless!

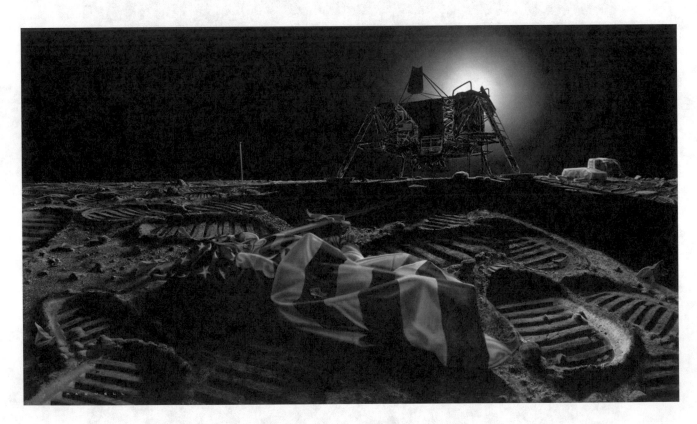

Fig. 10.22 *Legacy* by Mark Maxwell.

The rapidly evolving world of video games has also created new digital tools that can be quite useful to the space hardware artist. For example, the popular Kerbal Space Program (KSP) is a space flight simulation video game that not only features realistic physics-based orbital maneuvers, but also allows the user to construct spacecraft from a selection of parts. It is up to the users to utilize their own knowledge of space technology to assemble appropriate components in a realistic manner. For those artists interested in learning how to design a credible spacecraft, KSP can be a great teaching tool to explore and basically learn about what works and what doesn't in the world of spaceflight.

Fig. 10.23 *The Wanderer* by Simon Kregar.

Fig. 10.24 *Curiosity the Mars Mountaineer* by Steve Hobbs.

Today's space hardware artists are inspired by those who came before them and carry on the tradition of close collaboration with the space technology and engineering communities. They are an integral part of the difficult process of conceiving and developing new spacecraft concepts. Indeed, scientists and engineers are often amazed when they see how a skilled and knowledgeable artist is able to visually interpret the results of their studies and data. Such visualizations are essential to communicating the key aspects of an idea, enabling an understanding of the technological possibilities, and – importantly – selling the project. Their work makes it exciting. It is the business of the future to surprise us, and the work of space hardware artists will continue to point the way forward.

"Swirly Art": Techniques and Masterpieces of the Experimental and Abstract

Ron Miller, Kara Szathmáry, Judith Broome-Riviere, and Jon Ramer

Impressionism exploded onto the art scene about the same time that astronomical art came into being. However, it took several decades before artists started incorporating non-realistic styles into space art.

Fig. 11.1 *With Dreams of Tomorrow – Windows to the Future* by Kara Szathmáry, FIAAA.

R. Miller (✉)
South Boston, VA, USA

K. Szathmáry · J. Broome-Riviere
Panama City, FL, USA

J. Ramer (✉)
Mill Creek, WA, USA

© Springer Nature Switzerland AG 2021
J. Ramer, R. Miller (eds.), *The Beauty of Space Art*, https://doi.org/10.1007/978-3-030-49359-2_11

Representational space art might be broadly divided into two categories: art that depicts how we will explore the universe, and art that depicts what we might find there. These two categories are analogous to art illustrating the exploration of North America. On the one hand might be drawings and paintings of Conestoga wagons, clipper ships, settlements, and forts. On the other might be artwork depicting mountains, canyons, rivers, and prairies, with scarcely a sign of anything human in sight or so reduced in size as to appear as nearly an afterthought.

Fig. 11.2 *Angel Nebula* by Forest Arnold.

As we have seen in Chapter 9, space hardware artists focus on *how* we will get into space, and their artwork is filled with beautifully rendered and technically accurate spaceships, space stations, and space colonies. Meanwhile, realist astronomical artists – the "Rock & Ball" contingent of Chapter 8 – focus on *where* we go in space, and their artwork is filled with extraterrestrial landscapes, stars, and galaxies. In both cases, if there is anything human present, it is usually only there to convey scale.

But there is yet a third broad and no less important subject for space art – and that is the *impact* of space travel on the human psyche. Where hardware and realist artists build on a foundation of engineering, astronomy, and other hard sciences, *cosmic impressionist* space artists explore the sciences of psychology, sociology, and even religion and spirituality. The three approaches to space art form a kind of interconnected triad: *how* we get there, *what* we find and, finally, what it *means*.

Fig. 11.3 *Cosmosis* by Sean Yarbrough.

This subgenre of cosmic impressionism is nicknamed *swirly art* by its practitioners. Swirly art tends to focus on the act of creating art, i.e., manipulating media and the principles of design to emphasize the emotional and the subjective, rather than a strict adherence to rational and descriptive scientific phenomenon. Cosmic impressionists focus on the wonder and awe of the universe at large. For them, truth is the way things are unique, and not the way things are designed, nor the way they appear to be.

To do this, swirly artists might employ a broad variety of existing modes of expression. For instance, the artist might choose to create an abstract impression of an astronomical subject. The basic premise of an abstract painting is sim-

ple. Just as the abstract of a scientific paper tries to condense a complex subject that might entail many pages of detailed description into a single, short paragraph, the artist creating an abstract painting tries to do the same thing: reduce a subject to a few basic shapes, lines, or colors. Of course, this becomes highly subjective, depending very much on a series of deliberate choices made by the artist. Is the abstraction of a pine tree a triangle? A vertical line crossed by horizontal lines with their width decreasing from bottom to top? A splash of green? Any of these possibilities and more are all equally valid, depending on just what aspect of the tree the artist sees as best representing its fundamental nature.

Fig. 11.4 *Rocket 99* and *Two Asteroids* by Peter Thorpe.

A good way to think of abstract art is to compare it to the synopsis of a book or movie. Similarly, it is a visual subject condensed down to its very basic ideas or themes. Instead of the gallery visitor seeing a representation of everything the artist saw in a subject, they get a glimpse into the artist's mind by seeing what the artist chose to be the most important.

One way to convey a personal sense of a scene is through *impressionism*. Like the name suggests, the artist tries to capture an immediate experience rather than to achieve a visually accurate depiction. When impressionism first developed in France near the end of the nineteenth century, many of its practitioners focused on trying to capture momentarily fleeting effects of light and shadow. In other words, their *impression* of a scene instead of its details. For instance, an impressionist might try to capture the way sunlight sparkles on the surface of a pond, rather than paint the pond with representational realism.

Another avenue might be *expressionism*. In this case, the artist tries to convey a sense of how they felt upon seeing a subject. If a grand waterfall filled them with a sense of awe, the artist tries to instill that same sensation on the viewer. Perhaps they found standing on the edge of deep canyon a terrifying experience – they might suggest that terror by painting a violent splash of red.

Finally, *surrealism* has found a real niche in space art. This subgenre is a little harder to define. The word simply means "beyond realism." This can take a myriad variety of forms. One familiar way is to combine normally unrelated objects into a single picture. René Magritte's famous painting of a bowler-hatted gentleman with an apple suspended in front of his face is one familiar example, another is the equally famous "limp watches" painting by Salvador Dalí. The idea, in part, is to produce a work of art that is greater than its individual parts – and one that might shock the viewer with its apparent lack of logic. A bowler-hatted gentleman and an apple are both mundane subjects, but when juxtaposed in an unexpected way,

Fig. 11.5 *When Dreams Are Born* by Betsy Smith.

Fig. 11.6 *Spiral Galaxy Above an Imaginary Earthlike Landscape* by Sam Dietze.

they become something greater. One of the first major space artists to work in surrealism was Ludek Pešek. He in fact loved the juxtaposition of common Earthly items in astronomical environments and painted such images prolifically. His most well-known example is that of a Gothic cathedral in an impact crater on the surface of the Moon.

Fig. 11.7 *Cathedral* by Ludek Pešek.

The book *In the Stream of Stars* (1990) was published following IAAA workshops in Iceland and the Soviet Union. Its authors, IAAA members Ron Miller, William K. Hartmann, Andrei Sokolov and Vitaly Myagov explain the difference between the traditional space art of hardware and realism and the swirly school. And, perhaps significantly, the difference between the Western and East European approaches to space art. Where most of the American, Canadian, and British artists focused largely on realistic depictions of spacecraft and planetary scenes, the Soviet artists were almost unanimously fascinated with the human impact of space exploration, and their paintings in the book are filled with people experiencing and reacting to the cosmos – sometimes positively, sometimes not. Perhaps the best example might be Joseph Minsky's (1947–1994) moving painting of a lonely cosmonaut, sitting in a darkened room, his back leaning wearily against the wall behind him, waiting for the call to board his spacecraft. *Oh God, How Tired I Am*, is the title. By zeroing in on the experience of spaceflight rather than the technology, Minsky summed up the difference in attitude and approach between the representational and the swirly artists.

Fig. 11.8 *Oh God, How Tired I Am* by Joseph Minsky

Fig. 11.9 *Unity* by Adrianna Allen.

The term "swirly art" is derived from the swirling clouds of Vincent van Gogh's painting, *Starry Night*. As he painted outdoors, Vincent came to believe that the sky was also enduring constant heavenly winds and movement after he observed the rotation of wildflowers to keep their faces to the sun. Towards the end of his life, van Gogh painted *Starry Night* as seen in the eastern sky from his asylum window in the hospital. Many meteorologists believe van Gogh had witnessed a rare cloud formation called Kelvin-Helmholtz that makes wave-like shapes out of clouds. One of the bright stars in the painting to the right of the cypress tree would have been Venus, while the Moon was painted in a crescent on the upper right. Other stars and constellations included Capella, the Pleiades, Cassiopeia, and Pegasus.

Fig. 11.10 *Starry Night* by Vincent van Gogh.

Van Gogh's style for putting paint on the surface of his canvases emphasized the act of turning his wrists with every stroke he applied. He loved nature just as much as a cosmic impressionist of today loves the universe. Cosmic impressionism incorporates the artist's emotional expression, reaction, interpretation, and illustration of scientific phenomena, extraterrestrial landscapes, and cosmological vistas to represent seen and unseen mysteries of the universe.

These artists feel that the tremendous, mysterious realm above the surface of our planet Earth is important and strive to show this in their art. In each work, they invite viewers to step into their world and see the images and the stories of those distant realms, to know in our hearts what being there means, to sense the wonder and majesty of both the vastness and the journey there. In the words of van Gogh, "If one feels the need for something grand, something infinite, something that makes one feel aware of God, one need not go far to find it."

Fig. 11.11 *van Gogh's Reality on Jupiter* by Müzeyyen Abika.

Painting on location – or "en plein air" – as Vincent often did, gives the swirly artist a great way to develop their ideas. As discusse-d in Chapter 6, Space art workshop locations have provided many IAAA artists with views of "otherworldly" geology in the formations of rocks, fault lines, flood plains, and fields of volcanic materials on Earth that are similar to other worlds. And like the fields of flowers that inspired Vincent so much, these views have inspired many space artists to visualize impressionist views of other planets and cosmic worlds. The late Alan Bean, fourth astronaut to walk on the Moon and Fellow member of the IAAA, took seeds from Vincent's grave near Paris with him to the Moon. Upon his return to Earth, Alan planted the seeds in his yard in Houston, Texas, where the plants still thrive to this day.

Alan left his footprints on the Moon where no rain, wind, or other climatic event would erase them. Those footprints will survive for tens millions of years before micrometer-sized meteorite bombardments finally erode them away. The juxtaposition between the shortness of human life and how long those footprints will last struck him profoundly. At one point on his Apollo 12 mission with Pete Conrad, Bean turned and looked out to infinity and asked: "Is there an all-knowing, all-powerful Being out there who is in charge of everything in the universe?"

Fig. 11.12 *Is Anyone Out There?* by Alan Bean.

After leaving NASA, Alan painted memories of his experiences on the surface of a neighboring world in vivid colors. The surface of the Moon is mostly gray and dark, with only an occasional green or orange coming forth in the volcanic rock from its composition. When he began painting, Alan at first had difficulty expressing his feelings in his works due to the limited range of natural colors in his chosen subject. Then, he reached out and spoke to other space artists and remembered the works of Vincent van Gogh. Thereafter, Alan stopped trying to paint scientifically accurate views of his incredible journey and instead embraced cosmic impressionism, creating images of how he *felt* standing on the Moon,

utilizing different colors and contrasting shades such as purples and greens to convey emotions instead of the natural grays of the Moon's surface.

Alan's artwork is sublime and yet colorful, leaving no doubt what the subject matter is and where the location is. His illustrations are a unique window into a unique astronomical viewpoint. And they harbor a truly imaginative secret. Bean had the creative genius to scoop up some lunar dust while on the Moon, with the motive to eventually mix the individual particles with his paints when creating art in his studio after leaving the astronaut program. NASA let him keep the rock hammer he used to collect rocks on the Moon, and also the boot of his space

suit. He used these tools to make impressions in impasto on his canvases, giving the surfaces of his works a texture of hammer hits and boot prints. His works are not scientifically realistic, near-photographic representations of the surface of the Moon, but rather magnificent examples of cosmic impressionism. Bean remains a giant in memory as the astronaut-artist who walked on the Moon and shared his unique feelings and impressions of that journey with humanity though his paintings.

Art and astronomy are very similar, in that they both value space as an essential concept. Painters imply space; photographers capture space; sculptors rely on space and form; architects create space. It is a fundamental element in each of the visual arts.

Fig. 11.13 *Mysterium* by Betsy Smith.

Fig. 11.14 *Rocketman Triptych* by Amber Allen. These three paintings are titled, "All This Science," "It's Just My Job," and "It's Lonely Out in Space."

Fig. 11.15 *Saturn on Pad 39B* by Jackie Twine, FIAAA.

Fig. 11.16 *Walking in the Garden That is God* by Greg Prichard.

Fig. 11.17 *Ice Planet* by Michael d'Albertis.

Fig. 11.18 *Patterns of the Universe* by Lucy West.

As we step out into the universe and examine the wonders it holds firsthand, we too will create art that future generations will look upon and glean some inkling of how we felt and what we thought of the universe at large. Humans paint what we see, so, in time, much of the future's historical art may be astronomical in nature. Swirly artists provide emotional visions that are springboards to creative ideas. Future space artists will bring their unique images home on powerful spaceships to share with everyone who waits in anticipation. The beauty of space will continue to open imaginative doors for all of us.

Going Digital

12

Ron Miller and Nick Stevens

Though some thought the advent of computers and computer graphics would forever change or even bring about the end of traditional painting, all they really did was create new tools for artists. For space art, those tools proved to be the biggest boon of all.

Fig. 12.1 *Cosmonaut on the Moon* by Nick Stevens, FIAAA.

R. Miller (✉)
South Boston, VA, USA

N. Stevens
London, UK

© Springer Nature Switzerland AG 2021
J. Ramer, R. Miller (eds.), *The Beauty of Space Art*, https://doi.org/10.1007/978-3-030-49359-2_12

An artist using a computer to aid in the creation of their art will often hear questions like: Is digital art "real" art? Is digital art cheating? There has been a lot of debate about what the right answers might be.

The history of art is in part a history of technological advances. Oil paint, geometric perspective, lithography, the camera lucida, photography, the airbrush, acrylics, and countless other innovations all mark watersheds of one kind or another. Some of these innovations were absorbed painlessly and, in many cases, enthusiastically. Others took some time before they were fully accepted.

As often as not, an innovation is not met with universal enthusiasm. After the invention of photography in the early nineteenth century, painter Paul DeLaroche is supposed to have gloomily declared, "From today, painting is dead." Since the careers of many artists were supported by the creation of the highly represen-tational paintings – portraits, landscapes, historical scenes, and so forth – DeLaroche's attitude was hardly unique. The camera could capture a subject with a fidelity unachievable by even the finest painter. Photography was also relatively cheap and could be accomplished by anyone who possessed a camera.

On the other hand, many artists were quick to see the creative possibilities of photography, looking at it as not a rival, but an ally. By letting photography take over the mundane depiction of mere reality, and portraits, especially, the artist was set free to explore hitherto unimagined realms of color, light, and composition. It might be argued that the many non-representational schools of art that sprang up at the end of the nineteenth century – impressionism, expressionism, surrealism, etc. – may have been delayed by decades had it not been for the liberating influence of photography.

Fig. 12.2 *Comet* by Lynette Cook, FIAAA.

The kind of panic expressed by some artists following the invention of photography also followed the development of *digital art*, too often misleadingly called "computer-generated art." The last phrase is misleading because it implies that computers *create* art... which they do not. The computer no more creates art than a camera is responsible for the photographs it produces. Without the photographer, the camera is an inert box. It is only when the camera is operated by a human being that a photograph is created. Likewise, without its operator, a computer is an inert collection of plastic, metal, glass, and silicon, in exactly the same way that a chisel, brush, or pencil is an inert tool until manipulated by the hand and mind of an artist.

Fig. 12.3 Photograph of the Running Man Nebula by IAAA member Ken Naiff.

But digital art has its own inherent problems. Computers can help beginners achieve certain effects easily and therefore allow for a plethora of superficially "pretty" images to be created with minimal effort. The resulting lower quality digital works – ones lacking in resolution, design knowledge, perspective, etc. – that are being produced en masse has sharpened criticism of digital art as a unique genre, and again begged the question: Is digital art in fact "real" art?

Fig. 12.4 *Galilean Hiking - Io* by Jett McIntyre Furr.

The answer is obvious: of *course* it is art. *Art* is, by definition, what artists create. It doesn't matter what tools they use to accomplish this. After all, Gutzon Borglum sculpted Mt. Rushmore with jack hammers and dynamite. Yet, the use of a jack hammer doesn't make a Borglum of every road laborer. What makes the difference is the *mind* behind the tool. If it is an artist's mind, then what is being created is art, whether he or she is manipulating pixels or paint. It makes no difference.

Fig. 12.5 *Apollo 8 Christmas* by Mark Karvon.

So, what *is* digital art? As mentioned earlier, perhaps the greatest hurdle facing its acceptance is the very phrase itself: "computer-generated art." There is no such thing. The more fitting term may instead be "computer-aided art." Loosely, we're calling digital art anything of a visual nature that was created with the aid of computer. Although the first big computers built in the 1940s and early 1950s were strictly calculating machines, it was not long before someone realized that a device capable of generating mathematical curves and graphs might just as easily be programmed to generate curves and graphs that were *aesthetically* pleasing. In other words, the computer might be a tool for creating art.

By the mid1960s, a number of artists began exploring ways to exploit the computer. Until this time, the only people attempting to create art digitally were engineers, since they were among the only people who normally had access both to what were then extremely expensive machines, and also the technical expertise to use them. Neither was there any of the interactive software that today is so readily available. Programs had to be created from scratch, custom-tailored to each individual computer. Additionally, there was at first reluctance among many artists to embrace the new technology. There is no question that the complex machines and the math and technology that supported them were intimidating. Many did not want to have to obtain a PhD in programming in order to create a work of art. And there were other artists who strongly felt that computer technology was inimical to the entire idea of art.

Nevertheless, a small number of artists, encouraged by what they had seen being produced by engineers, began to realize that the computer held potential as an artist's tool. The first exhibitions of computer art, held in 1965, were arranged by scientists and featured only work created by scientists. Two years later, artists Billy Kluver and Robert Rauschenberg founded Experiments in Art and Technology (EAT). The organization, funded in part by Bell Labs, was devoted to bridging the gap between the artist, the scientist, and technology. A number of important avant-garde artists contributed work, including Rauschenberg, Andy Warhol, Jasper Johns, and composer John Cage.

Fig. 12.6 An example of early digital art.

In 1968 Jasia Reichardt created a two-month-long exhibition called "Cybernetic Serendipity" at the Institute of Contemporary Arts in London, England. It included work by 325 artists and scientists from around the world, including important work by John Cage, John Whitney, Charles Csuri, Michael Noll, and many others. While not the first such exhibition, it was one of the first to make both the public and the art world aware of computer and electronic art.

The introduction of fractals was a pivotal event in the evolution of digital art. Though fractals involve extremely complex mathematics, the basic concept is extremely simple. Start with an equilateral triangle. Divide one side of the triangle into three equal parts and remove the middle section. Replace it with two lines the same length as the section you just removed. Do this to all three sides of the triangle. The result will be a six-pointed star. Now do this again with the twelve new sides you've created. And do it again, and again…

What makes fractals special is the fact that they look the same at any scale. You can zoom in as much as you like and the fractal will look the same. And, fractals can be found throughout nature. A branch of a tree, for instance, resembles the entire tree. The indentations of a coastline seen from space resemble the indentations of a coastline seen from only a few feet away, or even when seen under a magnifying glass.

Fig. 12.7 *Fibonaccis Mandela* by Simon Kregar.

Today, the creation of complex fractals is done with computers. When they were first plotted in the late 1960s, mathematicians were astonished to discover their amazing beauty, and artists were quick to realize their potential.

Even though artists were beginning to realize the potential of the computer as a tool, there were two major problems that still had to be overcome before the idea could truly gain traction. As mentioned before, there was no way in which an artist who was inexperienced in mathematics or computer technology could work directly with a computer. An artist could not simply install a painting or drawing program into her computer and begin creating – such software simply did not exist at the time. To create a digital image, the artist had to be able to program a computer, and sometimes even build the computer itself from scratch.

Another problem was the availability of computers themselves. Sketchpad, the first program specifically designed to create drawings, was developed at MIT in the early 1960s on a computer that occupied 1,000 square feet (93 square meters) of space and had a main memory of 320 Kb stored in a memory core about a cubic yard in size. By way of comparison, a desktop computer today that costs only few hundred dollars may have up to two terabytes of memory – nearly thirty million times that of the computer used by Sketchpad! The widespread use and development of digital art thus had to wait until small, inexpensive computers and user-friendly software were made available. This did not occur on a wide scale until the 1980s.

Fig. 12.8 *Flare Star* by Robin Pleak.

Computer paint programs use a system based on the pixel (from "picture element"). Images are stored in a computer in the form of a grid made up of pixels. The pixels contain the image's color and brightness information as a series of numbers. Software programs, called image editors, can change the pixels by changing the numbers that describe them. The pixels can be changed individually or as a group. In this way, the entire image can be altered in any way the artist desires.

One of the earliest art programs was KoalaPaint, which was developed in 1984 for the now-defunct Commodore 64 home computer. It came with the KoalaPad, an early graphics tablet, but instead of a stylus the artist used their fingertips. KoalaPaint offered 16 pure colors and 16 "dithered," or blended, colors, along with eight basic tools. In 1985, PC Paintbrush was introduced by the ZSoft Corporation. Like KoalaPaint, it worked in only 16 colors (although the third version offered 256 colors). It was, however, one of the first examples of PC software to use a mouse.

One of the first programs of interest to astronomical artists was Vistapro. This software was specifically designed to produce pictures of landscapes based on accurate terrain data. It also came with terrain data for most of the planet Mars. The software was endorsed by writer Arthur C. Clarke, who made extensive use of it for his book, *The Snows of Olympus* (1994).

Fig. 12.9 The book *The Snows of Olympus* by Arthur C. Clarke, cover art by David A. Hardy.

Fig. 12.10 Photograph of images in *The Snows of Olympus*. Book and artwork by Arthur C. Clarke, photo by David A. Hardy.

Ever since the invention of photography, artists have used photos in many ways. For instance, instead of having a model pose for hours or days, a photo could be taken that could then be referred to whenever needed. Photos also allowed artists access to references that might not otherwise be easily available: landscapes in distant countries, ancient buildings, historical scenes, and so on. Some artists even discovered ways in which they could use photographs directly within their artwork.

When image-manipulation software was introduced, a photo could be scanned, and once it was in digital form, it could either be made part of a larger work of art or it could by itself be manipulated creatively. The ability to digitally manipulate images enabled photographers and artists to achieve effects that previously had been difficult or even impossible. Since the nature of digital images is such that copies are absolutely identical to the original, digital manipulation also meant that changes could be made without causing permanent damage to the original.

One of the most popular of all graphic editors, Photoshop, was introduced in 1990 and has since become an industry standard against which all other similar programs are judged. Photoshop's relatively low cost and ease of use made it widely popular, and it spearheaded major innovations in digital manipulation that nowadays are considered commonplace. With the advent of the digital camera, images could be directly imported into Photoshop and similar programs. The later introduction of the graphics tablet, which allows artists to draw as naturally as if they were using a brush or pen, further revolutionized the creation of original pieces of digital art.

Fig. 12.11 *Neptune by a Long Shot* and a composite of source scenery taken in Iceland by Marilynn Flynn, FIAAA.

Fig. 12.12 *Primordial Sunset* by Ronald Davidson.

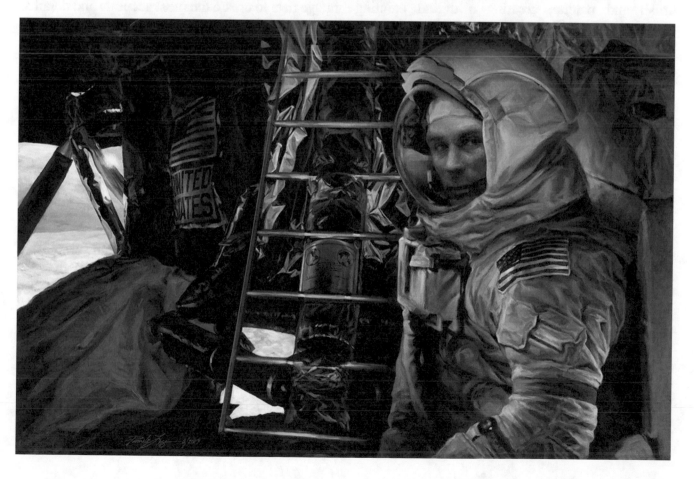

Fig. 12.13 *Last Man Last Look* by Pam Lee, FIAAA.

Although there are many different image manip-ulation software programs available, such as Photoshop, Corel PhotoPaint, Paint Shop Pro, and many others, there are basic functions they all share. Among these are the ability to *select* all or part of an image; change the size and proportions of an image; *crop* an image – that is, the ability to cut away unwanted portions of the top, bottom, and sides; clean up an image by removing dust, scratches, and other imperfections; change or adjust colors, contrast, light, and darkness; cut and paste elements from one image to another; and, perhaps most importantly, the use of *layers*. Layers can be thought of as being similar to transparent sheets of tracing paper stacked on top of each other, each capable of being individually positioned, altered, and blended with the layers below, without affecting any of the elements on the other layers.

There are, of course, a great many other func-tions such software is capable of, with different products offering different collections of tools. The digital artist can treat the computer as his or her canvas, and his or her mouse or tablet like a brush and palette, creating a digital painting directly on the computer. Many traditional paint-ing techniques such as watercolor, oils, charcoal, pen and ink, etc. can be simulated digitally, with varying degrees of realism.

The computer offers an artist some distinct advan-tages over traditional painting. For instance, by work-ing in layers, the artist can keep different elements of the painting separate. By doing so, he or she can eas-ily experiment without permanently changing the entire painting. The artist may want to add a figure to a scene but is unsure of exactly where it should go. By painting the figure on a separate layer, he or she can move it around until it is in the exactly perfect position. And if the artist then decides not to include the figure after all, it can simply be deleted.

The computer allows the artist to undo and redo: a mistake can be undone with a single key-stroke. This single ability is one of the greatest advantages digital artists have over artists work-ing in traditional media. If a digital artist makes a mistake, it can be erased with a simple click, returning the painting to the state it was before the mistake had been made. When a traditional artist makes a mistake, it might require hours or per-haps even days of hard work to undo. If a mistake is bad enough, a painting might have to begin again from scratch.

Additionally, the digital artist also has at their disposal several tools not available to the tradi-tional painter. Some of these include: a virtual pal-ette consisting of millions of colors, almost any size canvas or media, immediate access to tools such as pencils, air brushes, spray cans, brushes, and sponges, as well as a variety of special 2D and 3D effects.

The first digital painters worked more or less in traditional styles such as realism, impressionism, etc., but soon realized that the computer allowed them to evolve new, unique techniques and styles. Some were combinations of traditional styles, while others required new definitions. Suddenly, artists were able to mix media that would have been difficult or impossible to do in reality.

Some astronomical artists work directly with the data from space missions, using scientific image data to create the most accurate and detailed art images possible. One popular data source is NASA's JUNO mission to Jupiter. The processing required can be complex, as one must adjust for such factors as differing viewpoints from the rap-idly moving spacecraft when combining images, but the results can be spectacular, as processed images can bring out subtle details that may not be clear in the raw data.

Although digital art has been thoroughly accepted in the commercial art world, it still has not gained the level of respect accorded to "serious" art forms such as sculpture, painting, and drawing, perhaps due to the erroneous impression of many critics that "the computer does it for you," as well as the idea that an infinite number of copies can be made of a digital painting – there is no unique "original." Many of the objections to digital art have been over-come by the development of the *giclée* print, a high-quality method of reproducing digital artwork that features brilliant, permanent colors. Artist can now use these new printing technologies in the creation of original, physical artwork.

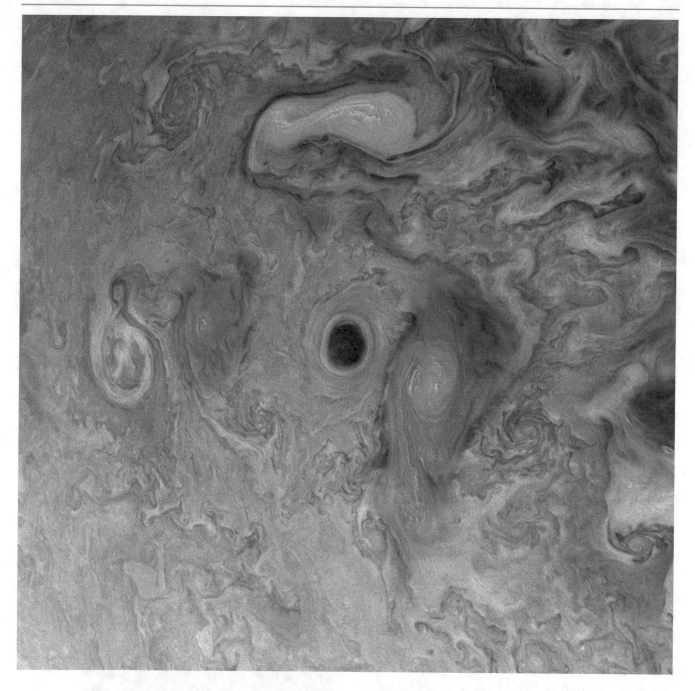

Fig. 12.14 Enhanced JUNO mission photograph of Jupiter's clouds by Bjorn Jonsson.

As in any other art form, there are as many different approaches to digital art as there are artists working in the media, with artworks ranging from the wildly surrealistic and abstract to images that are photographic in their realism, and every conceivable technique and style in between. And nowadays, many artists have realized that an artwork does not have to be either wholly digital or wholly painted. This has led to the evolution of hybrid works of art that combine the best features of traditional painting techniques and digital media. For instance, an artist may do a painting in oils, acrylics, or watercolors, scan the painting, and then complete it using computer software.

There are three primary kinds of digital software that space artists use. The first is software that give

Fig. 12.15 Wireframe model, details, and initial render of the New Horizon probe by Dan Durda, FIAAA.

the artist the ability to paint and draw naturally, emulating the effect of traditional media. This includes the ability to manipulate photographic images.

The second kind of software has the capability to create 3D models of spacecraft and other hardware. A 3D model can be rendered as simply as a *wireframe model,* or it can be shaded in a variety of ways. By including appropriate light, shadow, and color, the model may appear to be photographically realistic. Most 3D models that are intended for general viewing are covered with a *texture.* A texture is really nothing more than a graphic image, like a photo, that is fitted over the surface of the model like a form-fitting skin. It gives the model more detail than a simple flat color would, with the result that it looks more realistic. A 3D model of an animal or person, for example, looks much more realistic with a texture map of skin, clothing, scales, or fur than it would as a simple wireframe model.

Realism can be enhanced even further by employing special techniques such as *bump mapping.* Bump maps can create three-dimensional textures. An artist creates a special texture map for this purpose by painting what will be the three-dimensional texture as a pattern of light and dark areas. The com-

Fig. 12.16 Height map file for image by Ron Miller, FIAAA.

puter interprets anything that is light as being high and anything dark as being low. Three-dimensional modeling is most often performed by means of programs created especially for that purpose, such as Lightwave, Rhinoceros 3D, or Maya.

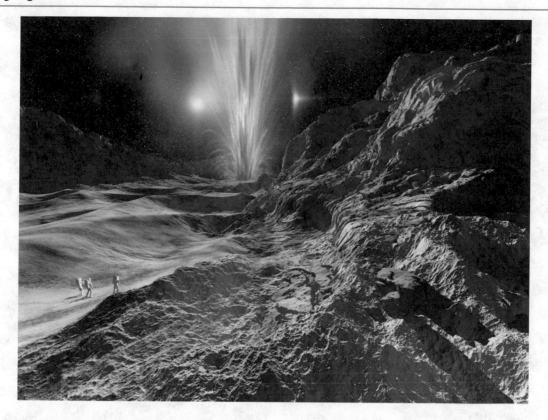

Fig. 12.17 *Cryogeyser on Enceladus with Explorers* by Ron Miller, FIAAA, image utilizes the height map above for 3D texturing.

The third common software is *terrain generators*. Programs such as Bryce, Terragen, and World Machine allow the space artist to create photorealistic, accurate renderings of extraterrestrial landscapes. Each of these programs works in different ways, but what they essentially do is to convert a *heightfield* or *digital elevation map (DEM)* into a realistic-appearing landscape, complete with (if required), light and shadow, textures, and atmospheric effects. Heightfields or DEMs are similar to bump maps in that they read light areas as being elevations and dark areas as being depressions. Heightfields can be created from real places. For example, NASA provides digital elevation maps of the Moon, Mars, and other bodies, while the US Geological Survey (and similar institutions in other countries) provide DEMs of regions of Earth. All of these can be incorporated and manipulated by the space artist, especially since a heightfield map is really nothing more than a black and white image. By using paint tools, the artist can add, delete, or alter any features they like. It is even possible to create heightfield maps entirely from scratch, which many space artists do.

One new technology being embraced by artists is 3D printing. This technology gives an artist the ability to take an object created in a 3D modeler program and actually, physically create it.

Plastic is the most common material used for printing, but other materials such as metal and wood are being developed for this purpose. With the ability to make physical versions of digital models, new opportunities for unique exhibitions have opened up. The UK's National Space Center features 3D printed models of rockets and satellites, such as the Blue Streak Rocket, which can be picked up and felt. This has proven to be very popular with children as well as visitors who are partially sighted.

Fig. 12.18 3D printing of the Blue Streak rocket on display at the National Space Centre by Nick Stevens, FIAAA.

What may be the future of digital art is the rapidly developing genre of virtual reality. This is the creation of an image with a complete 360-degree by 360-degree field of view. Usually seen through special goggles or a headset, these images immerse a viewer into a scene, giving them the ability to look around, up, down, and behind, and see things like they are actually there, occupying physical space. Virtual reality images often combine all digital techniques, mixing digital and traditional media, blending photography, 3D renders, textures, and bump mapping to achieve the most realistic effects. Using the latest data from probes, satellites, and scientific study, such images can place an art aficionado, astronomer, or scientist onto the very surface of bodies around our Solar System, or around distant stellar objects. And it is even possible to populate these locations with digital recreations of vehicle and spaceship designs that were never built. The artistic possibilities of the digital world are truly amazing.

Fig. 12.19 *Lunar Unicycle* by Frank Tinsley.

Fig. 12.20 *Lunar Unicycle with Earth* by Nick Stevens, FIAAA.

More than Paint or Pixels: Three-Dimensional Space Art

Matt Colborn

Astronomical art is more than just paint on a canvas or pixels on a screen. It can and does encompass many other forms of artistic expression that extend into three-dimensional space.

Fig. 13.1 *Mantle Chandelier* by BE Johnson, FIAAA and Joy Day, FIAAA.

M. Colborn (✉)
Bourne, UK

© Springer Nature Switzerland AG 2021
J. Ramer, R. Miller (eds.), *The Beauty of Space Art*, https://doi.org/10.1007/978-3-030-49359-2_13

There are many forms of art, but only one that breaches the third dimension: sculpture. The perspective of a sculpture is always different, the artwork constantly changing as light and shadows shift and the viewer sees the work from different angles.

As with two-dimensional art, sculpture falls into categories of style: abstract, expressionistic, representational, and others. Materials range widely. Just about any substance can be employed by an artist. Many artists use multiple materials, while others may choose only one. Other artists may use multiple disciplines on one work – sculpt the physical form in the material of choice, then paint it to achieve a certain effect. The combinations are endless.

Sculpture is a difficult, challenging medium. This is not to say that two-dimensional art is not difficult or challenging. Nothing could be further from the truth. Sculpture is demanding; like two-dimensional painting, it must exist in real time and in real space. But it must be built in physical form and, in order to be successful, it must be viewable from all angles. Parts must fit together and do so effectively and in a pleasing manner. If it is a kinetic work, the sculpture must actually "work."

Fig. 13.2 *Fireballs* by Patty Heibel.

Mistakes in a sculpture's creation are difficult to hide, especially if the work is representational. Imagine the stone statues of Michelangelo. One slip of the chisel that removes too much, and the work may not be salvageable. After a certain point, a wooden or stone sculpture's path is set. When working in metal casting, corrections in the original clay form are possible, but they must still be carefully considered or the final shape may not be able to support itself. And once cast, it is extremely difficult or even impossible to fix an error that wasn't noticed until viewed from a different perspective. Such are the challenges that the space artist takes on in his or her attempt to create in the form of sculpture.

There are only a few astronomical artists who work in three dimensions, but they have done so gloriously, using a wide range of diverse materials and creating works in categories equally diverse. Each creator has a unique viewpoint and the finished forms tell their stories in ways that no other medium can.

One challenging three-dimensional medium is ceramics. Artist Joel Hagen creates ceramic sculptures of skulls and skeletons intended to have the feel of paleontological museum specimens – but in his case, the paleontology of other worlds. Joel's creations tease the imagination of the viewer, inviting the viewer to participate in the creative process. Instead of modeling an entire extraterrestrial creature, Joel sculpts just the skull or skeleton in the hope that the viewer's imagination will flesh out the creature itself. There is something a bit "mysterious" about skulls and skeletons, archaeology and paleontology. By taking that mystery, science, and romance to the realm of other worlds, he helps viewers experience a little of what it might be like to jump ahead in time and visit a Museum of Extraterrestrial Life. Joel says,

> I try to make the sculptures look realistic in order to engage the viewer. By retaining familiar elements like eye sockets, teeth or beaks, the viewer immediately recognizes something familiar, yet alien. Most of the extraterrestrial life forms I have designed for programs about life in the universe are intended to be more scientifically speculative and do not look so familiar. By contrast, these creations are intended to be more in the realm of art, engaging people to imagine worlds and life beyond our own planet.

Joel also creates these alien "fossils" out of a modelers resin. It is slightly easier to work with and the finished works are less fragile than ceramic.

Another of the most demanding 3D mediums is glass. An unforgiving material, it is dangerous, time consuming, requires a lot of practice, and is expensive to work with. The materials, equipment, and energy costs are substantial and require levels of planning not needed when doing work in two dimensions. Glass as a medium has been described as, "Disastrous when things go wrong, glorious when they go as planned, delightful when serendipity steps in."

Two space artists that work in glass are BE Johnson and Joy Day. They approach new ideas in their craft as artist-engineers. Once an idea has been hatched, the sculpture is fully modeled and rendered in various high-end 3D applications to preview just how it will look, what shapes will be required, and if it will work the way it is designed to work. Engineering adjustments are made to the design until it both works and looks artistically pleasing, then the metrics of the components are extracted from the model and fabrication of the parts begins. The final work of art is assembled as each part is completed, which is usually where more artistry comes into play, to compensate for the variations and take advantage of serendipities that occur as parts are hand-manufactured.

Sculpture is by no means the only option for those who wish to work in media other than pixels or paint. Robin Hart creates masterpieces in fiber arts and art quilting. Hart's works are created using fabric that can be pieced together, appliqued, or made using a whole cloth, mixed materials, and paints and dyes. Hart makes her quilt pieces with a layered structure, with the art piece on top, batting sandwiched in the middle to give form and texture, and a back-fabric underneath. Threadwork then integrates the three component pieces in ways that complement the color and design. The integration is accomplished with a sewing machine. Robin guides the fabric through the machine needle to create design patterns. Binding then fixes the raw edges around the border of the quilt.

Fig. 13.3 *Alien Skulls* by Joel Hagen, FIAAA.

Fig. 13.4 *Orrery* by BE Johnson, FIAAA and Joy Day, FIAAA, a glass and wood combination sculpture.

Fig. 13.5 *Exploring New Worlds* by Diane C. Taylor. This image is made of layers of glass fused together in a kiln.

Fig. 13.6 *Celestial Spirals* by Joy Day, FIAAA and BE Johnson, FIAAA. Glass sculptures given as a lifetime achievement award by the Space Foundation.

Examples of Robin's work include *The Pillars of Creation*, based upon a Hubble Space Telescope photograph of the Eagle Nebula, showing glowing columns of interstellar dust and gas. Robin states that the background of the quilt is composed of a grid of squares in cotton batik. This is supposed to signify the pixelated data of deep space images. "Applique pieces of material were then fused to the fabric with sewing to soften the design and create undulating lines and movement. The art piece was then heavily thread-painted by free motion quilting over the entire surface in multi-color threads," Robin says "...the goal of this artwork was to express the dynamic energy of stellar birth through color, texture and form."

Another of her pieces shows the stellar nursery in the Orion Nebula. She used fabric paints and dyes on the surface, creating the shape of the neb-

ula. "Again, the threadwork in this space art quilt is quite heavy, with colors complementing the subject for texture and design. This accentuates the patterns in the nebula." She suggests that vibrant colors of the piece "...show the dynamic energy of the act of creation in stellar birth."

An intriguing aspect of three-dimensional art is model making, an artform with a long history. In his 2006 book *Scale Spacecraft Modelling*, Mat Irvine points out that scale models were found in Egyptian tombs. Famed space artist Chesley Bonestell often built models of rocket designs in order to paint them with the correct lighting and shadows (see Chapters 3, 4, and 5). Some of the most beautiful examples of three-dimensional space art can actually be found in movies – the spaceships of *2001: A Space Odyssey* (1968) being perhaps one of the most famous examples.

Fig. 13.7 *Pillars of Creation Quilt* by Robin Hart.

Fig. 13.8 *The Pillars of Creation* by Barbara Sheehan.

Fig. 13.9 *The Orion Nebula Quilt* by Robin Hart.

Models have been used for decades to depict spaceships in Hollywood television shows too. The first model of the starship Enterprise from the 1966–1969 show *Star Trek* now hangs in the Smithsonian National Air and Space Museum. Rick Sternbach worked on the sequel shows, *Star Trek: The Next Generation* and *Star Trek: Voyager*. He not only designed and built models of several spacecraft, but also assisted in converting the physical models into computer models for rendering scenes via computer. He also created a method of bringing the surface of Mars and the moons of Jupiter a bit closer to home. Using elevation data returned by far-flung space probes, Rick produces three-dimensional, scale geologic forms in resin so distant worlds can be held and seen as if flying at altitude over them. Valles Marineris, Kasei Valles, Gusev Crater, Olympus Mons on Mars, Tohil Mons on Io, and grooves on Ganymede take magnificent form in highly accurate resin castings. More than just maps, these works are carefully selected to show the beauty of distant, alien landscapes.

Fig. 13.10 Photograph of model made by Chesley Bonestell for one of his paintings.

Rick also uses his experience in fantasy spaceship design to create plausible ships. He designed and built a 1:100 scale rough study model out of card stock, foam core, and styrene of a vessel he calls the Solar System Explorer. It is meant to help understand what it might take to build a modular spacecraft for exploring the Moon, Mars, and even Mercury and Venus. The central structural core, attached propulsion, propellant, habitat sections, and other necessary equipment provide the dimensional foundations for the detailed, scratch-built, and 3D-printed parts for the model, which currently measures some 56 inches (142 centimeters) long. The purpose of creating such a detailed model was to demonstrate that a modular design for the SSE would allow different configurations of the vessel to be built, such as a smaller ship for lunar operations, just by moving different parts around – something easy to do with a model.

The SSE ship concept was inspired by fifty-plus years of interplanetary spacecraft designs. Nothing says the real thing will look exactly like this, but space artists like to explore different ideas, consult with engineers and scientists, and create models, paintings, and computer art dealing with humanity's future in space.

Mike Mackowski, author of a series of books titled *Space in Miniature* (1990–2019), has also built scale models of space hardware for decades. Especially notable are Mike's models depicting variants of the 1960s two-person McDonnell Douglas Gemini spacecraft. He creates dioramas of scenes using 1/48th scale Revell models and embellishes them with handmade parts made from a modeler's urethane resin. The value of this technique is being able to construct models of variants of the spacecraft that never passed the planning stages. One intriguing diorama is a Gemini lunar lander variant, the Lunar Rescue Gemini. The scale model displays a proposed design to use a Gemini capsule as a rescue vehicle in the emergency circumstance of Apollo astronauts being stranded on the Moon. The design never went beyond drawings, and no parts of the design were ever constructed or even modelled, but Mackowski's mostly scratch-built scene brings the craft to life.

Mike believes that "Enthusiasts want a piece of the space program they can see up close, hold in their hand, and relate to three dimensionally."

Although CGI models now tend to be prominent in the movies, physical models are still used for some special effects. In a YouTube interview for *Fine Scale Modeler*, Mat Irvine said that both models and CGI should be seen as tools, available for selection when needed. Often, there is a kind of mixed media approach, too, with models and CGI used together, taking advantage of the best features of both. In some movies, 3D models are enhanced with CGI.

Fig. 13.11 Photograph of model of the USS Discovery used in *2001: A Space Odyssey*. Photo by Jon Ramer.

Fig. 13.12 *Tohil Mons on Io* by Rick Sternbach, FIAAA.

As briefly mentioned in Chapter 12, virtual reality is a booming digital art form that combines digital painting skills with the third dimension. It is the creation of graphic "objects" that so closely mimic what objects in real life look like that they become indistinguishable from reality. When placed in a 360-degree virtual environment, a collection of objects can realistically simulate the views of faraway places. In the book *Team Human* (2019), Douglas Rushkoff states that virtual reality might be the basic tool needed to start a new Renaissance in art – the equivalent of the discovery of perspective in the fifteenth century.

Artist Lonny Wayne Buinis specializes in the production of VR artwork, a prime example being *The Jupiter Object*, a VR image he produced in cooperation with space artist Lucy West that was featured in the 2020 show *Art of the Cosmos*.

The Jupiter Object is the world's first ultrahigh-resolution VR image of the planet Jupiter. Buinis combined a 3D model of the planet with Hubble Space Telescope photos of Jupiter plus two images painted by West. When viewed through a set of VR goggles, *The Jupiter Object* can be rotated in all

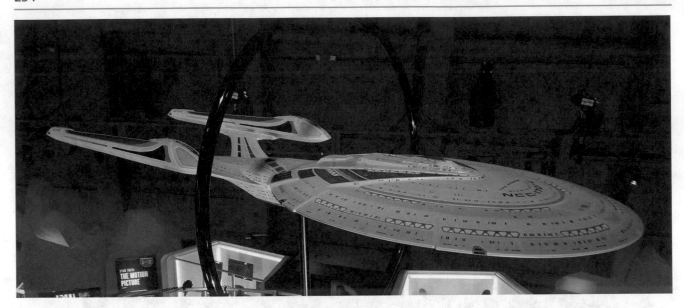

Fig. 13.13 Model of USS Enterprise NCC 1701-E used in the movie *Star Trek First Contact*. Photo by Jon Ramer.

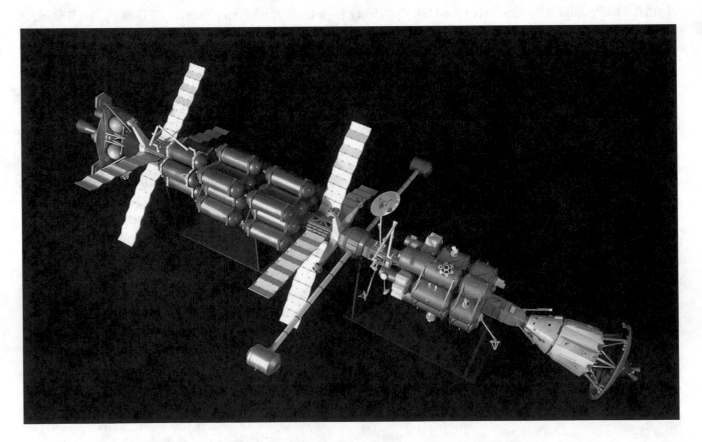

Fig. 13.14 *Solar System Explorer Model* by Rick Sternbach, FIAAA.

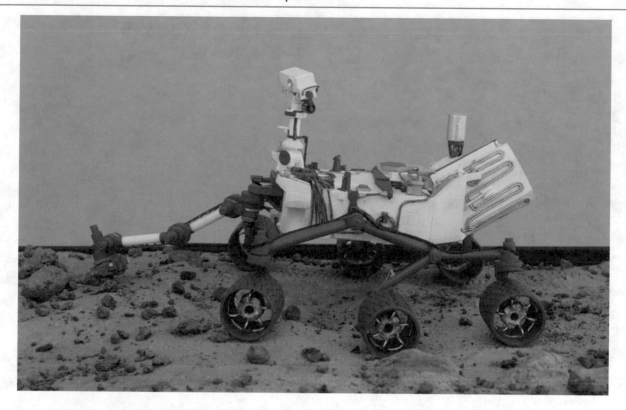

Fig. 13.15 *Curiosity Rover, 1/48*[th] *scale* by Michael Mackowski.

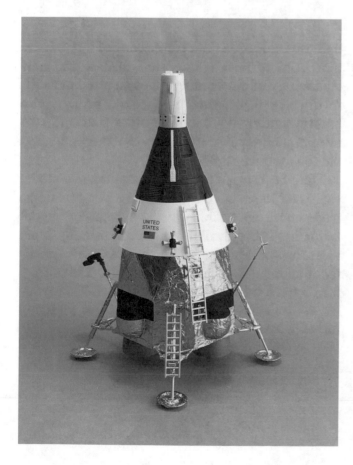

Fig. 13.16 *Lunar Rescue Gemini* by Michael Mackowski.

three dimensions with pointing hardware or fingers on any graphics capable device, including smartphones. The model, photos, and painted art are stacked and blended together with key features indexed in each layer. A zoom feature allows a viewer to see the planet from afar, then zoom down to witness the incredible detail of the atmosphere in Lucy's meticulous, hand painted work.

Another VR project of Lonny's was produced from the historical Slipher maps of Mars, drawn between 1958 and 1962. Earl C. Slipher worked with Percival Lowell, expanding upon studies of the apocryphal canals after Lowell's death. By the 1950s though, Slipher was no longer convinced the markings were canals of a Martian civilization and so made his work more ambiguous, suggesting that they might be signs of vegetation instead. Slipher's map was used by the US Air Force and NASA for planning the Mariner missions in the 1960s. Some of the albedo features he created actually correlate well with modern maps. For example, Slipher painted an area on his map called "Edom" which is depicted as an indent in the planet. It is in fact the crater Schiaparelli, though this was not recognized as such until it was photographed in 1965. A VR

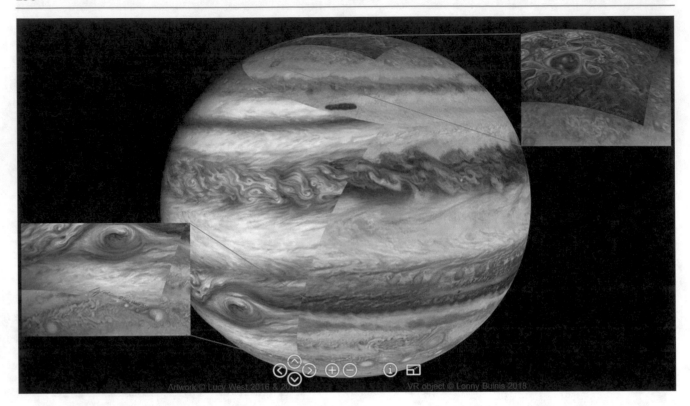

Fig. 13.17 *The Jupiter Object* by Lonny Buinis and Lucy West.

object was created of the Slipher map for the e-book *Space History Mysteries Solved* (2019), illustrated and animated by Buinis. With virtual reality, artists can literally recreate scenes of far off planets and depict historical events with uncanny realism.

VR artwork is an example of the ultimate fungibility of art. Through it, one medium can blend into another, sometimes almost seamlessly. Paint can be physically put on a canvas, then photographed or scanned into a painting program, such as Corel Draw, Affinity Photo, or Photoshop, then those pixels can be mapped onto objects and placed into a three-dimensional virtual landscape. A photograph of a rock in the Grand Canyon can be morphed into a rock in Valles Marineris on Mars, then placed into a 3D model

that uses elevation data from scans of a real location. And to take it one step further, the new technology of 3D printing gives an artist the ability to take that virtual image and print it into reality, adding other objects like spacecraft or even modelled alien lifeforms to the scene, all at the touch of a button.

The categories of painting, sculpture, and model work can blend together into new combinations, made more accessible by the advent of digital technology. The availability of 3D printing blurs these lines still further, giving an artist the capability of taking a two-dimensional image and turning it in a three-dimensional, solid object. These varied works can take on many beautiful, inspiring forms in many varied media.

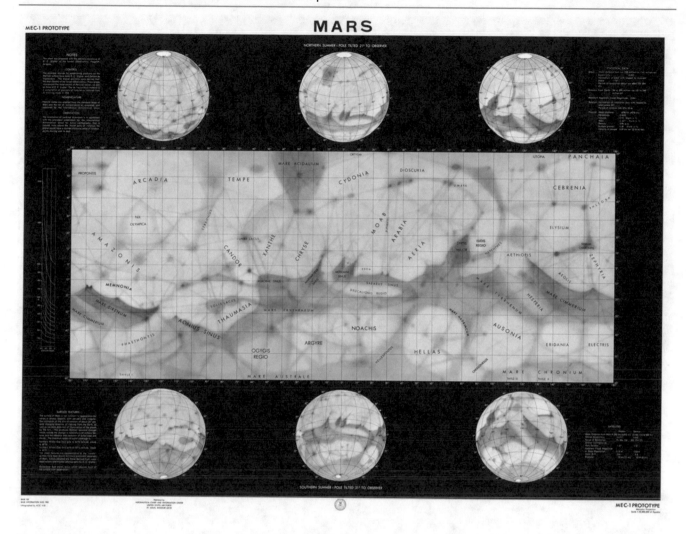

Fig. 13.18 *Map of Mars* by Earl C. Slipher, 1962. Published by the Aeronautical Chart and Information Center, US Air Force.

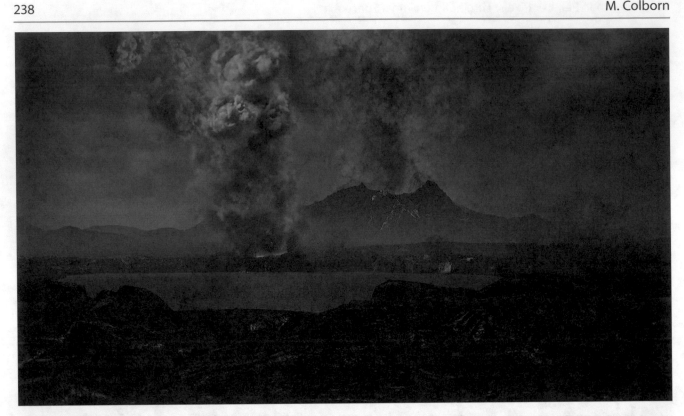

Fig. 13.19 *Evolution of Venus* by Michael Lentz. Two scenes from a virtual reality movie depicting the evolution of the planet Venus over a billion years.

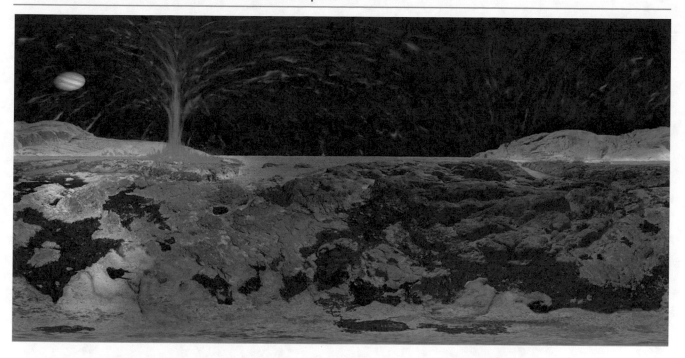

Fig. 13.20 *VR Loki Patera on Io* by Jon Ramer, FIAAA. This image is the two-dimensional flat file of a virtual reality image. When displayed in VR goggles, the image wraps completely around a viewer.

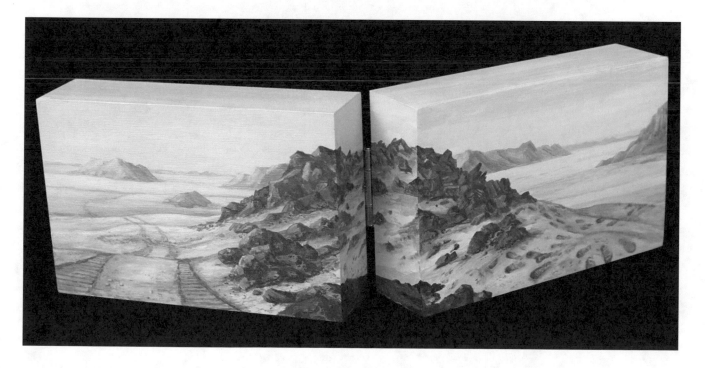

Fig. 13.21 *Today's Tracks, Tomorrow's Footprints* by Lucy West.

Mark Garlick

The subjects artists paint cover every aspect of humanity's existence, from the most mundane occurrence to the grandest and most spectacular of occasions. But space art offers views on objects that no human has ever seen or is likely to see.

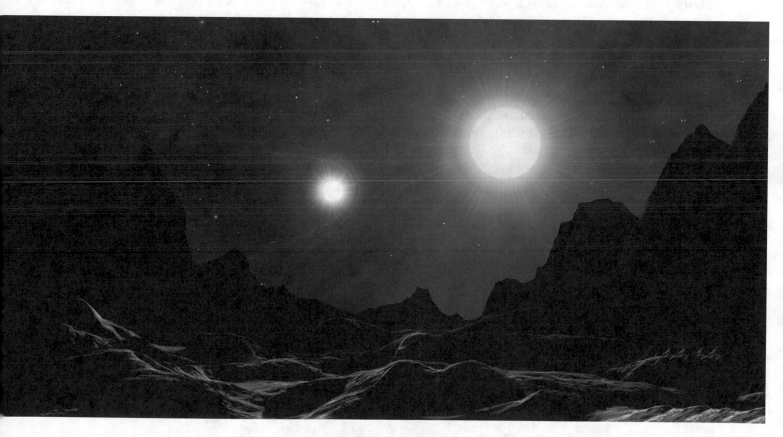

Fig. 14.1 *Blues for a Dead World* by Mark Garlick, FIAAA.

M. Garlick (✉)
Hove, UK

© Springer Nature Switzerland AG 2021
J. Ramer, R. Miller (eds.), *The Beauty of Space Art*, https://doi.org/10.1007/978-3-030-49359-2_14

"Space is big. You just won't believe how vastly, hugely, mind-bogglingly big it is. I mean, you may think it's a long way down the road to the chemist's, but that's just peanuts to space."

Douglas Adams, The Hitchhiker's Guide to the Galaxy

The venerable Mr. Adams was absolutely right – space is exceedingly, well, spacious. Indeed, no matter how hard we try to fathom how mind-bogglingly big it really is, the only real way to get a sense of the scale involved is to shrink everything down to user-friendly dimensions.

Let's imagine that the Sun were about the size of a marble, an inch across (25.4 millimeters). That's a scale reduction factor of *55 billion*. On this scale, the nearest star, Proxima Centauri, would still be 46 *miles* (74 kilometers) away. Such a huge gulf separates us from all of our stellar neighbors. The only star we have ever studied up close is, of course, the Sun. Only a handful of stars are large enough and/or close enough for astronomers to be able to resolve their discs in powerful telescopes. Betelgeuse, in the constellation Orion, was the first such star to have its surface directly imaged. Betelgeuse is in reality tremendously larger than our Sun, its diameter extending farther than the orbit of Mars! Still, at 640 light-years distant, it is so far away that it would take 13 *million* star-points like Betelgeuse to cover an area of the sky comparable to the Moon.

So vast is the universe that astronomers have to measure distances not in ordinary units such as the mile or the kilometer, but in light-years or parsecs or multiples thereof. A light-year is the distance that light, traveling at 186,200 miles per second (299,800 km per second) traverses in a year. A parsec is 3.26 light-years. The nearest stars to Earth are a few light-years away. This dwindles in comparison to the size of the galaxy we inhabit, the Milky Way. It is shaped a little like two fried eggs back to back, measures a good 120,000 light-years across, and contains 200-400 billion stars. All the stars you can see in the night sky occupy a spherical bubble only a few thousand light-years in diameter, centered on the Earth. This is a tiny fraction of the Milky Way's not inconsiderable cargo. The most remote objects of all, such as quasars, are billions of light-years away and have distances measured in megaparsecs – 1 megaparsec being equal to 3.26 million light-years, or a 19.2 trillion *trillion* miles.

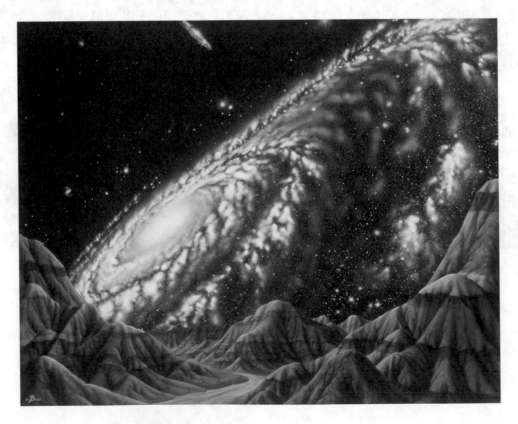

Fig. 14.2 *Vista Galactica* by Kim Poor, FIAAA.

But there is more to deep space than stars and galaxies. There are vast clouds of gas and dust called giant molecular clouds, which are the birthplaces of stars. There are smaller gas clouds – properly called nebulae (from the Latin for "cloud") – such as planetary nebulae and supernova remnants, which are the remains of stars that have run out of fuel and expanded or exploded. Other even more exotic objects are everywhere, from within our galaxy to the edge of the observable universe. Most notable and awe-inspiring are black holes – an object with such powerful gravity that not even light can escape them. The largest are the so-called supermassive black holes, which lurk at the cores of many – perhaps even most –

galaxies, including our own, and can contain as much matter as billions of stars. Neutron stars are another interesting phenomenon. Created when massive stars die, they cram the entire mass of a star into a rapidly spinning sphere no larger than a city. Some of them, called magnetars, have such powerful magnetic fields that they would wipe your credit cards and whip spoons off your dining room table from hundreds of thousands of miles away. Another recent area of active research is the exoplanets – planets orbiting stars other than the Sun. Since astronomers found the first few in the early 1990s, the number of known alien planets has ballooned to more than 4,000, with new ones found almost daily.

Fig 14.3 Exomoon by Ray Cassel.

Our telescopes are great for observing things such as nebulae and galaxies, which appear relatively large on the sky. But most deep-space objects are beyond the reach of imaging devices. Stars are just pinpricks even under the highest magnification; black holes emit no light; neutron stars are puny; and exoplanets are far too dark to be seen with any telescope, except as dots of light (most of them are not visible at all, their presences being inferred indirectly). So, we are lucky that we have in our arsenal not just powerful telescopes and space observatories like Hubble and Spitzer, but a unique breed of artists who, using their creativity and understanding of physics and chemistry, can go where these instru-

ments cannot. What we cannot directly see, space artists can imagine for us.

People tend to have difficulties imagining what astronomers try to tell us, the true scale and size of the universe. Most can understand the science of how astronomical data is collected, but what the data means is often quite elusive, especially for the most distant objects in space. For space artists, the idea behind a nebula or galaxy and the challenges of finding a balance between the data and the science to create an appealing image are enamoring. Deep space is filled with strange and mysterious objects – which are often fun to paint – and the data from probes and telescopes is critical to depicting them correctly.

Fig. 14.4 *The Brush Strokes of Star Birth* by Lucy West.

In general, there are two classes of subjects in space art. The first are those phenomena for which w3e have close-up photos and images from probes and telescopes. This includes images of most the Solar System's planets and moons, but for deep-space objects it is limited to large-scale structures such as nebulae and galaxies. For space artists, it is a relatively simple task to render their own visions of these objects. Everyone knows what a galaxy looks like. But having said that, the artist still has to use their imagination and break a few rules. "The point of art is that we can show things that no 'photo' can show," explains artist David A. Hardy. "But to make it interesting to the viewer we usually need to exaggerate color, details, etc."

"To some extent 'rules' are subjective," says space artist Lynette Cook. "Realism and accuracy are critical to producing a successful image, yet sometimes elements must be exaggerated in size, color, positioning, or some other element in order to depict what is m`ost significant about the subject or discovery. This is why it is important for the artist to consult/collaborate with science writers, astronomers, and discoverers – and also to be cognizant of the purpose/use/audience of any given piece of art."

A good example of this rule-breaking is with the depiction of, say, a nebula or a galaxy as seen from the imaginary vantage point of a nearby planet. We are all used to seeing these exotic objects rendered in deep, rich colors in processed Hubble photos. But up close, these things would probably disappoint the casual human observer. If the Andromeda Galaxy, for example, were located just outside the Milky Way (it is 2.5 million light-years away), it would look huge in our skies – but at the same time, its light would be spread over a vastly bigger area, which greatly dilutes the details. A camera can "integrate" the light it receives. By leaving the shutter open for long periods, the light is amplified and the end result is a beautifully detailed photograph. But the human eye cannot do this. To the eye, the view is much different – not just fainter, but different in color and tone, for our eyes have a different sensitivity and perceive color differently than cameras. For these reasons, such are necessarily exaggerated.

The second class of subjects in space art is that for which no high-resolution photos exist. This category includes pretty much everything else in deep space: black holes, stars, exoplanets, pulsars, quasars, etc. Here, the artist has to use even more imagination, because they have very little visual stimuli to build upon.

Indeed, the first "image" of a black hole was created in 2019 by the Event Horizon Telescope (EHT), a planet-wide array of eight ground-based *radio* – not optical – telescopes. Data from each telescope was combined in a supercomputer to create an image of unprecedented detail, but even this image is not a visible light image that the human eye would see – rather, it is computer generated. For the foreseeable future, the only detailed views we are likely to see of a black hole are those created by artists.

Nobody has ever seen an exoplanet up close, or, as explained earlier, any star other than the Sun. However, we know what the Sun and the Solar System planets look like. So, if an artist is trying to depict a gas giant orbiting a distant star, they at least have some idea where to start. Like Jupiter, it's likely to be gaseous; it may have rings like Saturn, and it'll almost certainly have satellites in orbit around it. Where the artistry comes in is in imagining how this distant world might differ from, say, Jupiter or Neptune. Perhaps they'll choose to show its atmosphere as turbulent like Jupiter's, but in greens instead of browns. And if its parent star is a different color from our Sun, this will also affect the planet's appearance. This form of space art is about applying what we know and blending that with a bit of imagination, while trying not to break the laws of physics!

Fig. 14.5 Reflecting Planet by Richard Bizley, FIAAA.

Fig. 14.6 *The Rosetta Nebula* by Eileen McKeon Butt.

Fig. 14.7 *Jetting Galaxy* by David A. Hardy, FIAAA.

Fig. 14.8 *Quasar* by Lynette Cook, FIAAA.

Fig. 14.9 *NGC 6357* by Patty Heibel.

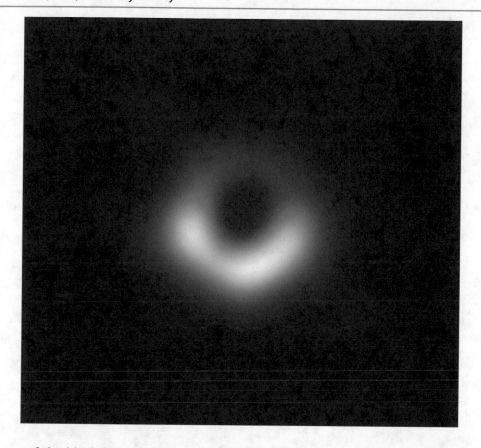

Fig. 14.10 Image of the black hole in the center of Messier 87 by the Event Horizon Telescope, ESA image 1907a.

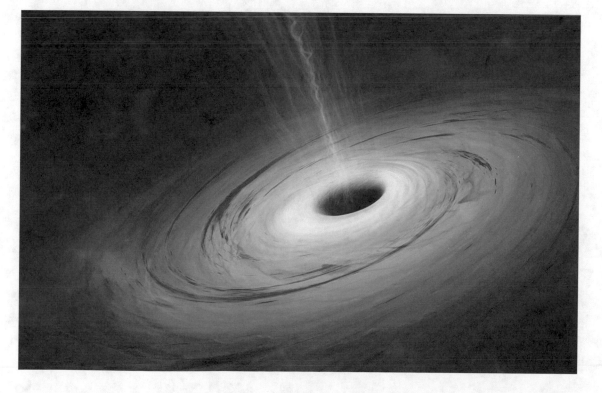

Fig. 14.11 *Black Hole* by Mark Garlick, FIAAA.

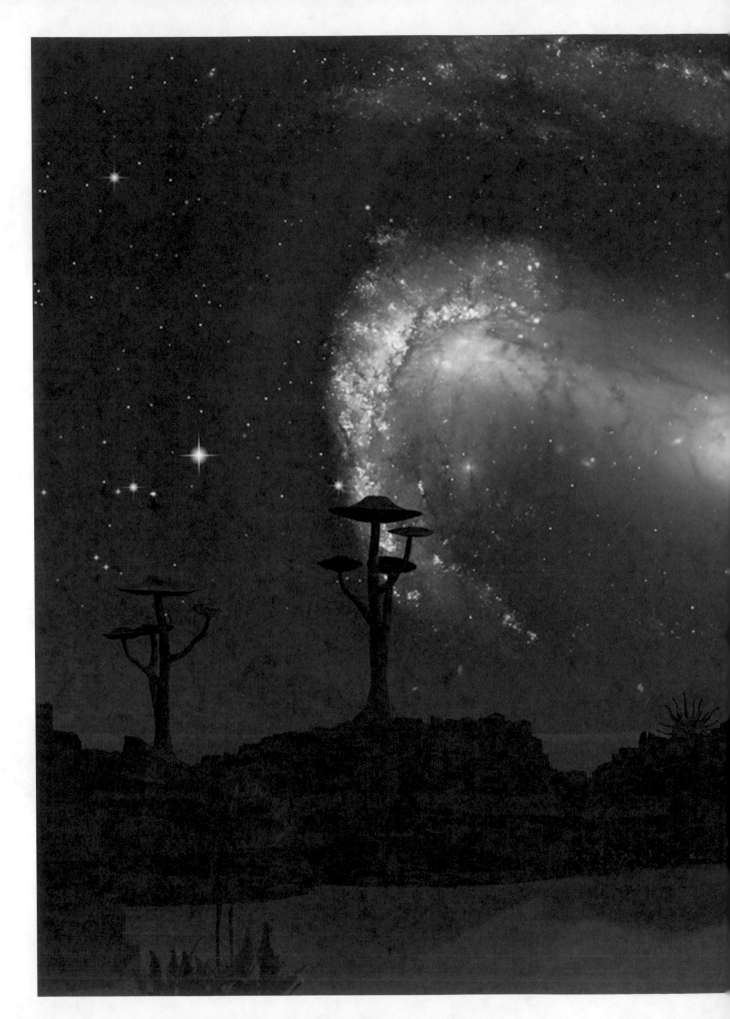

Fig. 14.12 *Red Galaxy Sunset* by Walt Myers.

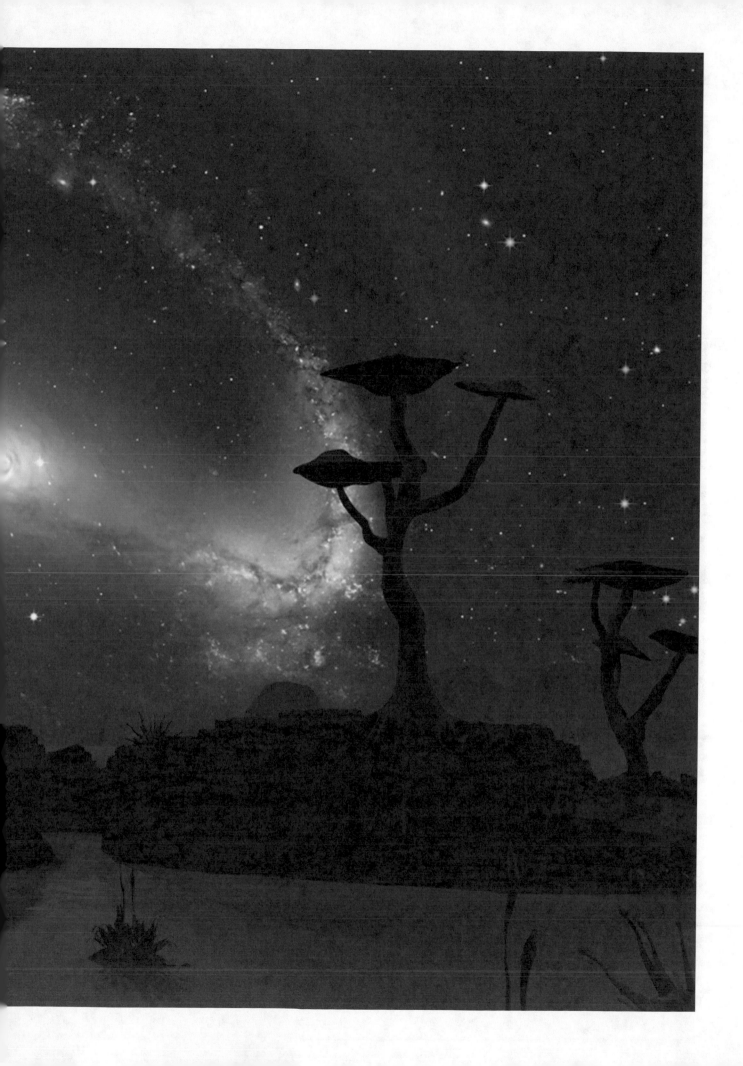

Depicting alien stars is another interesting and challenging problem. Almost everything we know about stars comes from our study of our Sun. Some of that knowledge can be used to predict what other stars might look like up close. We know that cool stars will have starspots on them, analogous to the sunspots that pepper the Sun's face – an observation that prompted Galileo, upon first spying the Sun telescopically, to declare it "spotty and impure." These cooler stars have convective surfaces like the Sun, and so will likely exhibit the familiar "pebble-dash" appearance we call *granulation*. It is caused by convection cells, heated from below and rising to the surface in gigantic "packets" of plasma. Most starspots are actually far larger in surface-area fraction than those on the Sun – they are more like continents than spots. Hotter stars will lack them entirely. And larger stars, such as red giants and supergiants, will look very different from the Sun up close, as they are not perfect spheres. Here, the convection cells are so huge that they occupy vast fractions of the star's surface, giving it a lumpy appearance.

Fig. 14.13 *Red Giant Sun* by Don Dixon, FIAAA.

Armed with this knowledge, a space artist striving for realism can then use his or her imagination to depict, say, a blue giant star seen from the vicinity of a nearby world. But again, exaggeration is needed. We all know how impossibly bright the Sun is. Now imagine a star like Rigel, a blue giant 66,000 times more luminous. It is impossible to show such a scene entirely accurately. With a camera we could use an extremely small aperture or a very short exposure time to capture the star, but then the foreground landscape will be deeply underexposed and dark. For the same reasons, stars are not visible in the sky in photos taken from the Moon's surface. So, an artist will need to imagine the star as if seen through some heavy filters, but render the landscape as if not. They need to play with the light in their scene to come up with something that looks right in our eyes.

Fig. 14.14 *Barren Rock, Living Light* by Jackie Twine, FIAAA.

Interacting binary stars are another interesting subject to portray. These are stars that orbit each other so closely that – so our knowledge of physics tells us – one or both on them is distorted by the gravitational pull of the other. These systems are so tightly bound together that quite probably no visible-light telescope will ever be able to resolve their individual members. We have only the skills of astronomical artists to show us what these might look like to the human eye in reality. One space artist who enjoys this subject is the author of this chapter, Dr. Mark A. Garlick, who has a PhD in astrophysics and studied these fascinating systems extensively. Using the appearance of the Sun as a

guide depicting stars in general, he produces accurate depictions of these close binary systems that no telescope can hope to see in detail for quite some time.

There will always be subjects that require the imagination and skill of an artist. And even for those things which we can see for ourselves in photos taken by Hubble, an artistic interpretation is still invaluable. "We will always need artists," says McKeon Butt, "because it's not just our job to show what things in the universe look like, but to also capture the aspirations of humanity, and reflect how our growing knowledge of the world changes our thoughts, behaviors and actions toward it."

Fig. 14.15 *LMXB* by Mark Garlick, FIAAA.

Fig. 14.16 *Star Formation* by David A. Aguilar.

Fig. 14.17 *Alien Planet Thrown Out of Colliding Galaxies* by William K. Hartmann, FIAAA.

Fig. 14.18 *Supernova Shockwaves* by Sam Dietze.

Robin Hart agrees. "Unless someone comes up with faster than light travel, we will have to rely on powerful telescopes to see deep space objects." She adds, "Humans interpret space subjects in a personal way. NASA realized this at the dawn of the space age and employed many artists to capture the 'feel' of missions, besides just photographing and filming them."

A comment by esteemed American illustrator Ron Miller sums up the contributions that a space artist makes quite succinctly. "A space artist can depict processes and events that may have taken place in the distant past or may take place in the distant future. We can go where a camera can never go." It would seem then, that space artists will continue to be invaluable.

Planetary Analogues: Other Planets Here on Earth

15

Jon Ramer

A popular technique for the artist is to set up their easel and tools outside and paint the view they see. This can be a bit problematic if the view the artist wants to paint is on another planet! Fortunately, there are ways around this difficulty.

Fig. 15.1 *Long Way Down* by Jon Ramer, FIAAA.

One of the most incredible things about the universe we live in is that the laws of physics are the same everywhere. Let go of an object above the surface of the Earth, and it will be accelerated downward at a velocity determined by the ratio of total mass of the matter below and the object's distance from the center of that mass. Let go of an object above a planet a billion light-years away, and it will be accelerated downward by the exact same ratio of mass and distance. The fundamental rules that make the universe "work" are the same across the entire cosmos.

This means chemistry works the same everywhere too. An independent electron will preferentially orbit an independent proton to make a hydrogen atom. An independent hydrogen atom will pair with another hydrogen atom to make a molecule of H2. Crush two H2 molecules together hard enough and they will fuse into helium, releasing energy in the form of photons. Gather enough H_2 together, and the pressure and heat from gravity will sustain the fusion reaction until a star is born. More atoms, more heat, and more pressure make helium fuse into heavier atoms like beryllium, silicon, nickel, iron, and oxygen.

J. Ramer (✉)
Mill Creek, WA, USA

Fig. 15.2 *Water Moon* by Justinas Vitkas.

Two hydrogen atoms will pair with one oxygen atom to make a molecule of water. If there are enough heavy elements like silicon, iron, and aluminum floating in space around a star, the gravity they have will form a planet that can hold water molecules to its surface. And if that planet is just the right distance from the star, that water will become a liquid ocean.

No matter where you are in the universe, stars shine, gravity makes rocks fall, and gases swirl about. It happens in the exact same way in every corner of our cosmos, on every body in our Solar System. Heat something up enough and it will melt. A gas or liquid under high pressure will move towards an area under lower pressure. Liquid flows down to the lowest possible point. This is amazing to consider. Identical laws of physics create processes that behave the same everywhere, resulting in geological formations that appear similar on far separate worlds. The mechanics of how a geyser works are the same, whether the geyser is on Earth or Enceladus. Dunes will form when wind blows sand around, whether the wind and sand are on Earth, Mars, or Titan.

Fig. 15.3 *Dune Walker* by Lyn Perkins.

In short, there are places on Earth that look just like places on other planets of our Solar System. There are canyons, and volcanoes, and geysers, and rivers, and craters, and more. Earth has all of these wondrous sights – and so do the seven other planets, 200-plus moons, and five dwarf planets we've discovered (so far!) in our Solar System. Missions to visit those distant bodies are difficult at best right now, even as humanity's technological level increases. But we can do the next best thing to visiting other worlds, and that is to visit places right here on Earth that look the same. What would it be like to walk on the surface of an alien planet?

Walk among the same geology. The scale of the view on Earth may be different, but the sights are still similar.

Interesting-looking geology is the main driving factor when the IAAA selects a location for a workshop, and the best workshops have all been to places that look just like those on extraterrestrial worlds. Standing on the edge of the Grand Canyon makes it pretty easy for a space artist to imagine what it would be like to stand on the rim of Valles Marineris, also called the Mariner Valley, and create a work of art that brings out the spectacular (see chapter 6).

Fig. 15.4 *Summit Party* by April Faires.

As stand-ins go, the Grand Canyon – the largest canyon found on Earth – is a pretty good one for the Valles Marineris, other than being far, far smaller. Yes, *smaller*. Even though it measures some 445 kilometers (276 miles) long, 1,800 meters (6,000 feet) deep at the lowest point, and more than 28 kilometers (17 miles) from rim to rim at its widest point, the biggest, grandest canyon on Earth is in reality less than 1% of the size of Mariner Valley. Named after the Mariner 9 spacecraft that discovered it in 1972, Valles Marineris is over 4,000 kilometers long (2,500 miles), seven kilometers deep (4.3 miles), and 200 kilometers wide (124 miles). If you dropped the Mariner Valley on Earth, it would stretch across the width of the entire United States of America. The entire Grand Canyon would fit inside one of the minor side chasms of Valles Marineris with room to spare.

How do you paint an image that captures such scale? Details are the key. You don't have to depict every nook, cranny, rock, and crack of such a vast formation, but it is necessary to convey the essence of the geological structures. The Grand Canyon is made up of layers upon layers of rock; the deeper you go in the canyon, the older the rocks are. Over millions of years, those layers were eroded away by the relentless Colorado River. This left a gorge with multicolored layers of rock and crags towering above the flowing water. A good painting of the Grand Canyon doesn't have every detail in the piles of rock debris at the base of cliffs, but it does show the viewer the effect millions of years of water erosion has had on the layers of rock. And it shows rows of crags and towers getting smaller and smaller, fading into the distance with the haze of atmosphere blurring the details. For the Mariner Valley, the Grand Canyon's wide-open vistas, layers of red rocks, and steppe mountains reaching to the distant horizon almost always works as a surrogate, only with a different colored sky.

The Mariner Valley experienced similar forces of erosion and, just like the Grand Canyon, the walls of Valles Marineris are made up of layers of different types of rocks. Those layers were eroded through by Mar's early, violent, geological history, but in the case of the Mariner Valley, the primary source of erosion was not water – it was lava.

Fig. 15.5 *Valles Marineris* by Steve Hobbs.

Billions of years ago, Mars was much more geologically active than today. As it is a small planet, the surface did not form continental plates like on Earth. Instead, the planetary mantle cooled into a single, planet-wide plate that did not drift or move. As a result, volcanoes that formed over hot spots in the mantle just grew and grew and grew, becoming supermassive structures.

Several supermassive volcanoes formed east of Mariner Valley in an area called the Tharsis Bulge, called "bulge" because it bulges up so high from the rest of the surface of Mars. So much volcanic material piled up in this region that the incredible weight of these gigantic mountains literally cracked the mantle of the planet. For hundreds of millions of years – possibly longer – liquid lava flowed though that crack, eroding it larger and deeper, creating the Valles Marineris we see today. There are giant outflow channels on the western end of the valley that show the history of these incredible events.

Different planets with different histories, but the same process of erosion. Yet, Mars has a gravity only 0.38 of Earth's and is barely more than half the size of our world. Ironically, this means that the results of that erosion process are tremendously larger than on Earth. The valleys are longer and deeper, the craters are bigger, the mountains are taller. In fact, the tallest mountain in the Solar System is Mt. Olympus, or Olympus Mons, just to the west of Valles Marineris. It rises a towering 22,000 meters (72,000 feet) – two and a half times higher than Mt Everest. This is because Olympus Mons isn't a mountain, it's a shield volcano, and it's the biggest part of the Tharsis Bulge. Volcanoes are ubiquitous across the Solar System; almost every major body has them, either active or dormant, and, quite probably, so will every rocky planet we ever encounter in the universe. This makes volcanoes highly interesting objects of study for space artists.

Fig. 15.6 *Caldera of Olympus Mons* by Ludek Pešek.

There are two types of volcanic eruptions: *effusive*, where liquid lava flows out of the ground, and *explosive*, where eruptions are gas-driven events that propel debris into the atmosphere. Shield volcanoes, like Olympus Mons, are built almost entirely from liquid lava flows. Repeated effusive eruptions come from a central vent and create a wide, gently sloping dome or cone. Because they often occur over hot spots in a planetary mantle, shield volcanoes are typically the largest type of volcanoes. The IAAA has held over a dozen workshops to volcanic spots around the Earth, each because they resemble a different type of volcano on different worlds. The Hawai'ian Islands are greatexamples of large shield volcanoes and have been the destination of multiple workshops (see chapter 6).

The Mauna Loa volcano on the island of Hawai'i is the largest shield volcano on Earth, measuring about 120 kilometers wide (75 miles) at the base and nine kilometers (5.6 miles) in height above the seafloor. This gives it an average slope on its sides of around eight degrees, fairly gentle. Olympus Mons has an average slope of just 2.5 degrees. Olympus is actually so large that when some future explorers are standing on its sides, the top of the mountain will be hundreds of kilometers away over the horizon. Even though they are standing on a gigantic mountain, it will seem like they are on a gentle hill.

Fig. 15.7 *Maat Mons* by Jon Ramer, FIAAA.

Mars and Earth don't have a monopoly on shield volcanoes. Venus has them too, and it has them in droves. There are over 1,600 major volcanoes on Venus and quite probably several hundred thousand smaller ones – far more than any other body in the Solar System. The largest volcano on Venus is called Maat Mons. It reaches 5,000 meters above its base (16,400 feet) and is about 400 kilometers in diameter (250 miles). The average slope on the sides of Maat Mons is one and half degrees, very similar to Olympus Mons on Mars. Because of the intense pressure of Venus' heavy, carbon dioxide-rich atmosphere, all volcanic eruptions on Venus are effusive: lava just oozes out onto the surface, making all volcanoes on Venus the shield type.

Maat Mons, Olympus Mons, and Mauna Loa have much in common. If you want to see what the surface of Venus looks like, take a trip to Volcanoes National Park in Hawai'i and stand on the edge of the caldera of Mauna Loa. The geology is just the same.

As discussed, the other type of volcanic eruption is explosive. What Venus lacks in explosive volcanoes, Jupiter's moon Io certainly makes up for. Io is the undisputed King of volcanic activity around our Sun. There are an estimated 150 volcanoes erupting on Io at any moment. On Earth that number is 40.

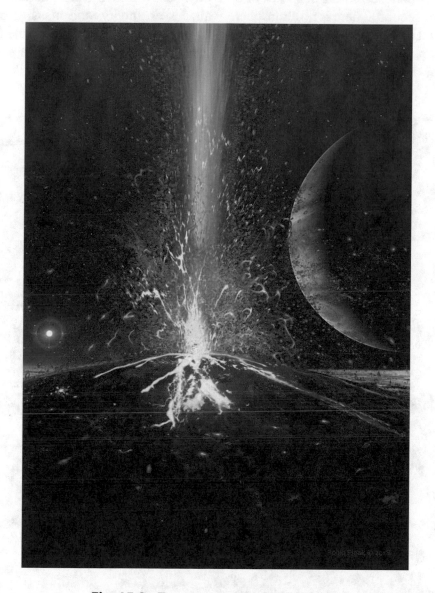

Fig. 15.8 *Eruption on Io* by Robin Pleak.

Some of those volcanoes are so explosively powerful that they shoot vast canopies of debris up to 500 kilometers into the sky – the International Space Station orbits Earth at 400 kilometers. These eruptions last for months and spew out billions of tons of material. How can this possibly happen on a moon so far from the Sun? The simple answer is gravity, one of those fundamental constants throughout the cosmos.

Jupiter's mass is an astounding 318 times greater than Earth's, and its huge gravity significantly changes in just a few thousand kilometers distance. Io's orbit is an ellipse, or a squashed circle, that varies by 3,000 kilometers from closest to farther point as the moon races around Jupiter in just 42.5 hours. This results in the entire moon being flexed, squeezed, and pulled on at different rates throughout its orbit. Jupiter's gravity is even stronger on the inner face of Io compared to the far side. The result of this gravitational tug-of-war is that the surface of Io heaves up and down by as much as 100 meters – the height of a 30-story building – in every single orbit. The "tide" on Io is the actual ground itself. This generates a tremendous amount of heat, so it should come as no surprise that Io is covered in volcanoes.

Of the 150 active volcanoes on Io, only a dozen or so create the giant plumes unique to the small moon. In those explosive eruptions, lava blasts out of the ground like a fire hose, exiting at speeds of up to one kilometer per second. There is no atmosphere on Io, so the material just arcs upwards on a ballistic trajectory. It cools as it rises and falls back to the ground as dust and debris, sometimes hundreds of kilometers away. We see similar ballistic trajectories of lava ejected from explosive volcanoes on Earth, though the blobs do not form umbrellas or travel as far due to atmospheric friction. The lack of air, lesser gravity, and massive energy input from Jupiter's gravity makes the scale of eruptions on Io tremendously larger. But there are also effusive eruptions on Io that look just like those on Earth.

Fig. 15.9 *Io* by April Faires.

Our probes have photographed the Tvashtar Paterae complex on Io erupting with massive, red-hot *lava curtains* that shoot a thousand meters into the sky (3,280 feet), making a fiery wall along an incredible 25 kilometer (16 mile) long fissure. These curtains look exactly like those at the Bardarbunga eruption in Iceland, though the Bardarbunga curtains barely reach 40 meters (130 feet) in height over a fissure. The ground patterns around Tvashtar and Bardarbunga are mirror images of the fissure eruptions of the Craters of the Moon volcanic park in Idaho. Furthermore, the effusive flow patterns on the sides of Ionian volcanoes look just like the channels and meanders of

lava flows of Mauna Loa. Iceland, Idaho, and Hawai'i have all been locations of multiple IAAA workshops.

The aftermath from volcanic eruptions creates some pretty spectacular scenery too. As lava flows down the side of a mountain, it tends to create channels. These channels stay hot, allowing the channel to erode into the ground or the surrounding rock to build up. As the top of a channel of lava cools, a crust will form over it that insulates the lava below and allows it to continue flowing as a liquid. When an eruption ends and the supply of lava stops, lava in the system drains downslope and leaves partially empty caves. These are called *lava tubes*.

The high atmospheric temperature and pressure on Venus result in lava tubes up to ten times the size of those on Earth. Radar images from the Magellan probe show tubes measuring tens of meters wide that appear to be hundreds of kilometers long. On Mars, lava tubes are even more amazing. There, the lower gravity and massive volcanic flows allowed tubes to grow to incredible sizes, as much as 250 meters (820 feet) wide.

Fig. 15.10 *Exploring Skylight at King's Crater* by Mark Maxwell.

But the Moon is where the truly spectacular tubes are. With no atmosphere and even lighter gravity than Mars, lunar geologists estimate that some lava tubes could be over 1,500 meters wide (4,900 feet) and dozens of kilometers long – large enough to fit an entire city inside! We have not yet explored lava tubes on the Moon, Mars, and Venus, but we know they exist. Tubes are often revealed by the presence of a *skylight*, a place where the roof of the tube has collapsed and opened up a hole in the ground above. Probes have returned pictures of hundreds of lava tube skylights on other worlds, including some where we can see down though the skylight and measure how wide and deep the tube

is. And of course, skylights exist in lava tubes on Mauna Loa and in the Craters of the Moon Monument & Preserve.

Another geological feature that often accompanies volcanic activity are grabens. A *graben* is a valley with an escarpment on the sides left by the downward displacement of the block of land in the valley. Grabens are actually common features all over the Solar System. There are two types of grabens: *expansion*, where the sides of the graben are pulled apart, and *compression*, where subsurface magma cools and shrinks, causing the ground above to fracture and collapse downward under its own weight.

Fig. 15.11 *Trappist-1 from the Surface* and reference photo of a graben in Death Valley, by Aldo Spadoni, FIAAA.

Strangely, the majority of grabens on Earth are expansion grabens, while compression grabens are most common on other planets. Both are highly educational for artists to study, and there is no better place to study them than Thingvellir National Park in southwestern Iceland. The park includes part of the rift where the ground is ripping apart as the North American and Eurasian tectonic plates move away from each other. Exo-geologists and space artists visit Iceland in droves to a get first-hand, ground-level view of the features they study from orbital imagery. At Thingvellir, the ground has several fault lines that have formed an amaz-

ingly beautiful landscape. There are numerous fissures, volcanic vents, geysers, and grabens all over the place. Grabens are also common in Death Valley, California.

Looking outward from Earth we see compression grabens everywhere, especially around mega-shield volcano formations like Olympus Mons, made when the lava below cooled and contracted. The Tharsis region is filled with patterns of graben cracks radiating away from the volcanoes as they settled downward. This radial pattern of grabens is also seen on the innermost planet of the Solar System, Mercury, especially

around large impact craters where the subsurface mantle was melted by the impact, then cooled and compressed again.

Grabens are commonplace on Earth and are therefore easy to study. There is however another astronomical landform that is actually rare on Earth, yet incredibly common on other bodies: impact craters. Opportunities to study impact craters are limited, but the IAAA has had the pleasure of doing so at the Barringer Meteor Crater in Arizona.

Fig. 15.12 *Exocrater* by Steven Hobbs.

Craters happen when two celestial bodies run into each other. On bodies like Mercury, the Moon, Pluto, and the moons of Jupiter, there is little to no atmosphere, allowing an impactor to hit at full orbital velocity. But on bodies with an atmosphere, friction will burn up many potential impactors before they can hit. At Earth, no rock smaller than 25 meters wide (80 feet) will reach the surface. Venus's ten times thicker air burns up anything smaller than 1,000 meters (3,280 feet) across, and Titan's 500-kilometer-high atmosphere will vaporize everything but meteorites that would create anything smaller than a massive 20-kilometer diameter crater (12.5 miles).

What is even more spectacular than the scale of some of these craters is the fact that they all look alike. When an impactor reaches the surface of a planet or moon, the crater it makes is usually circular with a rim of material thrown out from the center and a field of debris scattered around it. Large craters may have a set of double rings around them or a peak of rebounded matter in the center; super large craters are filled back in by the molten magma from the mantle below and have a flat floor. We see many of these patterns not only in craters on Earth, but also on every body in the Solar System. This is why studying craters is so important to a space artist.

Fig. 15.13 *Lunar Crater* by Lucien Rudaux, 1937.

Fig. 15.14 *Triton Caldera* by Michael Carroll, FIAAA.

Some discoveries on other worlds are so unexpected that they just cry out to be painted. The 1989 Voyager 2 discovery of giant active geysers on Neptune's moon Triton was just such an astonishing event. *Geysers* are basically a fountain of pressurized liquid shot up into the air from a reservoir in the ground. On Earth, a geyser requires water, a chamber to gather it in, and enough heat to boil it to steam. Triton has a surface temperature of -235°C (-391°F). Water there is harder than rock, yet there are definitely geysers. The liquid in these geysers isn't water though – it is liquid nitrogen. The materials and environmental conditions on Triton may be completely different than that of Earth, but the process is the same: a reservoir of liquid is heated to boiling and a stream is shot up into the air. But since Triton's gravity is just 8% of Earth's, those streams go up 8,000 meters high (26,000 feet)!

After cryo-geysers were discovered on Triton, scientists began noticing clues for geysers on other planets. Carbon dioxide geysers were found in the polar caps of Mars. Water geysers were discovered coming from cracks in surface ice on Saturn's tiny moon Enceladus, proving that the small moon was being flexed by Saturn's gravity in the same way that Jupiter flexes Io. And signs of possible cryo-geysers were spotted in images of the distant dwarf planet Pluto.

From the largest geological features to the smallest particle, the physical processes that make up our universe are the same everywhere. If there is a seed particle in the air on Earth, water will condense on it and form clouds and rain drops. On Saturn's moon Titan, the same thing happens with liquid methane. That rain falls and gathers into streams and rivers, eroding the ground away into gorges and canyons. Those rivers flow downhill with gravity until they reach an ocean or sea where they form river deltas. It doesn't matter whether the liquid is water or methane; it is actually difficult to tell the difference between photographs of some river deltas on Earth and Titan. And there is no reason to think that these processes are unique to planets around our Sun. There undoubtedly are planets across the universe with the same features.

Erosion occurs from more than liquid too. Even a marginal atmosphere will pick up and blow small particles of dust around, shaping rocks into strange formations over time. The actions of gas and liquid will grind larger rocks into smaller pieces and eventually into the powder we call sand. Sand is perhaps the most ubiquitous substance on the surface of the Earth, and quite possibly on all planets. Vast oceans of sand exist on every planet and moon with air in our Solar System. When wind blows on sand, it pushes it into various shaped dunes. Data from space probes show dune fields on Mars, Venus, Titan, and even some comets. What is so remarkable about this isn't that there are sand dune fields on other planets – it's that the sand dunes on other planets all look the same.

As a sand particle is blown across a dune, the particle travels up the face of the dune, packing the other particles down slightly until it reaches the top. At the top of the dune the sand isn't as tightly packed down, so the edge eventually collapses and the sand avalanches down the back at a steeper angle. The angle of the collapse is called the *angle of repose*. The remarkable thing is that the angle of repose is always between 29 and 34 degrees. Everywhere. On every dune, on every planet, no matter the strength of gravity, material the dune is made of, or composition of the air. Studies have even been done in parabolic airplane flights with different simulated gravity, and the angle is always between 29 and 34 degrees. This is why a sand dune on Mars looks just like a sand dune on Earth.

Fig. 15.15 *Titan Flash Flood* by Marilynn Flynn, FIAAA.

Fig. 15.16 *Dunes and Moons* by Jon Ramer, FIAAA.

Similarities between planets aren't just limited to surface geology. Jupiter's moon Europa has an ocean of water that is more than twice the volume of all the oceans on Earth. Since the surface of Europa at the equator is a chilly -160°C (-260°F), the top of that ocean is frozen solid, forming a skin of ice over the entire moon. But like Io, Europa is flexed and pulled by Jupiter's giant gravity, warming the interior of the moon enough to make an ocean up to 150 kilometers deep (93 miles). And as Europa circles Jupiter, that ocean rises and falls in massive tides. Tides below an ice cap will lift and crack the cap, moving sections of floating ice around in a process called *rafting*. There are numerous regions across Europa that have the exact same appearance as rafting ice floes in the polar ice caps on Earth. IAAA artists have traveled to Iceland and Antarctica just to see those floes in order to paint better images of Europa.

Fig. 15.17 *Ice Floes of Europa* by Michael Lentz.

Fig. 15.18 *Evening at a Gas Giant* by Justinas Vitkas.

Even clouds on other worlds behave the same way as those on Earth. The famous painting *Starry Night* by Vincent van Gogh depicts rolling waves in the night sky (see Figure 11.10). It is believed van Gogh witnessed a rare cloud shape called a Kelvin-Hemholtz formation. These shapes are cre- ated by a fast-moving air flow passing over a slower moving layer with a cloud and contorting the clouds into wave formations. These exact same shapes have been photographed in the cloud decks of the planet Saturn and form for the exact same reason.

Fig. 15.19 *Moana Loa* by Erika McGinnis.

Fig. 15.20 *In Maxwell Montes on Venus* by William K. Hartmann, FIAAA.

Fig. 15.21 *Basalt and Pumice Dunes* by Matt Colborn.

The more an artist studies the Earth, the more accurate they can make artistic portrayals of those features on other worlds. We go to places around the planet with unusual geological formations, because those features really aren't that unusual. It is incredible to consider just how similar our home is to the trillions and trillions of worlds out there in the universe. And even more incredible to think that you can "visit" those other planets by simply combining the sights of Earth with the imagination of an artist.

Afterword: The Future of the Genre

Ron Miller

Fig. 16.1 *Uranus Aurora* by Ron Miller, FIAAA.

R. Miller (✉)
South Boston, VA, USA

© Springer Nature Switzerland AG 2021
J. Ramer, R. Miller (eds.), *The Beauty of Space Art*, https://doi.org/10.1007/978-3-030-49359-2_16

Fig. 16.2 *Apollo Lunar Lander* by Mark Karvon.

"Now that we've landed on the moon and Mars and have flown by all the planets, what is there for space artists to paint?"

I am sure that most of my colleagues have been asked a question more or less like this one. I know that I have. It reminds me very much of a similar question put to science fiction authors in 1969: "Now that we've landed on the Moon, what are you going to write about?"

Most science fiction authors – at least the more polite ones – responded with an answer something like this: "Landing on the Moon? Ha! That's old stuff! We stopped writing about *that* decades ago!"

A similar reply might be given by the space artist. While landings on the moon, Mars, Venus, Titan, asteroids and comets, along with flybys of all the planets and many moons, sounds impres-sive, humans have in reality explored only the minutest fraction of the Solar System. Indeed, all of the territory covered by all of the astronauts and rovers really only amounts to a few square miles. And, by perfectly understandable necessity, these have often been the safest landscapes. This means that the most visually exciting landscapes – mountains, valleys, canyons, etc. – have been largely avoided. This is why so many of the images of the surface of the moon and Mars appear to be flat plains. (All that being said, there can be no real complaint about the scenery the Curiosity rover has visited, and there could have hardly been more Bonestell-like vistas than those taken on the surface of comet 67P/Churyumov-Gerasimenko by the cameras on board the Philae lander.)

Fig. 16.3 Photo of Gale Crater on Mars by the Curiosity rover, photo courtesy NASA/JPL-CalTech/MSSS.

Fig. 16.4 Photo of Comet 67P/Churyumov-Gerasimenko by the Rosetta probe, photo courtesy ESA/MPS.

Fig.16.5 *Haumea* by Justinas Vitkas.

Fig. 16.6 *Over Mars* by Nick Stevens.

But Curiosity and Philae aside, of our eight neighboring planets, nearly 190 moons, and countless asteroids, comets, and Kuiper Belt Objects, we have only been able to stand vicariously on the surfaces of scarcely half a dozen, and of most of those we have gotten only a glimpse of one small area. It's rather like a visitor to North America being dropped into the middle of Kansas and allowed to look around a few minutes before being whisked away again. They would be missing a lot.

Flybys or orbiters of distant worlds put us in a worse position. When a spacecraft zooms past a planet or moon or observes one from orbit, the images it returns to earth are like aerial photographs: we are looking *down* on a world's landscapes from a great altitude. It is like visiting the United States by looking out the window of an airliner. It is one thing to see the Grand Canyon from 30,000 feet and quite another to see it from the North Rim.

But space artists are not bound by any of these limitations. They are not restricted to safe locations: they can visit, through their imaginations, what lies over that distant hill and can take us with them. They can bring us to places where humans cannot survive and even spacecraft might not be able to easily reach, from the scorching surface of Venus and the radiation-soaked volcanoes of Io to the depths of the liquid hydrogen seas of Jupiter. They do not have to be content with looking down on a giant mountain; they can view it towering above them, or even scan the surrounding landscape from its summit. What might seem like little more than an insignificant crack in an orbital photo is a vast canyon to the imaginary visitor standing on its brink.

To this end, space artists do scientists a great service by making their discoveries accessible to the lay public. A flyby or orbital image of the surface of a world – even of our own – has no context, no scale. Firstly, because it is a viewpoint that we as surface-dwellers are unaccustomed to. Secondly, there is the flattening effect of looking more or less directly down on mountains, valleys, and craters.

The space artist can place us on the surface, so we might look back and say, "Aha! So *that's* what that bump *really* is!" By interpreting the spacecraft imagery, the artist adds scale and context and, as a consequence, comprehension. It's a process very similar to that of the paleontological artist, who can make a handful of dinosaur fossils live and breathe again, or the forensic artist, who can restore a face to a skull.

The space artist often has even much less to work with than a photo. A newly discovered object may be little more than a dot on a photographic plate. But by knowing all of the conditions – estimated size, distance from the sun, probable composition, etc. – the artist can create a realistic approximation of what the object might look like to a nearby observer. Sometimes an artist has even less than a dot to work with. An object may be known to exist only by its effect on other objects, it may be intrinsically unobservable, or it may even be entirely hypothetical.

There is a symbiotic relationship between that of the scientist and space artist. On the one hand, the artist helps the lay viewer understand what they are seeing in a photograph or a page full of graphs and numbers. On the other hand, the photo and data add verisimilitude to the artist's rendering.

Not everybody is a visual thinker, and that holds doubly true for many number-crunching scientists. I recall once having to create a painting of the Milky Way as it might appear to someone standing on a hypothetical planet. I wondered just how bright the Milky Way would seem to be compared to, say, a full Moon on the Earth. I was pretty sure it wouldn't really be the bright pinwheel of light as I'd often seen it depicted. After all, I thought, we live *inside* the Milky Way and it looks pretty dim to the naked eye. So, I contacted the late Bart Bok, who was *the* leading expert on the Milky Way at the time.

"How bright," I asked him, "would the Milky Way seem to be if seen from such a distance that it would fill the sky?"

"Gee," he replied, "I've never thought of that."

Fig. 16.7 *Neutron Star Collision* by Dana Berry.

Fig. 16.8 *Light* by Barbara Sheehan.

A space artist often combines information from a variety of disciplines. Where a scientist may focus on just one aspect of a planet or moon – its geology, atmosphere, magnetic field, cratering, etc. – the space artist must of necessity take all of these things into account when creating a painting. The result can be a valuable amalgamation of data into a single entity that is more than the sum of its part.

Aside from the practical services space art can provide, it also has inherent value as *art*, and the best of it strikes a balance between the two. Being technically accurate is one often important criteria of space art – but it is not everything. This is likely the reason why Chesley Bonestell's paintings are still so highly regarded and appreciated, even though in many cases science has overtaken them. We now know that Bonestell's craggy, Alpine lunar landscapes and bright blue skies of Mars and Titan do not exist – but that does not lessen their greatness as *art*. They are still incredibly beautiful landscape paintings that to this day manage to convey an emotional impact about the universe we live in, which is as at least as important as the science they once illustrated.

If anything, space artists today have much more subject matter available than space artists of earlier generations. And by that, I am not necessarily speaking of physical subjects. Space artists of Chesley Bonestell's heyday certainly knew nothing of Kuiper Belt Objects and black holes, let alone the definite existence of exoplanets. But given that the surface of Pluto was as mysterious and little known then as the surface of Proxima Centauri b is to us today, the principles of extrapolation are the same for both the pre-Space Age and post-Space Age artist. What more importantly set the earlier space artists apart – what was missing then that we have now – is the human experience of space travel. Today, more than 500 people have flown in space. When Chesley Bonestell published his first space art, the V-2 rocket had just made its first flight, and the farthest any human had ever risen above the surface of the Earth was 72,000 feet (22 km) – not quite 14 miles.

Fig. 16.9 *Earth* by Jacob Coble.

Exploring the human reaction to space travel – its effects on the imagination, psychology, and psyche – is something that was not really possible for pre-Space Age artists. They might only conjecture, if these things were really thought of at all. The rapture of exploring other worlds was a common thing naturally enough, and the dangers were often exploited for their drama (even Lucian Rudaux once devoted an illustrated magazine article to the "Hazards of Space Travel" back in the 1930s). But it really wasn't until humans left their home world that artists truly considered what this meant to the mind and spirit. This opened up entirely new possibilities for subject matter. Artists were now dealing not only with space travel and other worlds but also their *effect*s. European artists, and especially Russians, were pioneers in exploring this aspect of space art. An example explored in this book of the difference in approach can be seen in the book *In the Stream of Stars* (Workman, 1990), which was the result of a collaboration between Russian and Western space artists. Of the nearly 200 works reproduced in the book, the majority of Western artists focused on either the technology of space flight – *a la* Robert McCall – or the places being explored – *a la* Chesley Bonestell. On the other hand, the Russian art was dominated by depictions of the human experience of space flight, which was often expressed in non-representational, abstract, surrealistic, or expressionistic form.

Fig. 16.10 *Rock* by Detlev van Ravensway.

So, with the constant influx of new discoveries, new events, and new theories, modern and future space artists are not lacking in inspiration. If nothing else, there is a surfeit, with some unexpected discovery to think about almost every day. New techniques and materials are also constantly providing new means to express these ideas. Computer-aided art has opened entirely new vistas and possibilities, but this by no means means that traditional media has been abandoned. Painting in watercolor, oils, and acrylic – to say nothing of the graphic arts – is still alive and well. And there are artists who create hybrid works, where a traditionally rendered painting might be completed digitally, or where digital elements might be added to a traditional work. Modern space art has also embraced virtually every means of artistic expression.

In this book, we have explored works created in traditional and digital media, as well as works in sculpture, glass, and even quilting. Space art appears in every imaginable style as well, from the photorealistic to the abstract.

One medium we have been unable to include examples of is space art's most recent additions: music. While examples of space-inspired music go back at least to Gustav Holst's *The Planets* (1914–1916) or Leslie Stevens' evocative score for *Destination Moon* (1950), or even the score for 1950s *Rocketship X-M*, created by Ferde Grofé, the composer best known for his *Grand Canyon Suite*, Amanda Lee Falkenberg's recent *Moons Symphony* is one of the most extraordinary achievements in space-inspired music, and perhaps the first to be accomplished in direct collaboration with astronomers and scientists.

Fig. 16.11 *Grand Eclipse* by Justinas Vitkas.

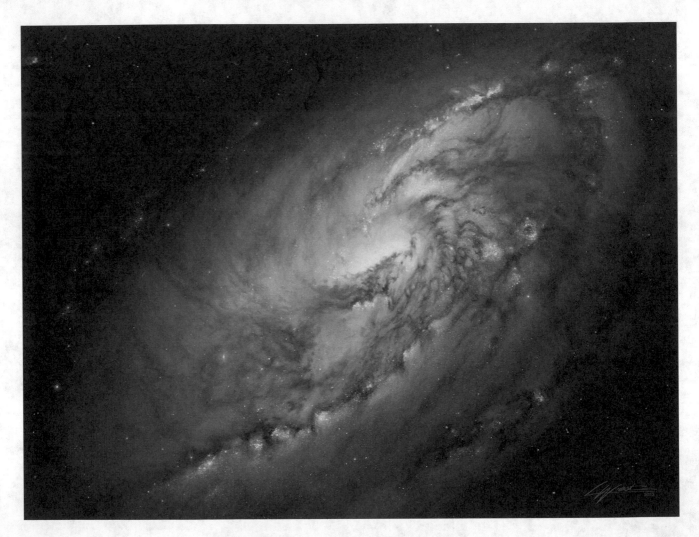

Fig. 16.12 *Mighty M106* by Lucy West.

So, space art is not only still around, but it is healthy and thriving, with a future ahead of it that – to paraphrase famed evolutionary biologist J.B.S. Haldane – is not only going to be more exciting than we imagine, but it is going to be more exciting than we *can* imagine.

Appendix A: Further Reading & Resources

Books

A list of books, by no means complete, that have featured space art over the years. Some were published as much as a century ago, others are brand new, but the common item is that they all feature space art.

- *Across the Space Frontier* – Cornelius Ryan, illus. Chesley Bonestell, Fred Freeman & Rolf Klep
- *Album of Astronomy* – Tom McGowen and Rod Ruth
- *Alien Horizons* – Bob Eggleton
- *Alien Seas: Oceans in Space* – Michael Carroll with Rosaly Lopes and a team of talented authors
- *Aliens in Space, an Illustrated Guide* – Steven Caldwell
- *Apollo* – Alan Bean
- *The Art of Chesley Bonestell* – Ron Miller and Fredrick C. Durant, III
- *The Art of Robert McCall* – Robert McCall
- *The Art of Space* – Ron Miller
- *The Art of Star Trek* – Judith and Garfield Reeves-Stevens
- *Astronomy: A Visual Guide* – Mark Garlick
- *Barlowe's Guide to Extraterrestrials* – Wayne Barlowe
- *The Beauty of Space* – Written and illustrated by members of the IAAA
- *Beyond Jupiter* – Arthur C. Clarke, illus. Chesley Bonestell
- *Beyond the Solar System* – Willy Ley, illus. Chesley Bonestell
- *Beyond Tomorrow* – Dandridge Cole, illus. Roy G. Scarfo
- *Bildatlas des Sonnensystem* – Bruno Stanek, illus. Ludek Pešek
- *The Book of Sea Monsters* – Bob Eggleton
- *Challenge of the Stars & The New Challenge of the Stars* – Patrick Moore, illus. David A. Hardy
- *Complete Book of Space Travel* – Albro Gaul, illus. Virgil Finlay
- *The Conquest of the Moon* – Cornelius Ryan, illus. Chesley Bonestell, Fred Freeman & Rolf Klep
- *The Conquest of Space* – Willy Ley, illus. Chesley Bonestell
- *Cycles of Fire* – William Hartmann, illus. Wm. K. Hartmann, Ron Miller, Pam Lee, & Tom Miller
- *Das Grosse Buch von Himmel und Erde* – Norbert Golluch, Burckhard Monter, illus. Thomas Thiemeyer
- *Drifting on Alien Winds: Exploring the skies and weather of other worlds* – Michael Carroll
- *The End of the World* – Kenneth Heuer, illus. Chesley Bonestell
- *Earths of Distant Suns* – Michael Carroll
- *Expedition* – Wayne Barlowe
- *The Exploration of Mars* – Willy Ley & Wernher Von Braun, illus. Chesley Bonestell
- *The Exploration of the Moon* – Arthur C. Clarke, illus. R.A. Smith
- *Exploring the Moon* – Roy A. Gallant, illus. Lowell Hess
- *Exploring the Moon and Solar System* – Terence Dickinson, illus. Zig Kucharski
- *Exploring Space* – Ron Miller
- *Extraterrestrials, A Field Guide for Earthlings* – Terrence Dickenson
- *Eyewitness to Space* – Hereward Lester Cooke & Thomas Paine
- *Faraway Worlds: Planets Beyond Our Solar System* – Paul Halpern, illus. Lynette Cook
- *The Fires Within* – David A. Hardy
- *First Men on the Moon (The Illustrated Edition)* – HG Wells, illus. Bob Eggleton
- *First Men to the Moon* – Wernher von Braun, illus. Fred Freeman
- *Flug in die Welt von Morgen* – Ludek Pešek
- *Frank Kelly Freas: The Art of Science Fiction* – Frank Kelly Freas
- *Frank Kelly Freas: As He Sees It* – Frank Kelly Freas
- *Frank Kelly Freas: A Separate Star* – Frank Kelly Freas
- *Futuropolis* – Robert Sheckley
- *Futures: 50 Years in Space & 50 Years in Space* – Patrick Moore, illus. David A. Hardy
- *Galactic Tours: Thomas Cook Out of This World Vacations* – Bob Shaw, illus. David A. Hardy
- *Great Space Battles* – Stewart Cowley

© Springer Nature Switzerland AG 2021
J. Ramer, R. Miller (eds.), *The Beauty of Space Art*, https://doi.org/10.1007/978-3-030-49359-2

- *The Grand Tour* (three versions) – William Hartmann & Ron Miller
- *Greetings From Earth* – Bob Eggleton
- *Hardyware: The Art of David A. Hardy* – Chris Morgan, illus. David A. Hardy
- *High Road to the Moon* – Bob Parkinson, illus. R.A. Smith
- *The History of the Earth* – William Hartmann, illus. Wm. K. Hartmann & Ron Miller
- *Imagining the Spheres* – Dr Steven Hobbs with contributions from the IAAA
- *Infinite Worlds: An Illustrated Voyage to Planets Beyond Our Sun* – Ray Villard, illus. Lynette Cook
- *In the Stream of Stars* – W. Hartmann, R. Miller, A. Sokolov, & V. Myagkov
- *Journey to the Exoplanets* – Ed Bell, illus. Ron Miller
- *Journey to the Planets* – Peter Ryan, illus. Ludek Pešek
- *Le Ciel* – Lucien Rudaux
- *Living Among Giants: Exploring and Settling the Outer Solar System* – Michael Carroll
- *Mars* – Robert Richardson, illus. Chesley Bonestell
- *Men of Other Planets* – Kenneth Heuer
- *Man and the Moon* – Robert Richardson, illus. Chesley Bonestell
- *Messung des Unermesslichen* – written and illus. Ludek Pešek
- *The Microverse* – edited by Byron Preiss
- *Moon and Planets* – Josef Sadil, illus. Ludek Pešek
- *N-1: For the Moon and Mars A Guide to the Soviet Superbooster* – Matthew Johnson (Author), Nick Stevens (Author, Illustrator)
- *NASA and the Exploration of Space* – Roger Launius & Bertram Ulrich
- *Natural Satellites: The Book of Moons* – Ron Miller
- *Other Worlds in Space* – Terry Maloney
- *Our World in Space* – Isaac Asimov, illus. Robert McCall
- *Out of the Cradle* – William Hartmann, illus. Wm. Hartmann, Ron Miller, & Pam Lee
- *Picture This: Grasping the dimensions of time and space* – Michael Carroll
- *Planetarium* – Barbara Brenner, illus. Ron Miller
- *Planet Earth* – Josef Sadil, illus. Ludek Pešek
- *Planet Earth* – Peter Ryan, illus. Ludek Pešek
- *The Planets* – edited by Byron Preiss
- *Planets* – Ron Miller
- *Race to Mars* – Dana Berry
- *Rockets Through Space* – Lester del Rey, illus. James Heugh
- *Rocket to the Moon* – Chesley Bonestell
- *Satellites, Rockets and Outer Space* – Willy Ley, illus. Chesley Bonestell
- *The Seventh Landing: Going back to the Moon, this time to stay* – Michael Carroll
- *Seven Wonders of the Rocky Planets* – Ron Miller
- *Seven Wonders of the Gas Giants* – Ron Miller
- *Seven Wonders of Meteors, Comets & Asteroids* – Ron Miller
- *The Smithsonian Intimate Guide to the Cosmos* – Dana Berry
- *The Snows of Olympus* – Arthur C. Clarke
- *Solar System* – Peter Ryan, illus. Ludek Pešek
- *Solar System* – Chesley Bonestell
- *Space & Nature* – Kazuaki Iwasaki
- *Space Art by Marilynn Flynn* – Marilynn Flynn
- *Space Art: How to Draw and Paint Planets, Moons, and Landscapes of Alien Worlds* – Michael Carroll
- *Space Art Poster Book* – edited by Ron Miller
- *Space History Mysteries Solved!* – With Animation and Interactive Virtual-Reality by L. Wayne Buinis, Animation and VR by Lonny Buinis
- *Space Shuttles* – Bruno Stanek, illus. Ludek Pešek
- *Space Wars: Worlds & Weapons* – Steven Eisler
- *Space Wrecks* – Stewart Cowley
- *Starlog Space Art* – edited by Ron Miller
- *Stars and Planets* – Christopher Lampton, illus. Ron Miller
- *The Stars Are Awaiting Us…* – Alexei Leonov & Andre Sokolov
- *Star Trek Spaceflight Chronology* – S. & F. Goldstein, illus. Rick Sternbach
- *The Story of the Solar System* – Mark Garlick
- *Super Space* – Kazuaki Iwasaki
- *Sur Les Autres Mondes* – Lucien Rudaux
- *Terres du Ciel* – Camille Flammarion, illus. assorted artists
- *Tour of the Universe* – Malcolm Edwards and Robert Holdstock
- *UFOs and Other Worlds* – Peter Ryan, illus. Ludek Pešek
- *The Universe* – edited by Byron Preiss
- *Visions of Space* – David A. Hardy
- *Visions of Spaceflight: Images from the Ordway Collection* – Frederick I. Ordway, III
- *Visions of the Universe* – Isaac Asimov & Carl Sagan, illus. Kazuaki Iwasaki
- *Voir l'Espace: Astronomie et science populaire illustrée (1840-1969) Astronomy and illustrated popular science (1840-1969)* – Elsa De Smet
- *War for the Moon* – Martin Caidin, illus. Fred L. Wolff & Bert Tanner
- *Worlds Beyond: The Art of Chesley Bonestell* – Frederick C. Durant, III & Ron Miller
- *Worlds Beyond* (11-book series) – Ron Miller

- *Worlds in Space* – Martin Caidin, illus. Fred L. Wolff
- *The Zoomable Universe* – Caleb Scharf, illus. Ron Miller

Following is a selection of internet links to space art, space-related, and artist information websites.

Art Groups & Organizations

- International Association of Astronomical Artists – http://iaaa.org/
- Graphic Artists Guild – http://gag.org/
- Society of Illustrators – http://www.societyillustrators.org/
- Society of Illustrators – Los Angeles – http://www.si-la.org/
- Society of Illustrators, Artists and Designers – http://www.siad.org/

Copyright and Legal Resources for Artists

- R.I.G.H.T.S. – http://www.rightsforartists.com/
- United States Copyright Office, The Library of Congress – http://lcweb.loc.gov/copyright/
- The Copyright Website – http://www.benedict.com/
- Volunteer Lawyers for the Arts National Listing – http://www.dwij.org/matrix/vla_list.html

Space Groups

- The Planetary Society – http://planetary.org/
- National Space Society – http://www.nss.org/
- Astronomical Society of the Pacific – http://www.astrosociety.org/
- ESA Home Page – http://www.esa.int/
- NASDA (Japan) – https://global.jaxa.jp/
- NASA – https://www.nasa.gov/

Libraries of Space Images

- NASA 3D Model Resource https://nasa3d.arc.nasa.gov/models/printable
- NASA Planetary Maps https://maps.jpl.nasa.gov/
- Space Telescope Recent Photos – http://www.stsci.edu/
- Hubble Space Telescope images – https://www.spacetelescope.org/images/
- NASA Photojournal – https://photojournal.jpl.nasa.gov/
- NASA Human Spaceflight – http://spaceflight.nasa.gov/
- Photos from the Udvar-Hazy Center – http://www.ninfinger.org/models/udvarhazy/udvarhazy.html

Glossary

Like every artistic genre, Space Art has its own set of terms and phrases each with their own special meanings.

Astronomical Art That subset of space art dedicated specifically to the depiction of stars, planets, moons and other celestial objects. This art may or may not include spacecraft but when they do appear, they are always in a subordinate role. Also see Space Art.

Asynchronous Illumination Referring to the inconsistent lighting of objects in scene, i.e. stellar objects that appear to have differing phases despite there being one source of light in the image.

Bonestellosphere, Or, Titan's Bonestellosphere Chesley Bonestell created a seminal painting in 1948 titled *Saturn as seen from Titan*, which inspired a whole generation of space scientists, engineers, and astronomers. It showed a rocky, icy surface with a beautiful ringed Saturn through a sapphire sky. Unfortunately, Titan was later found to be cloaked in opaque orange clouds. Space artist Ron Miller humorously postulated that there must be a region within Titan's atmosphere above the opaque cloud layers where Saturn could still be seen, and dubbed it the Bonestellosphere. Happily, the Cassini orbiter discovered that there actually is just such a haze layer above Titan's clouds.

Bump Map In the world of 3D computer graphics, modeling, and rendering, bump mapping is a technique for simulating bumps and wrinkles on the surface of an object. Bump maps are important to the 3D digital space artist as a means of generating realistic planetary or spacecraft surface detail. Bump mapping is achieved by perturbing the *surface normals* of the object and using the perturbed normals during lighting calculations. In simple terms, a surface normal is a mathematical line that is perpendicular to a surface.

Cosmic Impressionism Also known as *Swirly Art*. A style of space art that uses color and form to give a viewer the artist's impression of the subject matter without trying to be technically accurate, highly detailed, or adhering to known scientific principles. Despite being loose in style, the subject matter is still clearly inspired by space.

Cosmic Zoology Though the question of other life in the Universe has yet to be answered, artists can speculate about it and imagine the possibilities. Cosmic Zoology is the depiction of extraterrestrial life in extraterrestrial settings.

Digital/Photographic Reference The collection of images most space artists have of texture, light effects, geological references, etc. These are employed either directly as elements in the art or are used as textures or patterns in the creation of computer graphic three-dimensional models.

Greebles A small piece of detail added to break up and add visual interest to the surface of an object, particularly in movie special effects. Greebles are closely related to Nurnies.

Hardware Art Also known as *Nuts & Bolts Art*. This space art style focuses on the detailed depiction of spacecraft hardware and related equipment being used in a space setting.

Heightmap In the world of 3D computer modeling and rendering, a heightmap is a 2D image that can be used to generate a landscape in 3D terrain programs. Heightmaps are important to the 3D digital space artist as a means of generating realistic planetary surface terrain. The heightmap contains one channel interpreted as a distance of displacement or "height" from the "floor" of a surface. It is sometimes visualized as a grayscale image, with black representing minimum height and white representing maximum height. When the map is rendered, the artist can specify the amount of displacement for each unit of the height channel, which corresponds to the

J. Ramer, R. Miller (eds.), *The Beauty of Space Art*, https://doi.org/10.1007/978-3-030-49359-2

"contrast" of the image. Heightmaps can be used with the bump mapping technique to calculate where this 3D data would create shadows on a surface. Heightmaps can be created by hand with a classical paint program or a special terrain editor. These editors visualize the terrain in 3D and allow the user to modify the surface. Normally there are tools to raise, lower, smooth, or erode the terrain. Heightmaps can also be derived from various elevation databases provided by NASA, ESA, and other space organizations.

Imaginative Reimaging A circumstance where another artist substantially "borrows" elements of another artist's work and recreates it in their own. Often an unwelcome event and generally frowned upon in professional artistic company.

Gum Swallow Nebula/Galaxy A galaxy or nebula seen through a telescope that is so amazing it makes you swallow your gum.

Nurnies Bits of detail incorporated on object surfaces, intended to represent fictional technical detail. They serve no real purpose other than to add visual complexity to the object. They can be used on both physical as well as computer generated objects. The detail can be made from geometric primitives, including cylinders, cubes, and rectangles, combined to create intricate, but meaningless, surface detail. Nurnies are commonly found on models or drawings/renderings of fictional spacecraft in science fiction. Nurnies are closely related to Greebles.

Nuts And Bolts See Hardware Art.

Rendering The application of artistic tools and methods to create an image or painting. Renderings can encompass a wide range of artistic or photorealistic styles. In the world of 3D computer modeling, rendering is the process of generating an image from a 2D or 3D model (or models in what collectively could be called a scene file) by means of computer programs.

Rocks & Balls The direct inheritor of the artistic standards of Chesley Bonestell, Rock & Balls is an aspect of astronomical art whose primary emphasis is to show a viewer a scientifically accurate visual depiction of extraterrestrial locations in the cosmos. Descriptively real space art should convey a sense of why the lighting, sky color, even the chosen landscape surroundings appear as they do, and how a change in a specific condition as on other worlds could alter the scene. A descriptively real space artist might have a reasonable grounding in astronomy, the nature of the sky and weather, geology for knowing the Earth, space technology if depicting space hardware, and science in general.

Romantic Realism Also known as *artistic license*. This is an area where the truth of a subject can't be captured by the camera, and the artist has to expand the senses to truly capture the energy or wonder of an event or scene. An example of this is when an artist shows stars that would normally be washed out behind a brightly illuminated landscape, or a glowing blast from a rocket engine in a vacuum that would otherwise be too faint or invisible. In both cases they could be perceived, but by different visual camera exposures or stimuli (the sense of hearing – though, not in a vacuum – or the feel of pressure).

Space Art The general term for a genre of modern artistic expression that strives to visualize the wonders of the universe. Like other genres, space art has many facets and encompasses realism, impressionism, hardware art, sculpture, abstract imagery, zoological art, etc. Though artists have been making art with astronomical elements for a long time, the genre of space art itself is still in its infancy. Whatever the stylistic path, the space artist is generally attempting to communicate ideas relating to space, often including an appreciation of the infinite variety and vastness that surrounds us. In some cases, artists who consider themselves space artists use more than illustration and painting to communicate scientific discoveries or works depicting space. Some have had the opportunity to work directly with space flight technology, scientists, and engineers in attempting to expand the arts, humanities, and cultural expression relative to space exploration. Also see *Astronomical Art*.

Space Black It's not Benjamin Moore #2119-10 or Behr #N460-7. Many space artists use their own combinations of specific colors, not just black, to achieve what they consider the best and most appropriate representation of the black space background.

Space Sculpture Works of space art sculpture are more difficult to recognize as such, as they are usually more symbolic or abstract in nature, like a rocket shape, stained glass windows rep-

resenting stellar objects, or a sculptured work designed specifically for zero gravity display. However, the prime inspiration for three-dimensional works of space art is the same as other styles – space itself.

Spatial Compression When objects that are spread out are all shown in one image to convey a concept. Used often on extraterrestrial bases on the Moon and Mars, as the distance between landing sites and habitats might be too great to show together, without both being too tiny in frame.

Swirly Art See Cosmic Impressionism.

Terrain Generation In the world of 3D computer modeling and rendering, Terrain Generation involves the use of various computer programs and techniques to create realistic landscape imagery. Many of these programs employ fractal-based algorithms. Some of these tools have become quite sophisticated and in addition to terrain, they can create realistic skies, clouds, oceans, flora, planets, etc. Some terrain-generating software applications that are used or have been used by space artists include Terragen, Bryce, Vue, and others.

Terrestrial Analog A place on Earth where geology, atmospheric phenomena, technology, or other features resemble, directly mimic, or are morphologically similar to features found on other planetary surfaces. Terrestrial analogs such as the Grand Canyon, Death Valley, and volcanoes and glaciers in Iceland have been the focus of many space artist expeditions.

Texture Map In 3D computer modeling and rendering, Texture Mapping is a graphic design process in which a two-dimensional surface or image, called a texture map, is "wrapped around" a three-dimensional object. Thus, the 3D object acquires a surface texture similar to that of the 2D surface or image. This technique is important to digital space artists, who use it to render realistic planets, moons, spacecraft, etc. A number of space organizations and individuals have made some very high-quality texture maps available for the worlds of the Solar System.

Time Compression Where non-concurrent events that happen close in time are shown concurrently to illustrate a concept.

Tradigital Art Space art that is created digitally on a computer, but using traditional artist hand movements & techniques with digital brushes, pencils, and sometimes scanned traditional images done in acrylic, oils, etc. Tradigital space artists do not use any premade textures, photo elements, 3D techniques, etc. They typically use a tablet device and treat it as a physical canvas or drawing surface. They "hand paint" details using a selected digital brush and their own hand motions in exactly the same manner as if they were painting with traditional paints, brushes, and canvas. Some space artists like to work completely in this manner, while others will combine tradigital techniques with other digital methods to create their artwork.

Zero-G Art Any kind of art created in a microgravity or zero gravity space environment. The art subject matter does not necessarily need to be inspired by space, astronomy or science. The term "space art" has erroneously been used to describe any kind of art *created* in space. This is not correct unless the subject matter also conforms to the accepted definition of space art. See space art.

Index

© Springer Nature Switzerland AG 2021
J. Ramer, R. Miller (eds.), *The Beauty of Space Art*, https://doi.org/10.1007/978-3-030-49359-2

Printed in the United States
by Baker & Taylor Publisher Services